THE IMPOSSIBLE ROAD TRIP

ERIC DREGNI

Illustrations by

RICK LANDERS

AN UNFORGETTABLE JOURNEY TO PAST AND
PRESENT ROADSIDE ATTRACTIONS IN ALL 50 STATES

INTRODUCTION

ARE WE THERE YET?

Lazily cruising in a land yacht across the zigzag of secondary highways, I grew sleepy in Grandpa's baby-blue Oldsmobile. Endless fields blurred into the acres of jack pines slipping by the tinted windows. But then . . . what the hell was that? A 35-foot (10.5 m)-tall talking lumberjack lifting his enormous limbs—thanks to concealed ropes and pulleys. His mannequin-like mouth guessed all the visiting kids' names. Ignore the man behind the curtain who was fed the secret information to read through a loudspeaker coming from Paul Bunyan's mouth to dazzle and terrify the tots with his stunning psychic abilities. I believed it all.

In second grade, I paged through the *Guinness Book of Records* with classmates and saw the photo of a man who spent twenty-nine years of his life winding twine into a 12-foot (3.5 m) ball. He lived just an hour west of where I lived. Here was a man who made it to the big time. A local hero. I heard his neighbors wondered about his sanity and probably pitied his life dedicated to string collecting—that is until hundreds of visitors started pulling into town to admire his ball after his feat turned up in *Guinness*. Like it or not, the twine ball molded the town's identity.

Because of my eyes being opened by these local wonders (and a copy of the hilarious 1992 guidebook, *The New Roadside America*), I began researching and snapping photos of every roadside attraction I saw over the past

twenty-nine years. Most travel books ignore this essence of Americana; however, these one-of-a-kind marvels are the fruit of the creativity of individuals who refuse to succumb to the mind-numbing conformity of suburban sprawl and strip malls. The problem with my new hobby was I kept discovering oodles more attractions. This book could easily be twenty times its size and still be incomplete, but this is a sampler of some of my favorite sites with the best backstories.

This isn't simply about the "World's Largest" since that's hardly a new pursuit. After all, one of the Seven Wonders of the World, the Colossus of Rhodes, stood about 100 feet (30 m) tall before it fell in 226 B.C.E. Today, the burning desire to build ever bigger statues across the world shows no sign of abating. The largest

colossus in the United States, the Statue of Liberty at 305 feet (93 m), isn't even in the top forty of the world's tallest statues, but it's still one of the most iconic.

Beyond the awe inspired by yet another "World's Largest," I'm stumped by the perennial artistic question of "Why?" The best roadside attractions are the result of a practical joke, inspired boredom with lots of building materials, or a burning desire to create a giant monument to prove that "I Was Here." This is not normal behavior, and the United States is full of it—thank heavens!

Tourist bureaus drool over the idea of a roadside attraction to boost local tourism, but it doesn't work that way. The most successful oddball sites are seldom devised by committee. No! The best attractions date back decades and require the gumption of a creative (some would say delusional) visionary who would not go calmly into that good night but wanted to leave something for future generations to scratch their collective heads over. Often residents rally around endangered idols and make them into beloved homegrown symbols. After all, no one wants to see a stoic statue of some self-important town founder whom everyone is supposed to respect when instead they can look at a giant, smiling peanut.

These sites comprise a truly impossible road trip. I couldn't visit all these sites, so many of these photographs are from John Margolies who traveled more than 100,000 miles photographing roadside attractions with his Canon cameras and treated these outrageous sculptures, signage, and architectural oddities as valid pieces of art.

Inside this book you'll find a mix of museums, oversized statues, bizarre buildings, and anything else that will cause me to stop the car to scratch my head. Along the way, don't ignore the classic signs for motels, the historic movie marquees, and the small-town diners. Avoid the chains and embrace the mom-and-pop establishments that gladly destroy tedious monoculture one attraction at a time. Many of these sites only survive thanks to your attention. The photo you take of a roadside attraction may be the last since many are unprotected by any sort of National Register of Historic Places and may lead you to yet another destination along the romantic roadside.

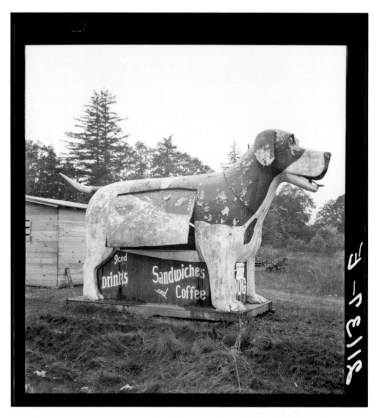

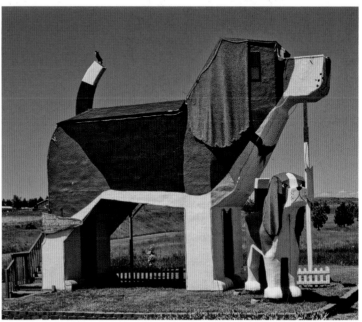

↑ Dorothea Lange's classic 1939 photo of a dog diner in rural Oregon captured a moment of the effects of the Great Depression and the burgeoning roadside culture. In Cottonwood, Idaho, a more modern canine inn opens its insides to visitors at the Dog Bark Park Bed and Breakfast Cabin so lodgers can sleep in the belly of the pooch.

Canada

Maine

Vermont

New Hampshire

New York

Hood

Massachusetts

Connecticut

Rhode Island

Pennsylvania

New Jersey

Maryland

Delaware

Atlantic Ocean

NORTHEAST

The stately buildings in the Northeast may seem sophisticated and even snobby, but look closely at that replica of an Italian bell tower and you'll notice it's an ad for sodium bromide tranquilizers. Other structures are shaped like flying saucers, milk bottles, shoes, ducks, and elephants. There's even a giant termite and a fake giant that inspired the saying, "There's a sucker born every minute."

MAINE

ORGONE-ENERGY ACCUMULATOR

WILHELM REICH MUSEUM IN RANGELEY, MAINE

Wilhelm Reich did Sigmund Freud one better. Reich studied under his fellow Austrian and inventor of psychoanalysis. While both agreed that sexual motivation is the primary driver for all humans, Reich took it a step further and announced the new element of "orgone" (the similarity to "orgasm" was intentional) that could save all mankind. He figured out how to harness this sexual radiation with an "Orgone Accumulator," essentially a wooden and metal box that measured 4.5 feet (1.5 m) tall, just big enough for the patient to sit inside.

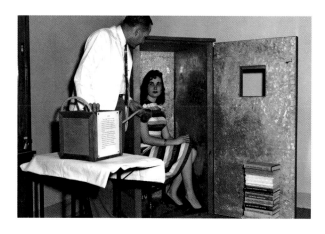

Reich even convinced Albert Einstein to hear his theory and met with the famous physicist at Princeton in 1941. Reich displayed his Orgonoscope that supposedly proved the existence of this ethereal electricity that could be used in the battle against Nazism. Einstein put aside his other research and spent ten days evaluating Reich's devices and theory. Einstein's assistant realized that the heat difference within an Orgone Accumulator is simply convection from the heat accumulating within the enclosed space from the person inside.

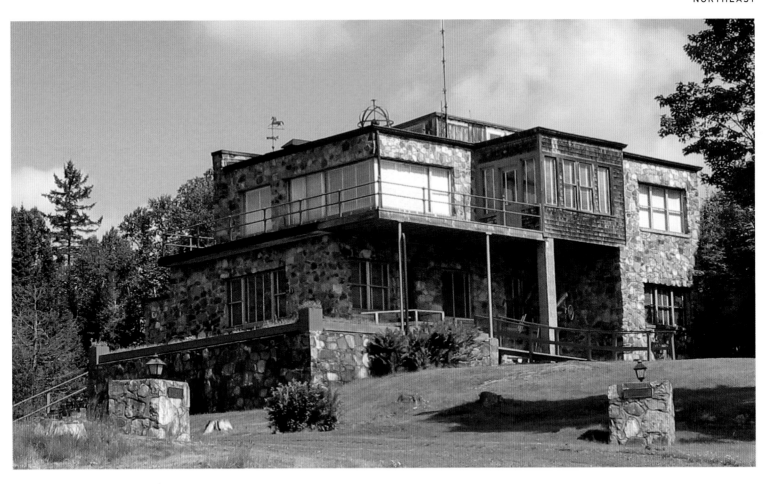

← ⬆ When Wilhelm Reich came to the United States, he bought a patch of land in Rangeley, Maine, to open "Orgonon," a research center and retreat to study the effects of "orgone" and how to harness this orgasmic energy from humans and from the sky in order to, among other things, make it rain. Today it is the home of the Wilhelm Reich Museum.

Reich wrote about the encounter with Einstein: "When I told him, in concluding, that people considered me mad, his reply was 'I can believe that.'" Reich assumed Einstein was complimenting him. After the meeting, Reich bragged in his writings that his orgone findings had made Einstein's theories on physics outdated.

In his early years, Reich had proven himself a charismatic professor with anti-authoritarian writings insisting that economic oppression is caused by sexual repression. He wrote *The Mass Psychology of Fascism* and *The Sexual Revolution* and gained a cult following well into the 1960s. He influenced Michel Foucault's landmark *History of Sexuality*. Reich's Orgone Accumulators became a symbol of sexual liberation and were purchased by such luminaries as J. D. Salinger, Norman Mailer, Sean Connery, and Jack Kerouac.

In his later years, however, Reich became more outrageous and warned of Deadly Orgone Radiation (DOR) dispersed on us by hostile UFOs that he called Energy Alphas. Fortunately, he started his Cosmic Orgone Engineering research that produced "cloudbusters," essentially six long aluminum tubes that sucked orgone from the sky, could control the weather, and kept the evil aliens at bay.

The U.S. Food and Drug Administration (FDA) cracked down on Reich's bogus medical claims for the Orgone Accumulators, but most likely J. Edgar Hoover was worried that Reich had sponsored some sort of scandalous sex cult. To censor Reich, the FDA burned hundreds of his books and literally tons of his papers, which, of course, had the opposite effect of increasing interest in his theories. Reich was sentenced to two years in prison, where he died.

NEW
HAMPSHIRE

SANTA CITIES

SANTA'S VILLAGE IN JEFFERSON, NEW HAMPSHIRE

Since Santa Claus seems to be the business engine behind our economy—Christmas sales are up to $1 trillion, or 19% of the economy (2019 figures)—it's easy to believe that Coca-Cola "invented" the modern image of Santa Claus, even if the sugary behemoth just popularized the red-and-white man with the sack of presents to fit with its color scheme.

No wonder Santa's Village in the White Mountains in the North Country of New Hampshire proved so popular even before the modern commercialization of all things Christmas. Opened in 1853, early attractions had a dancing chicken and Francis the Talking Mule, which was probably a letdown to see that the chatty donkey was just a movie trick and the kid behind the curtain was no substitute. Animals proved unreliable attractions (imagine that?) so rides replaced them. Even so, the holiday theme remains with swinging chairs called Rockin' Around the Christmas Tree and the Skyway Sleigh monorail.

In nearby Putney, Vermont, Santa's Land is another yuletide-themed park that has managed to survive since the 1950s and avoid ridiculous stomach-churning rides. More impressive still is the renowned Santa's Workshop in North Pole, New York, dating back to 1949 and little changed ever since. Apparently, Walt Disney based much of Disneyland off this winter wonderland that is sometimes deemed the first theme park in the country.

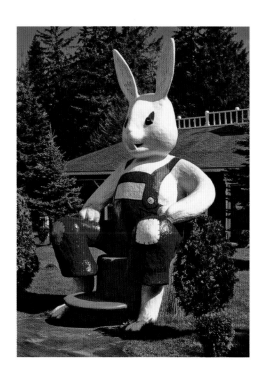

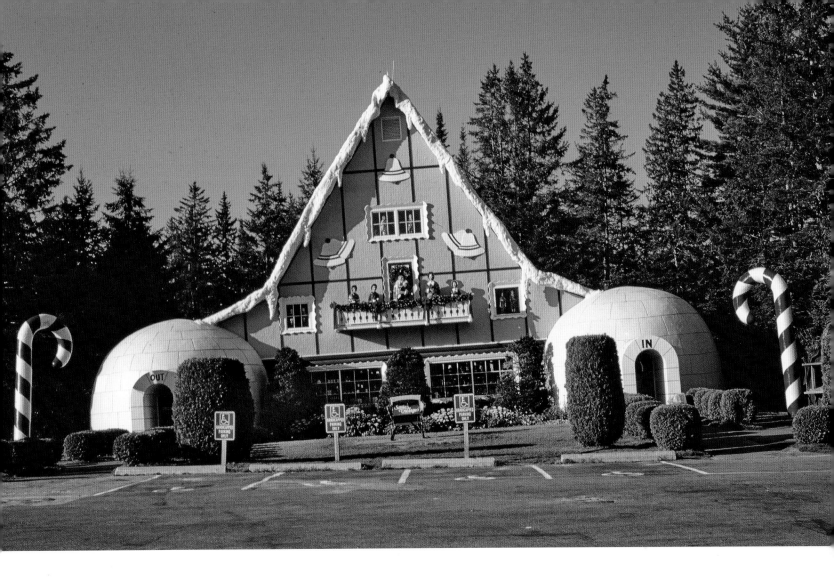

Tell that to Santa Claus Land (now Holiday World) in Indiana that dates back to 1946. The town's name was originally Santa Fe, but another Indianan city had beat them. Santa Claus, Indiana, sounded much more magical, so now half a million letters with wish lists for impossible gifts pour into town each December. The town even has a Santa Claus Cemetery—don't tell the kids! The real St. Nicholas died in what is now Myra, Turkey, in 343 C.E. on December 6, which became St. Nicholas Day. When the Saracens took over the area, Christians worried that the sacred relics (a.k.a. bones) of the saint would be desecrated by Muslims. They brought them to Bari in southern Italy and built the Basilica di San Nicola to house what was left of the saint—but those naughty Venetians tried, and perhaps succeeded in, stealing some of the precious skeleton. Don't stop there, though, because the St. Photios Greek Orthodox Shrine in St. Augustine, Florida, has bones of many saints, including St. Nicholas apparently. Even Morton Grove, Illinois, has a piece of Santa Claus' pelvic bone.

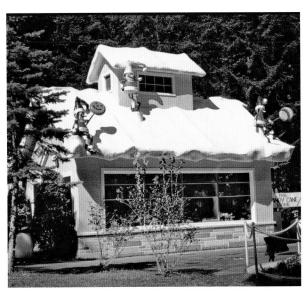

⬆ Santa's Village in Jefferson, New Hampshire, has managed to preserve some of its classic attractions from the 1950s while introducing some small-scale rides for the believers.

VERMONT

HANG YOUR HAT, OR ELSE!

THE DINER TOUR

Road trips are all about finding the next meal. Don't stop at some ho-hum chain, but seek out the classic dining cars mostly around New Jersey, Pennsylvania, Massachusetts, and New York.

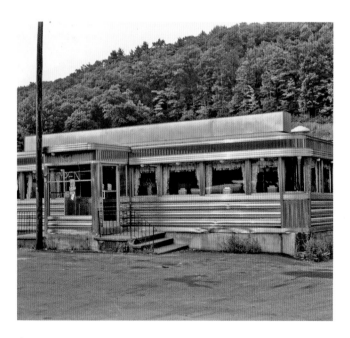

⬆ The Royal Diner in Kingston, New York, was a fixture of the town since 1955 when the O'Mahony Company of New Jersey built this beauty. When the Royal closed down at the end of the twentieth century, the 28-ton diner was put on a flatbed truck to its new home in Springfield, Vermont, in 2002.

Many were simply old train cars parked downtown in a vacant lot, but diners designed specfically as cafés were built by many companies, such as Tierney Company of New Rochelle, New York; Worcester Lunch Car of Massachusetts; Fodero Dining Car Company of New Jersey; and the O'Mahony Company of New Jersey.

We may think of most buildings on the National Register of Historic Places as grim old brick buildings, but many diners are now on the books as bona fide monuments. The Modern Diner in Rhode Island was the first to make the list with its Streamline Moderne international style that looked like it was ready to break the sound barrier. This opened the door for other classic diners to be protected, but they aren't necessarily the best examples of dining car cafés. Mostly the preservation of this bit of Americana

is the effort of dedicated owners who don't want this legacy bulldozed in the next purge of old landmarks to pave new parking lots.

The credit for the first diner goes to Walter Scott of Providence, Rhode Island, who sold newspapers and brought sandwiches to late-night journalists at the newspapers along Westminster Street in 1872. He got a horse named Patient Dick for his snack wagon, but the riffraff would often dine and dash. He got a billy club and enforced his new policy: Get a hat, or get a sore head.

Scott took the hat off one freeloader, but "he took a shot at me with his fist . . . I fell on top and pounded his head on the pavement until he cried enough . . . I heard afterward that he'd served a sentence in State Prison for biting off a man's nose in a fight."

Even though Vermont may not be the home of diners, some gems have been beautifully restored and some even salvaged from other states and moved here to be treasured. New York state is full of classic old disappearing diners, so residents of Springfield, Vermont, loaded up the closed down Royal Diner from Kingston, New York. The diner was put on the back of a flatbed truck and shipped through a New England blizzard, in which it was stuck for two days, to its new home next to a museum of another American icon: the Corvette.

➡ The Miss Bellows Falls Diner was built by the Worcester Lunch Car Company in 1941 as #771 and moved to Bellows Falls a few years later after a stint in Lowell, Massachusetts, as Frankie & Johnny's. This is the only Worcester diner to make the National Register of Historic Places.

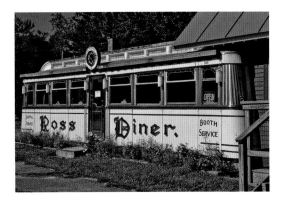

⬅ The Ross Diner was built by the Worcester Lunch Car Company in 1946 to serve the locals in Holyoke, Massachusetts. When the diner closed in 1990, it was moved to New Hampshire and then to Quechee, Vermont, where it has been named the Quechee Diner, the Farmer's Diner, the Yankee Diner, and now the Public House Diner.

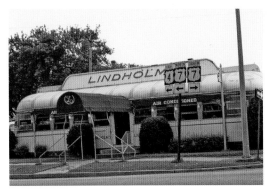

⬅ Rutland, Vermont, simply covered up Lindholm's Diner, a classic Sterling Steamliner, with a roofed building called Minard's Restaurant. Then in the 1980s, the original diner was uncovered and prepared for a move.

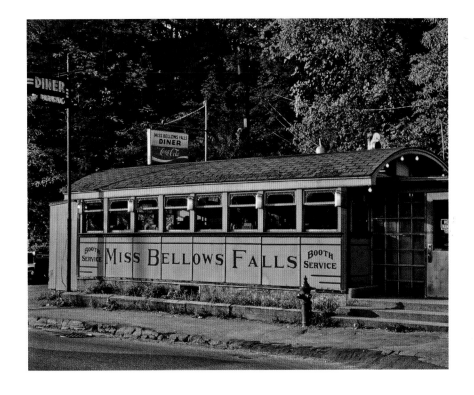

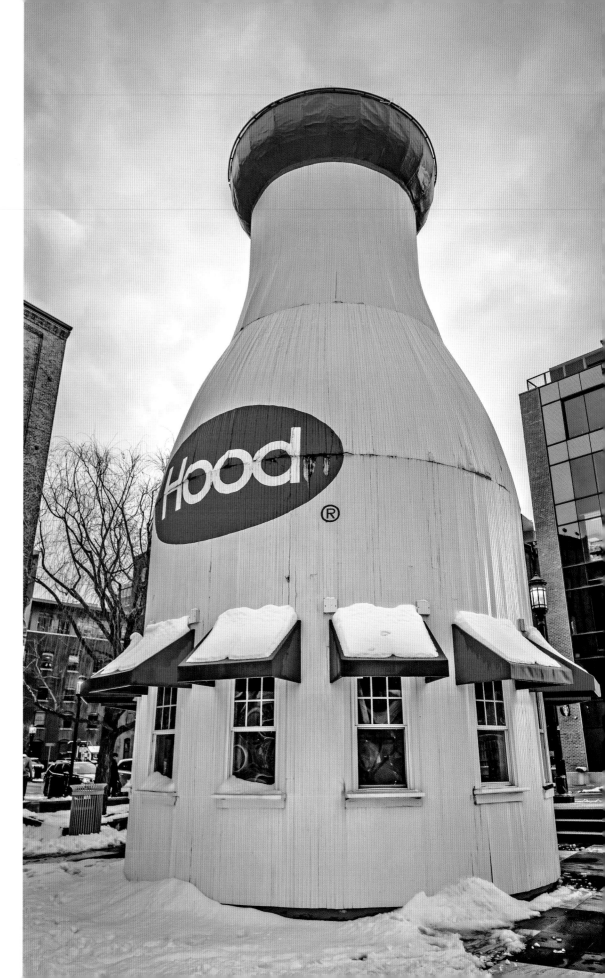

➡ The giant Hood bottle serves as a snack bar and was lovingly restored after the foundation cracked under the weight of all that milk.

99 BOTTLES OF MILK ON THE WALL

HOOD MILK BOTTLE IN BOSTON, MASSACHUSETTS

Plenty of houses across the United States are made from old bottles wedged into the cement walls to form green and brown stained glass that the sun streamed through. Some dairies decided to just make giant bottles of milk to advertise and sell ice cream and other lactose-filled goodies.

Perhaps one of the more prominent bottles stands on the Boston Wharf right next to where the Boston Tea Party took place to show that the new Americans didn't switch to coffee, but to milk instead. Stop in for a snack in this 40-foot (12 m)-tall milk bottle and marvel that it could hold 200,000 quarts (189,000 l) of milk. This historic bottle dates back to 1930 and was moved to its current site in 1977. It doubles as a sandwich bar with the requisite clam chowder (they don't even need to add "Boston" or "New England" to the navme of this creamy dish).

➡ Salvatore's Drive-In in South Dartmouth, Massachusetts, has been whitewashed and the name un-Italianized as Salvador's Ice Cream.

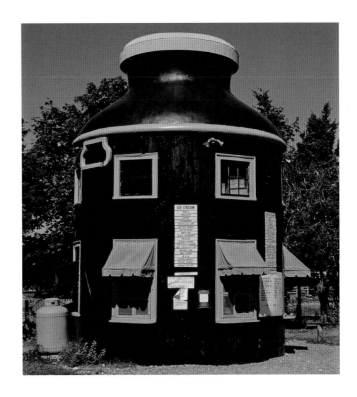

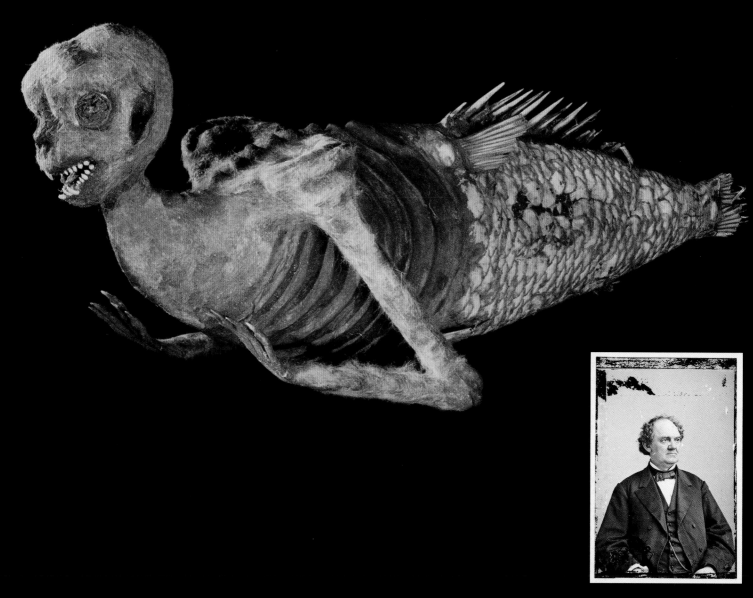

⬇ Tucked into the prestigious Peabody Museum at Harvard University, the Feejee Mermaid could be easily missed except for the fact that it's a sham amid world-class artifacts from around the world. This shriveled half-fish, half-chimp could hardly do justice to the tales of sirens of the sea luring sailors to their deaths beneath the waves.

⬆ Nineteenth-century showman P. T. Barnum is associated with the Feejee Mermaid prank. One could argue there's a little bit of Barnum in a lot of the folks responsible for America's most iconic roadside attractions.

SHRIVELED SIREN OF THE SEA

FEEJEE MERMAID IN CAMBRIDGE, MASSACHUSETTS

Just as the improbable duck-billed platypus and Egyptian mummies proved real, why couldn't mermaids be just as true?

Often shown next to other chimeras and oddities, the Feejee Mermaid supposedly was a "beautiful . . . half-fish, half-human," and posters showed a voluptuous, bare-breasted woman with a fish tail. Only after springing for admission did spectators see a close-up of this specimen of an orangutan and a salmon sewn together, but it could have just as easily been a chimpanzee and a codfish.

The origin of the Feejee Mermaid begins in Japan in 1810 when a merchant from Holland—the only country allowed to trade with Japan at the time—acquired the bizarre creature. Some sources claim the mysterious mermaid hailed from Calcutta from 1817, but perhaps that was a stopping off point when the Dutch merchant brought it home. Once in Europe, American ship captain Samuel Eades bought the mermaid for $6,000, a fortune at the time for which he had to sell his ship. He displayed the mermaid in London to marveling masses of people—at least until the critics arrived and debunked

his myth. A couple of decades later, the mermaid made its way to New York where P. T. Barnum took it on tour and reveled in the publicity and outraged scientists who debunked his shenanigans at every turn. Once his prank was discredited, Barnum had already moved on to the next town.

Incredibly, the mermaid ended up at the most respected university in the country: Harvard. In 1897, the Peabody Museum in Cambridge was given the Feejee Mermaid, which is still on display next to authentic artifacts. Ironically, the mermaid at Harvard could very well not be the original Feejee hoax since Barnum described it as having a "large head and pendulous breasts." The specimen at Harvard is rather small with no bosom in sight. Of course, P. T. Barnum was not above having several specimens that traveled the country to double or triple his money, and who could blame him for making a copy of a hoax?

TALL TAILS

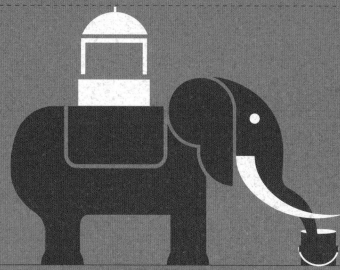

LUCY THE ELEPHANT
MARGATE, NJ
65 ft. (19.7 m)

SALEM SUE
NEW SALEM, ND
38 ft. (11.6 m)

KFC ROOSTER
MARIETTA, GA
56 ft. (17.1 m)

PINK ELEPHANT
FORTVILLE, IN
19 ft. (5.8 m)

THE BIG DUCK
FLANDERS, NY
20 ft. (6.1 m)

WORLD'S LARGEST BUFFALO
JAMESTOWN, ND
26 ft. (7.9 m)

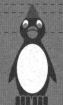

PENGUIN
CUT BANK, MT
27 ft. (8.2 m)

NIBBLES WOODAWAY
PROVIDENCE, RI
9 ft. (2.7 m)

MIGHTY TERMITE

BIG BLUE BUG IN PROVIDENCE, RHODE ISLAND

In searching for a muse for a giant statue, how many things could you make more than 900 times the size of the original? Think small, insect small. That's exactly what New England Pest Control did with their giant termite. (Actually 900 times bigger than the original assumes a termite is ¾-inch [2 cm] long, whereas most of these pests are no more than ½-inch [1.2 cm], which would make the statue nearly 1,400 times bigger than the bug!)

The 58-foot (17.5 m) insect would be anyone's nightmare, but Providence has embraced the bug that has appeared in numerous films. *The Providence Journal* even proclaimed that the world's biggest bug sets "Guinness-worthy records every day." Originally colored purple (even though termites are typically brownish), the bug awoke one morning to discover that it had transformed into a gigantic blue insect. The sun had bleached out all red from the purple paint and the bug had the blues. The company didn't resist the metamorphosis and soon changed its name to Big Blue Bug Solutions in honor of the beloved termite on the roof.

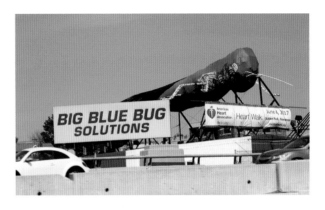

⬆ The World's Biggest Bug in Providence needed a name beyond just Big Blue Bug, so a 1990 contest chose the clever moniker Nibbles Woodaway, a name which was difficult to get everyone to use even after ten years.

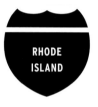

VIKING LIGHTHOUSE?

NEWPORT TOWER IN NEWPORT, RHODE ISLAND

Norse mooring stones, runestones, and other supposed Scandinavian artifacts dating to the late 1300s dot the landscape of the northeastern United States. Whether one confirms they are authentic depends upon the nationality of the archaeologist. For example, one of the oldest intact buildings on the eastern seaboard in Newport, Rhode Island, had been deemed a Viking Tower by Scandinavian historians. Danish scholar Carl Christian Rafn declared the tower a Norse baptistery or round church tower built by Viking settlers in the eleventh or twelfth century when they came to Vinland, the name the Norse gave to the New World.

Scandinavian supporter Hjalmar Holand concluded that this tower was built later, "by the Royal expedition of 1355–1364," of post-Viking-era adventurers led by Paul Knutson who supposedly left the Kensington Runestone in central Minnesota. He disparaged later Spanish-sponsored expeditions in his book *Explorations in America before Columbus* and extoled the superiority of the Scandinavians, writing, "When Columbus started on his westward journey to Cathay, he was accompanied by so many untrained hotheads and jail-birds that his plans for a peaceful conquest were irreparably wrecked, and Spanish affairs in Haiti became one of the worst muddles in history. In contrast, the men of the Paul Knutson expedition were probably as carefully selected as were ever the members of any exploring expedition."

The poet Henry Wadsworth Longfellow, who never hesitated to distort historical accuracy to make a good story, waxed poetic about the Newport Tower and a

supposed Viking tomb found in Fall River, Massachusetts, in 1832. In his poem, "The Skeleton in Armor," he mused, "I was a Viking old! /My deeds, though manifold... There for my lady's bower /Built I the lofty tower, /Which, to this very hour, /Stands looking seaward."

Too bad that excavations at the site in 1948 showed that the tower was likely built in the mid-seventeenth century, probably in 1653 by Benedict Arnold, who was governor of the Rhode Island Colony. "Not so!" argues author W. R. Anderson, who points out in his *Norse America* book saying that the tower "was already in existence in 1632, being mentioned in the so-called Plowden Paper of that date, which includes reference to a 'rowed stone towre'... [and] is clearly depicted in the well-known world map of Mercator drawn in 1569—six decades before the first colonist."

Despite some saying the Newport Tower is the work of the Portuguese, Chinese, or the Knights Templar, the architecture is nearly identitcal to six-arched, seventeenth century windmills in central England.

⬇ The Newport Tower in Rhode Island, perhaps the oldest building still intact in all of North America, is also a big mystery. Evidence of large wooden posts away from the tower show that perhaps it was aligned to be an astronomical observatory. New excavations in 2008 confirmed the tower's likely construction in the seventeenth century due to objects found from that period. Skeptical Norse scholars say this proves nothing!

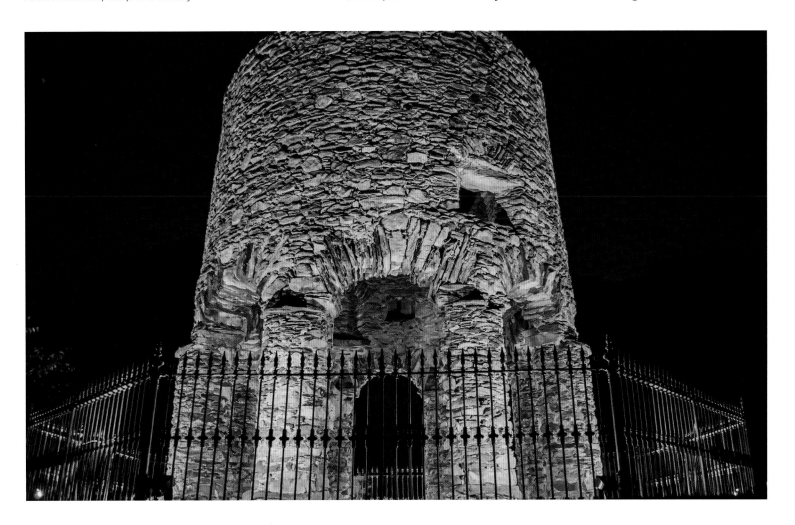

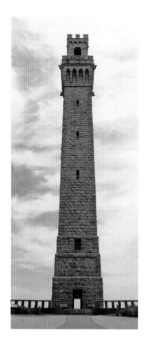

⬆ The Pilgrim's Tower in Provincetown, Massachusetts, is a slightly shorter version of the Torre del Mangia from Siena and marks the spot of the first landfall of the Pilgrims and then the signing of the Mayflower Contract.

➡ Siena's Torre del Mangia was completed in 1348, the same year the plague struck. Waterbury, Connecticut, completed its tower in 1909 but couldn't match the height of the Tuscan tower's 337 feet. Still, its 245 feet (75 m) seem all the more impressive because of the smaller buildings in the area. The town raised nearly a million dollars to renovate the clock and tower in 2016.

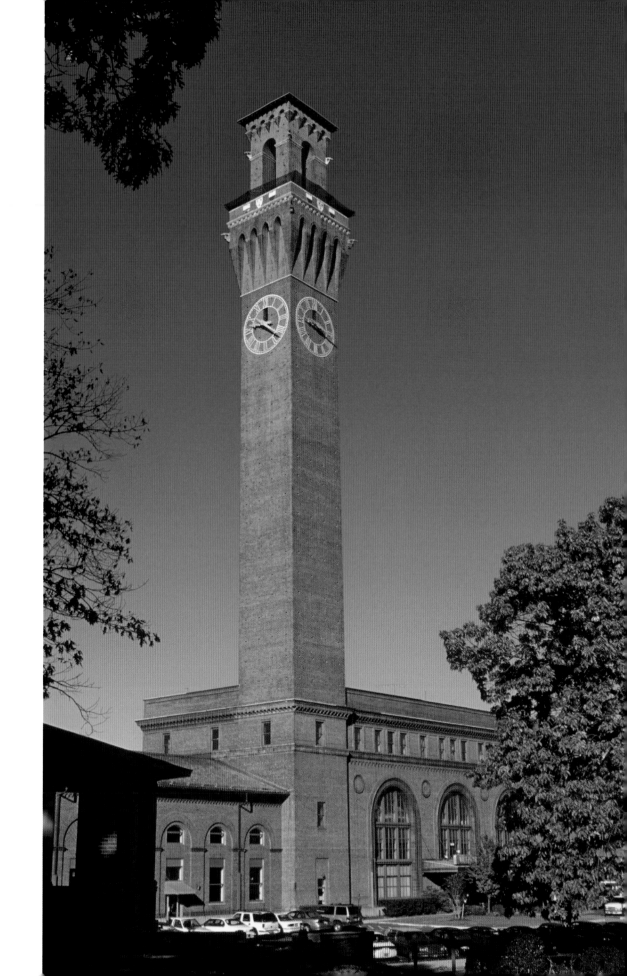

PLAGUE TOWERS

TORRE DEL MANGIA IN WATERBURY, CONNECTICUT

To prove to the rest of New England its importance, the residents of Waterbury built a 245-foot (75 m) tower as a replica of the Torre del Mangia in Siena, Italy. The square below Waterbury's tower may not have the famous Tuscan bareback horse race, the Palio, or the history of being besieged by neighbors catapulting plague-infected corpses over the city walls in early uses of biological warfare, but both towers share the duty of beating out the time to peasants toiling below. Waterbury's tower served as the train station clock. Siena's tower was named for its version of Quasimodo, whom they nicknamed Mangiaguadagni ("earnings eater") since he banged out the time on the bells and then spent all his savings at the delicious restaurants in town.

The Torre del Mangia was the second tallest tower in Italy, and most importantly, taller than the towers of Florence. Waterbury's replica is the tallest clock tower in New England and one of the tallest in the country. The church decreed that Siena's government tower couldn't exceed the height of the cathedral. What's more, Siena's religious leaders had big plans to expand the cathedral to be at least as big as Florence's. The plans were abandoned when the Black Plague hit in 1348 and wiped out an estimated half of Siena's population within a year. In the same vein in 2020, four Catholic priests climbed Waterbury's tower to pray the rosary and rid the town of the COVID-19 pandemic.

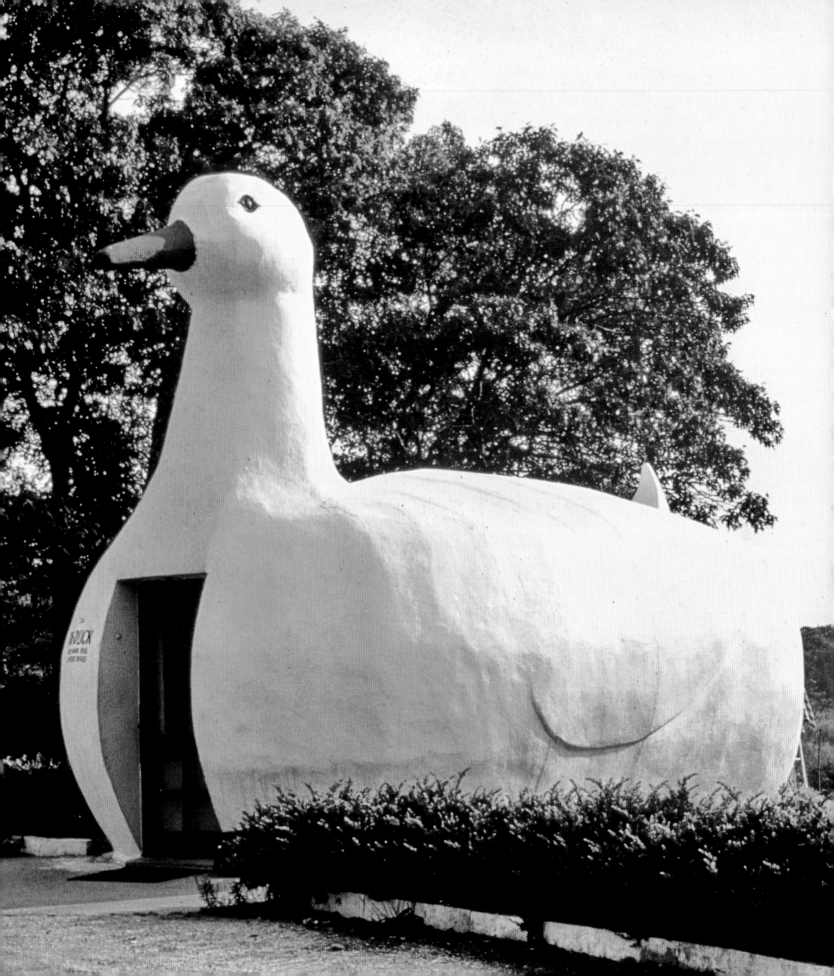

NEW YORK

DUCK SOUP

THE BIG DUCK OF FLANDERS, NEW YORK

During the Great Depression, eastern Long Island was known for ducks. Dozens of duck farms took advantage of the marshy landscape to raise the fowl for sale. In 1931, Martin Maurer needed something special to promote his poultry, so he envisioned a giant building in the form of what he sold: a duck. The Big Duck doubled as advertising and as a functional building to sell all things fowl.

← In 1931, Martin Maurer had a dream to promote his duck farm on Long Island, by making an enormous duck building. Along with Lucy the Elephant in New Jersey, the "Big Duck" has become an inspiration to would-be architects across the nation to make oversized animals and live in them.

Perhaps the Big Duck would have fallen into disrepair like so many other animalistic architectural wonders if it weren't for the attention of famed architect Robert Venturi who coined the term "Big Duck Architecture" to describe these uniquely American structures that represent giant creatures or objects. An icon and inspiration, the giant bird has since been listed on the National Register of Historic Places.

Maurer moved his duck from the center of Riverhead a few miles east to his duck farm in Flanders so visitors would know where to go. The Big Duck has since migrated back to its home in Flanders on the eastern end of Long Island.

TOWERING HEIGHTS

340 ft. (103.6 m)

* 51-foot (15.5-m) illuminated bottle of Bromo Seltzer since removed

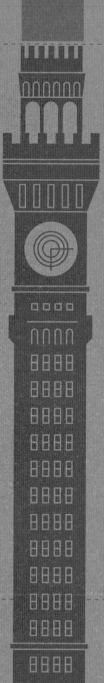

289 ft. (88.1 m)*

252 ft. (76.8 m)

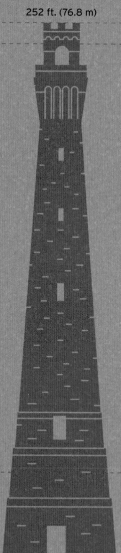

245 ft. (74.7 m)

28 ft. (8.5 m)

NEWPORT TOWER
NEWPORT, RI

WATERBURY UNION STATION
WATERBURY, CT

PILGRIM'S TOWER
PROVIDENCE, MA

EMERSON BROMO-SELTZER TOWER
BALTIMORE, MD

NEW YORK

A SUCKER BORN EVERY MINUTE...

CARDIFF GIANT IN COOPERSTOWN, NEW YORK

George Hull was a cigar maker and avowed atheist who decided to test the beliefs of Christians. In secret, he had a 12-foot (3.6 m) chunk of gypsum quarried and paid a sculptor to carve Hull's image in the rock.

Hull then sneaked onto his neighbors' property in Cardiff, New York, and buried his giant in a spot that he knew would be dug up the next year when his neighbors planned on digging a well.

And dug up it was. Some excited Christians assumed this was the "giants in the earth" that Genesis professed. A gaggle of doctors thought it was a petrified giant. Even Ralph Waldo Emerson proclaimed this mysterious find as "beyond his depth . . . and undoubtedly ancient."

Hull laughed all the way to the bank. He had paid $2,600 for the sculpture and sold it for $37,500, a fortune in 1870. The new owner refused P. T. Barnum's offer of $60,000 to rent the giant for three months. Barnum simply commissioned his own giant and made even more money, leading one owner of the original giant to declare "There's a sucker born every minute"—a quote popularly misattributed to Barnum.

Hull's original giant can be viewed at the Farmer's Museum in Cooperstown where it has been on display since 1948.

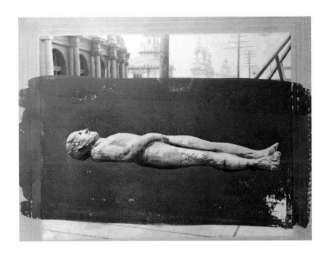

↑ George Hull's giant in its current resting place in Cooperstown. Fort Dodge, Iowa, has a copy of the original hoax. Farmington Hills, Michigan, has yet another replica, and the over-the-(big) top Circus Museum in Baraboo, Wisconsin, has P. T. Barnum's famous fake.

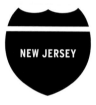

NEW JERSEY

THE JERSEY SHORE

UNDER THE BOARDWALK IN NEW JERSEY

Atlantic City claims to have built the world's very first boardwalk dating back to 1854, apparently to stop the sand entering the posh hotels and give tourists a pleasant place to promenade in the evening. More popular boardwalks popped up along the Jersey coastline, such as Ocean City, Seaside Heights, Point Pleasant Beach, and Wildwood with their classic amusement parks often on piers stretching out above the waves.

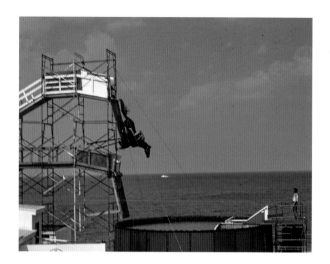

⚑ Sometimes called the Las Vegas of the East Coast, Atlantic City predates Sin City and has the amusement parks to prove it. Steel Pier was the original, but many others followed, such as the Steeplechase Pier, often with horses jumping into swimming pools.

For the glitz and kitsch, however, it's hard to beat Atlantic City. Its historic Steel Pier, the oldest amusement park on the boardwalk, was nearly doomed when Caesars Atlantic City went upscale and a pre-president real estate mogul Donald Trump, who owned a neighboring casino, wanted to scrap Steel Pier to keep up with the Joneses.

The spas and health clubs that once attracted tourists to Atlantic City were soon overshadowed by glitzy gambling clubs. Soon the themed casinos in Las Vegas overshadowed Atlantic City, and the trend was impossible to resist. Caesars Atlantic City boasts faux Roman statues and waitresses in togas with gold trim—never mind that women didn't wear togas in ancient Rome. Caesars once had a giant replica of Michelangelo's *David* statue made from the same

↑ The historic Steel Pier is the oldest amusement park on the boardwalk. It was nearly doomed when developer Donald Trump, who owned a neighboring casino, moved to scrap it.

Carrara marble as the original and standing just as tall (17 feet [5 m]). Just ignore that Michelangelo hailed from the Renaissance, a thousand years after the fall of the Roman Empire. As the casino tried to cut costs, the statue went up for sale with a note that this copy took the sculptor two years to finish and cost nearly a million dollars.

While the Taj Mahal in Agra, India, is a monument to love, the Taj Mahal in Atlantic City is monument to money. Trump's decadent and flamboyant casino came in at a cost of nearly $1 billion, but perhaps made up some of these costs in money laundering, although that conviction led to a $10 million fine. Despite all the links to organized crime and bankruptcy, the over-the-top décor and excess is worth

the stop along the boardwalk, perhaps even more so now that Hard Rock has taken over Taj Mahal and added its own ritzy twist.

Atlantic City and the Jersey shore have constantly transformed themselves to lure in tourists from East Coast cities who stroll by the knickknack shops and fried food stands and then get out of the sun to go under the boardwalk for some fun.

➡ Sure, the Vatican may have the original, but Caesars Atlantic City has a giant replica of Augustus Caesar with Cupid at his feet to show that this is indeed the house of the gods. Be sure to see the four horses pulling Caesar in a chariot at the entrance to the casino.

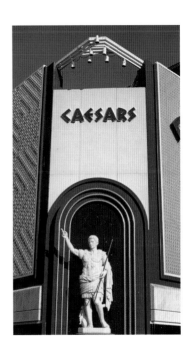

NEW JERSEY

INTO THE BELLY OF THE BEAST

LUCY THE ELEPHANT IN MARGATE, NEW JERSEY

Older than the Statue of Liberty, Lucy the Elephant heralded visitors to the Jersey Shore beginning in 1881. The 65-foot (19.7 m) pachyderm was the brainchild of real estate developer James V. de Paul Lafferty who wanted tourists to flock to his patch of land filled with lackluster scrub brush and a beach that only showed its sandy side at low tide.

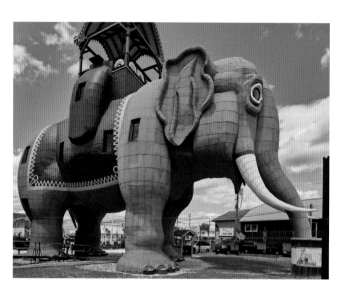

⬆ This New Jersey monument is likely the oldest animal building in the country—dating back to 1881. Lucy stands over Margate Beach and has stairs in her legs that lead up to several rooms inside her big belly.

And flock they did. Lucy became so popular that a second elephant was built at Cape May but stood only 40 feet (12 m) tall compared to Lucy and Lafferty's giant 125-foot (38 m) beast towering over Coney Island. Lafferty wanted to patent his pachyderms and build them across the country, but his novel idea soon wore off. The biggest beast, the Colossal Elephant, caught fire in 1896 and went out in a blaze of glory. Lucy's little sister soon aged and crumbled. Lucy, on the other hand, had to be moved to a brighter beach.

The colossal Elephant has doubled as a vacation home, a bar, a real estate office, and the heart of adoring kids at a summer camp. The brave elephant has faced down the wrecking ball many times and won every time.

MAN OF STEEL

GIANT HOCKEY PLAYER IN NEWARK, NEW JERSEY

Rather than risk its statue exposing itself to bullets, baseball bats, or flaming arrows as others have across the country, Newark made its 22-foot (6.5 m)-tall hockey player completely out of hardened steel. This is the enforcer who makes sure that no one pushes around the New Jersey Devils. Perhaps this tough exterior is to hide that this local hockey franchise had failed in Kansas City as the Scouts and in Denver as the Colorado Rockies.

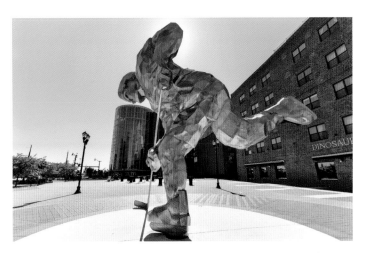

↑ The giant metal hockey player stands in the optimistically named "Championship Plaza" guarding the hockey arena for the New Jersey Devils in Newark, New Jersey.

The locals voted to make their mascot the mythical Jersey Devil, a griffin-like monster with horns, cloven hooves, and bat wings. Jersey occult history reports about this chimera roving the pine barrens in the 1700s and sightings in the 1900s led to mass hysteria. So why not make a cuddly devil statue? Perhaps this is a warning to any New York Islanders or Rangers fans who dare cross the Hudson River that they must face not only an evil ogre, but also a steely hockey player who dominates the square right outside of the New Jersey Devils' hockey arena.

FLYING SAUCER SKI SHACK

FUTURO IN MILTON AND HOUSTON, DELAWARE

Decades before the tiny house movement, Matti Suuronen made a prefab house that didn't rely on boring old right angles and straight lines. Suuronen was born in Finland but should not be confused with another famous Finnish architect with a similar last name, Eero Saarinen, who designed the Gateway Arch in St. Louis. Suuronen was a Modernist as well but worked with new materials, in particular polyester plastic reinforced with glass fibers. This versatile manufacturing compound allowed Suuronen to follow the Space Age rage—the year was 1968 after all—and make a rotund flying saucer house.

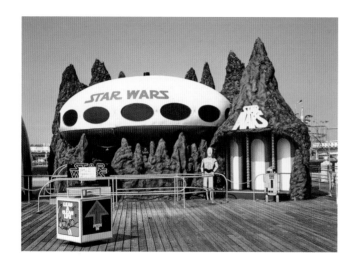

The Futuro was born when a classmate of Suuronen wanted to go skiing. He needed a ski hut that was efficient and quick to heat. Suuronen went a step further and made this UFO-like dwelling completely portable. This original mobile home could be simply flown to any remote skiing outpost and set down on a stand. Alternatively,

◄ The inescapable similarity to a flying saucer made the Futuro a natural for sci-fi exhibits like this one at Morey's Pier in Wildwood, New Jersey. As it did with *Star Wars*, the UFO morphed into exhibits for *Star Trek* and *Planet of the Apes* and then went on sale in 2014 for just $30,000.

the Futuro could be delivered in sixteen parts and easily assembled in two days.

Suuronen envisioned a whole series of similar such buildings for his Casa Finlandia series. Perhaps even more interesting is his Venturo vacation home with wide windows, rounded corners, and plastic everywhere. The house was delivered in two parts and included the mandatory Finnish sauna.

Even so, the otherworldliness of the Futuro house has spawned a cult following of Suuronen's oblong eggs on stilts. Even if fewer than a hundred Futuro houses were made worldwide, about twenty survive in the United States (two in Delaware alone) and still look futuristic even though they are more than fifty years old.

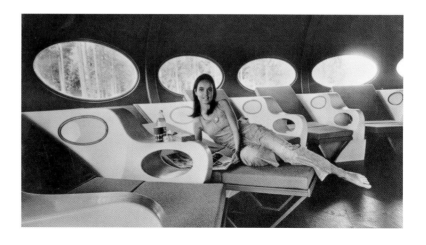

⬆⬇ Finnish architect Matti Suuronen designed Futuro flying saucer houses as little ski chalets that could be easily assembled even in rugged terrain, as seen in this one outside Frisco, North Carolina (below). Today, two examples survive in Delaware. Inside, a 23-foot (7 m) curved couch curves around a central stove opposite a rounded kitchen. In fact, everything is curved in an oval house (above).

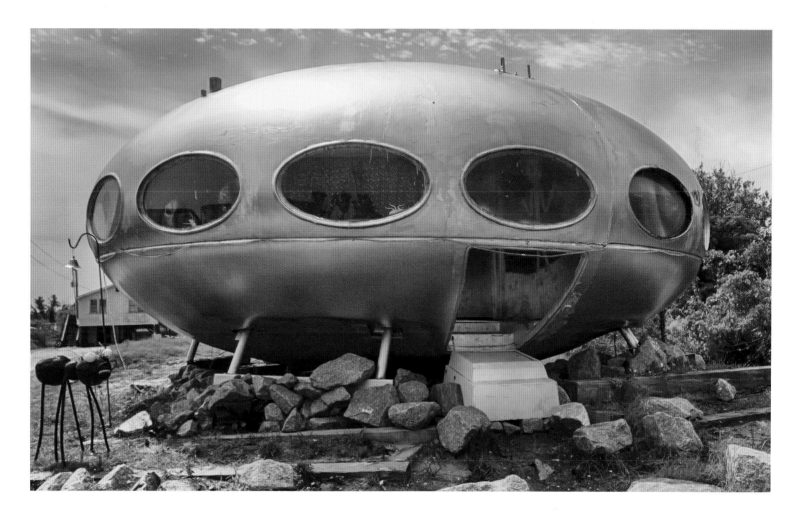

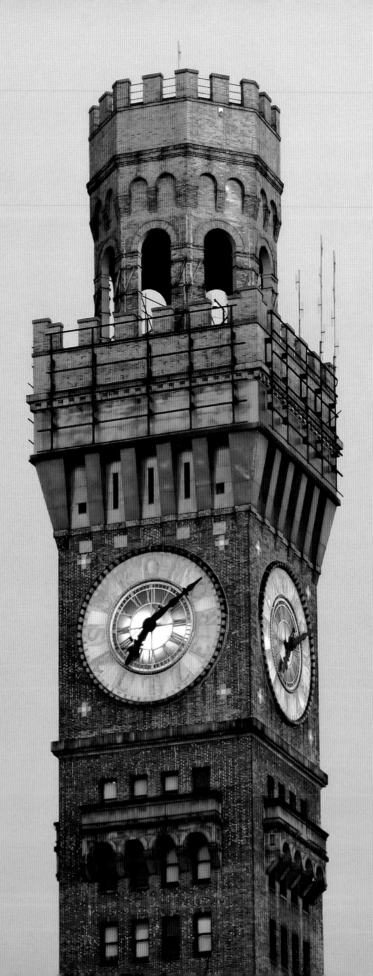

The Emerson Bromo-Seltzer tower in Baltimore boasts "the largest four-dial, gravity-driven, non-chiming clock in the world," apparently a competitive category of clocks. This replica of the tower above the Palazzo Vecchio in Florence was an advertising gimmick for Bromo-Seltzer and once had an enormous bottle of the tranquilizer atop the tower.

MARYLAND

HANGOVER HELPER

BROMO-SELTZER TOWER IN BALTIMORE, MARYLAND

Inspired by the dizzying heights of the tower of Palazzo Vecchio in Florence, the Bromo-Seltzer company built a 289-foot (88 m) equivalent in the heart of downtown Baltimore. The American replica was nine feet (2.7 m) shorter than the Italian tower, but once had a 51-foot (15.5 m) illuminated bottle of Bromo-Seltzer slowly spinning at the top to tell the world about its surefire cure to ward off the aftereffects of a night of hitting the hooch. Tragically, the gigantic bottle was deemed dangerous and removed from its perch before it could crush pedestrians below.

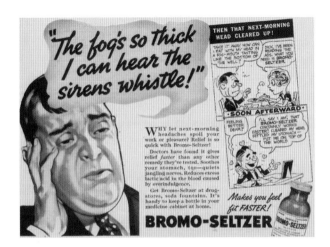

Even if the bottle is missing, the clock still has the twelve letters of "Bromoseltzer" encircling its face in place of numbers. The fifteenth floor of the tower features a display of cobalt blue bottles of this guaranteed antidote to alcohol. The only problem was the "Bromo" part of the name stems from sodium bromide, a tranquilizer, which succeeded in sedating any takers. In 1975, the FDA recognized bromides as a cumulative toxin that slowly poisoned people. Still, was this any worse than what happened in the shadow of its sister tower in Florence, which served as an office for Machiavelli, a prison for Cosimo il Vecchio, and the backdrop for Friar Savonarola who was burned at the stake?

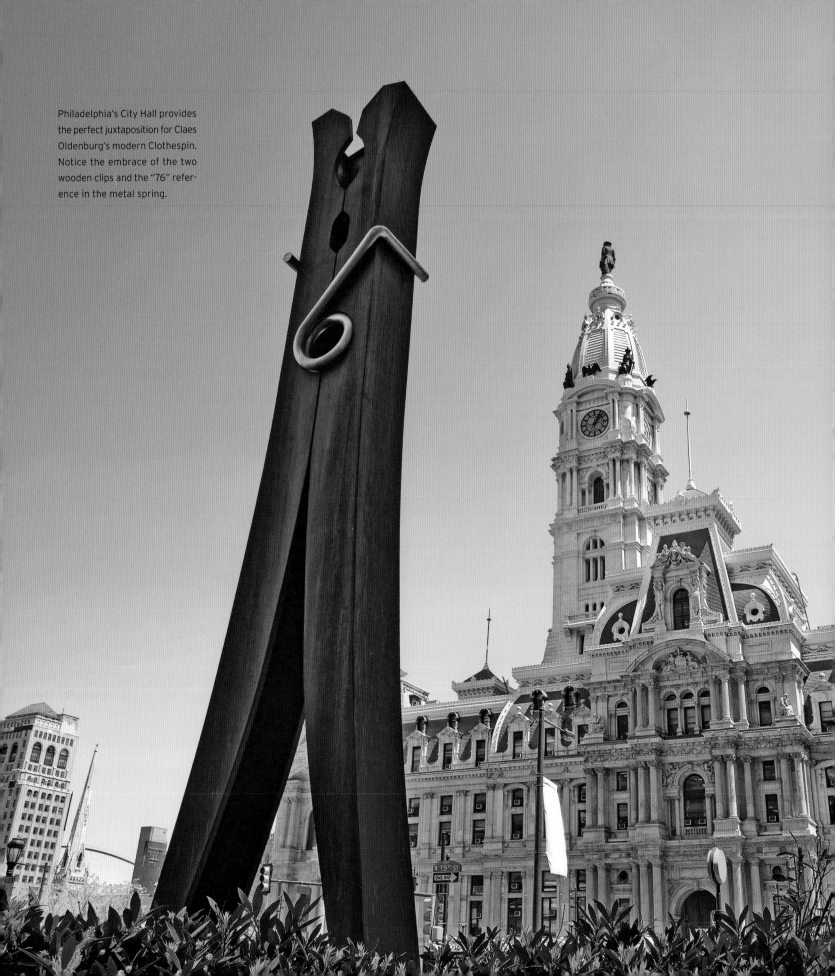

Philadelphia's City Hall provides the perfect juxtaposition for Claes Oldenburg's modern Clothespin. Notice the embrace of the two wooden clips and the "76" reference in the metal spring.

ABSTRACT EMBRACE

CLOTHESPIN IN PHILADELPHIA, PENNSYLVANIA

With a backdrop of Philadelphia's ornate City Hall, the *Clothespin* sculpture by Claes Oldenburg sums up the City of Brotherly Love. Skeptics just see a 45-foot (13.7 m)-tall black clothespin, but locals see a sleek embrace of two smooth pieces leaning into each other and held close with a spring that looks like the number 76 in honor of the bicentennial.

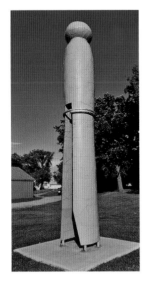

Oldenburg and his wife/ collaborator Coosje van Bruggen went on to make dozens of oversized versions of household objects as part of the Pop Art movement. They are credited with "democratizing" sculpture to make it more accessible, but their formal education and connections to the art world opened doors (and funding) that homespun sculptors rarely see. In fact, their art is urban, whereas most roadside attractions are rural.

Oldenburg stated he was inspired for *Clothespin* by the sculpture *The Kiss* by Constantin Brancusi at the nearby Philadelphia Museum of Art, but photographer Fred Case wondered if his artistic muses were a bit more psychedelic in nature. Case told me that in the height of the 1960s, "In San Francisco, I went to see the famous artist, Claes Oldenburg. He had an ounce of pure LSD powder he sold us.... We started putting it into capsules, but we didn't think to use gloves. We laughed as our hands started dissolving and multiplying. The person across from me melted right under the table."

Regardless of the inspiration, their seemingly simple sculptures are mesmerizing. Indeed, look at *Clothespin* from a certain angle and the two halves appear to be smooching in plain view, making this the ultimate public display of affection.

◄ Perhaps taking a page out of Oldenburg and van Bruggen's playbook, self-taught sculptor Ken Nyberg welds scraps of 10-gauge steel together to make giant sculptures of everyday objects from clothespins to pliers to doorknobs in the tiny town of Vining, Minnesota. He told me he even thought of doing a statue of a big middle finger once, "But I don't think many people would like that."

BIG SHOES TO FILL

HAINES SHOE HOUSE IN YORK, PENNSYLVANIA

What better way to hawk your wares than make a giant version of what you sell. Richard Haines, the "shoe wizard," built a five-story shoe in 1948 and let old women (and men) who didn't have shelter stay inside and enjoy an ironic life of luxury with three bedrooms and two baths.

The marketing ploy doubled as a philanthropic venture with doubly good press for Haines' forty shoe stores. For a while, honeymooners could rent the big boot to consummate their marriages and foot fetishes. After its stint as a footwear love nest, the instep of the shoe where the garage is located doubled as an ice cream stand.

Other shoe companies jumped on Haines' bandwagon and made giant versions of their own. To celebrate its centennial, the Red Wing Shoe Company rolled out huge swatches of tanned leather and stitched together the world's largest boot. "The laces are huge! They're like rope," the excited security guard told me. The big boot traveled 40,000 miles (64,373 km) annually to festivals all over the country in a specially constructed vehicle to house it—think of a box truck with a hydraulic roof. Red Wing marketing director Peter Engel bragged, "It's been to Farm Fest in southern Illinois, Bike Week in Daytona Beach... It weighs a ton, literally, and folds up like a circus tent to be 20 feet [6 m] tall."

South Dakota may not have the shoe manufacturers, but it does have two giant shoes. Even Imelda Marcos

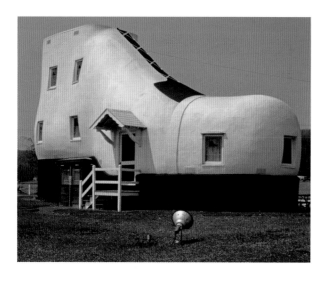

◄ This stucco-toed shoe in York, Pennsylvania, may be no-frills footwear, but it could surely go the distance since it dates back to the 1940s. The Haines Shoe House has since been carefully restored and returned to its original canary yellow color.

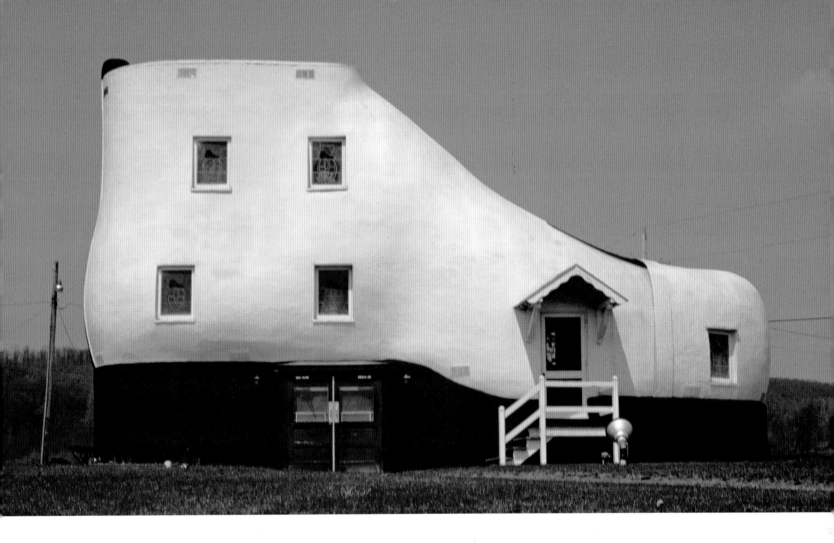

would turn green if she heard of Mildred O'Neil's closet bursting with more than eleven thousand shoes. An ex-librarian, O'Neil organized her collection with the precision of the Dewey decimal system with a little card catalog kept on each shoe. A printed card adorns each pair of footwear to illuminate its history. Shoes are separated into twenty-two classifications, including baby shoes, children's, cowboy boots, straw, sport, jewelry, clown shoes, and anything else you can imagine.

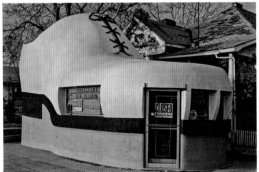

← A similarly historic shoe graces beautiful Bakersfield, California, and dates back to 1947. For several years, this classic white buck lay dormant, but once again a cobbler returned to repair shoe leather, and the old woman and her kids had to find a proper home.

← Mildred O'Neil built her shoe-shaped home to house her growing collection of more than eleven thousand shoes, which could provide more than two pairs of shoes per person for her hometown of Webster, South Dakota, which has a population of fewer than two thousand.

West Virginia

Virginia

Kentucky

North Carolina

Tennessee

Arkansas

Kentucky
Fried
Chicken

South
Carolina

Mississippi

Alabama

Georgia

Louisiana

61

Florida

Gulf of Mexico

Atlantic Ocean

SOUTHEAST

You could be forgiven for believing you've time-traveled to see the Seven Wonders of the Ancient World when standing in front of a perfect Parthenon or Mausoleum at Halicarnassus. Then you're shaken from your slumber as you notice a giant shark's mouth gobbling up tourists, a toothy grinning peanut, or turkeys dropped from a plane. Yup, you never left the United States.

ALMOST HEAVEN?

PRABHUPADA'S PALACE OF GOLD IN NEW VRINDABAN, WEST VIRGINIA

Nicknamed West Virginia's Taj Mahal, this golden palace dedicated to the love of Krishna seems an unlikely site in the green hills of West Virginia. Swami Srila Prabhupada traveled from India to New York in 1965 with translations of sacred bhakti texts from Hinduism, including the *Bhagavad-Gita*. His ideas inspired thousands to shave their heads, don saffron robes, and chant "Hare Krishna."

The Supreme Court later deemed his devotees could no longer solicit in airports as they once did, so many came with all their alms to New Vrindaban, named for the pilgrimage site, Vrindavan, India, where Krishna grew up. Dozens of untrained and unpaid Hare Krishna followers kept expanding on the temple made of onyx, teak, marble, and lots of stained glass. The first frigid winters were tough but seem like a distant dream now that the estate extends 4,000 acres with magnificent palaces.

The site was finally dedicated in 1979, unfortunately two years after Srila Prabhupada had gone on to a higher plane. Much of the magnificence of the palace came from the persistence of his successor, Swami Kirtanananda, known as Keith Ham to the rest of the world. Perhaps his power went to his head as he was indicted on charges of racketeering, mail fraud, and conspiracy to murder two of his Hare Krishna opponents who supposedly were going to reveal his pedophilia. He was convicted on nine out of the eleven charges and given thirty years in prison, but he was let out after eighteen months because of prejudicial testimony.

At its apex, more than 600 Hare Krishna disciples lived in New Vrindaban with thousands of pilgrims visiting each year. Now barely 100 call this place home as thousands of curious visitors vastly outnumber them. To open up minds and stomachs, an eco-friendly, curry-heavy Indian restaurant opened here. As diners indulge in vegetarian delights, notice how happy the cows are, who are regarded as holy beings in a bucolic pasture by the palace.

◄ Is Prabhupada's Palace of Gold in West Virginia more magnificent than the Sun King's mansion of Versailles? Well, at least it's more interesting with stunning windows consisting of 187,000 pieces of stained glass, 30-foot (9 m) gilded Hindu statues, and sacred cows.

7TH WONDER OF THE WORLD

GEORGE WASHINGTON MASONIC NATIONAL MEMORIAL IN ALEXANDRIA, VIRGINIA

The Pharos of Alexandria was built by Ptolemy II around 280 B.C.E. and became one of the Seven Wonders of the World. Julius Caesar captured this lighthouse but accidentally burned down the world's greatest library in Alexandria while fighting to snag Cleopatra's love and get rid of her brother. The Pharos of the pharaohs survived until the fourteenth century and now lies in ruins underwater in the Egyptian harbor, unless you wish to go to the *other* Alexandria in Virginia and see what the lighthouse likely looked like.

While other tourists are busy in the District of Columbia trying to climb the Washington Monument, which is just a giant copy of the Egyptian obelisks, you can cross the Potomac and see how modern architects envisioned the original Pharos. What's more, you can ponder all sorts of conspiracy theories about Freemasons while in this Masonic monument. Washington was made a Master Mason who approved the Great Seal on the dollar bill with the Masonic "All-Seeing Eye" above the pyramid and the New World Order slogan "Novus Ordo Seclorum." In fact the whole city that bears the first president's name was designed with Masonic significance to stop at nothing to achieve their goals! Consider the numerology: The Masonic building is exactly 333 feet (101 m) high with three sections divided into nine stories. Yes, Washington was warned about the Illuminati, but perhaps he was one of them! Inside, ask if the Masons somehow faked the moon landing, are intent on world domination, know something about the demise of John F. Kennedy (who as a Catholic was clearly not a Mason), and are responsible for anything else that seems fishy.

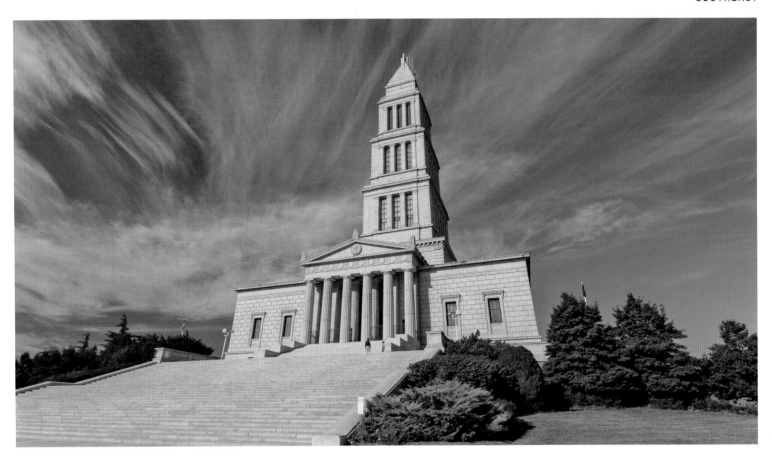

⬆ Most tourists stick to the sites in the District of Columbia, but the Masons built this giant memorial and museum to the first freemason president. George Washington seemed to have slept everywhere throughout the original thirteen colonies and forgot his possessions in every inn, but this memorial has the actual clock beside his bedside that was stopped at the exact moment he died.

Inside the building you can skip the display of fezzes and go right to the George Washington memorabilia. See the cruel tools used by Washington's doctor (also a Mason, a Worshipful Master no less) to cure the president's sore throat by bleeding 40 percent of the blood out of his body. Was this a plot? Maybe! The angled elevator accommodates the narrowing building as you rise to the seventh floor to see a replica of the Temple of Solomon and the ninth floor to see King Solomon's throne room. Better yet, the fifth floor has a replica of the Ark of the Covenant, but how can we be sure it's fake? Perhaps this is just a ruse to throw us off the scent. Wouldn't this be the perfect place to house the plunder of the Knights Templar and even the Holy Grail?

With your head spinning with conspiracies, visit another replicated Wonder of the World in downtown D.C. The Tomb of King Mausolus of Halicarnassus survived until the 1500s in Bodrum, Turkey, before crazed Crusaders quarried it to make a castle. The architects of the House of the Temple copied what we know of the original Mausoleum complete with sphinxes guarding the door. You've hit the jackpot. After all, this building is officially known as the Home of the Supreme Council, 33°, Ancient & Accepted Scottish Right of Freemasonry. Over the door runs the ominous decree, "Freemasonry builds its temples in the hearts of men and among nations."

NORTH CAROLINA

SHE SELLS SEA-SHELL GAS

SHELL-SHAPED GAS STATION IN WINSTON-SALEM, NORTH CAROLINA

The old saw that burning petroleum is essentially setting dinosaur bones on fire isn't entirely accurate—it's more the old plants, clams, mussels, and other prehistoric carbon-based creatures. Thus Shell Oil. Why not glorify this symbol with an entire filling station shaped like a shell?

In the 1930s, Shell built eight such stations/sculptures to grace the burgeoning roadside with oversized effigies of miniscule mollusks. Only one building survived the wrecking ball but sat idle for years until locals recognized the diamond in their midst. The National Register of Historic Places added the station to its list, and in 1997 was lovingly restored but lacks all the messy gasoline of the pumps.

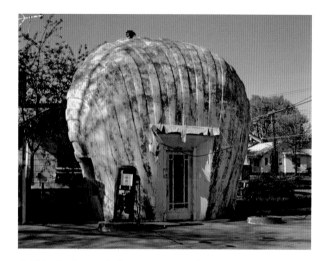
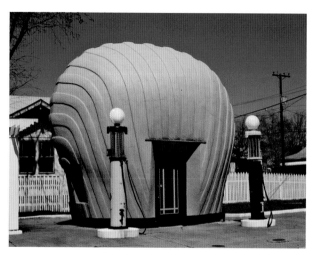

⬆ This classic gas station was rundown in the 1980s but perfectly renovated by Preservation North Carolina in the late 1990s. This is the last shell standing out of eight such stations built by Quality Oil. Dating back to the 1930s, each one was handmade out of wood and wire covered with concrete.

BUREAU OF INFORMATION

WORLD'S LARGEST CHEST OF DRAWERS IN HIGH POINT, NORTH CAROLINA

Thomasville, North Carolina, built what was for a time the "World's Largest Chair" that sat at 13.5 feet (4 m) tall in 1922. Soon the big chair battle erupted and the town made an even larger chair in 1948 to reclaim the title that was rightfully theirs. This chair was soon eclipsed by numerous other up-and-comers who wanted in on the hordes of tourists stopping for a photo op.

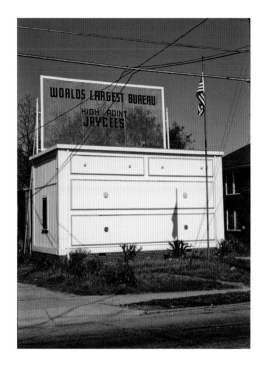

Thomasville settled by naming their monument to sitting: The World's Largest Duncan Phyfe, which indeed it is, but then they had to explain to the kids that this is a name for a kind of chair. Huh?

High Point, North Carolina, skipped the seat skirmish with its neighbor, which inflated itself as Chair City. Instead, High Point shed its grim nickname as the Industrial City for Furniture City and created the World's Largest Bureau as a celebration of bureaucracy. Rather than just a statue, the chest actually houses people, well, a visitor's center. A giant Jaycees billboard used to stand above it like a looking glass.

◄ The chest is actually the façade of a building that was originally constructed in 1926 to prove to the world that High Point, North Carolina, was indeed the Home Furnishing Capital of the World. The original tongue-in-cheek nickname for the drawers was the Bureau of Information when it was white. Soon it was moved, renovated to expose the original wood, and a basement was added to the bureau.

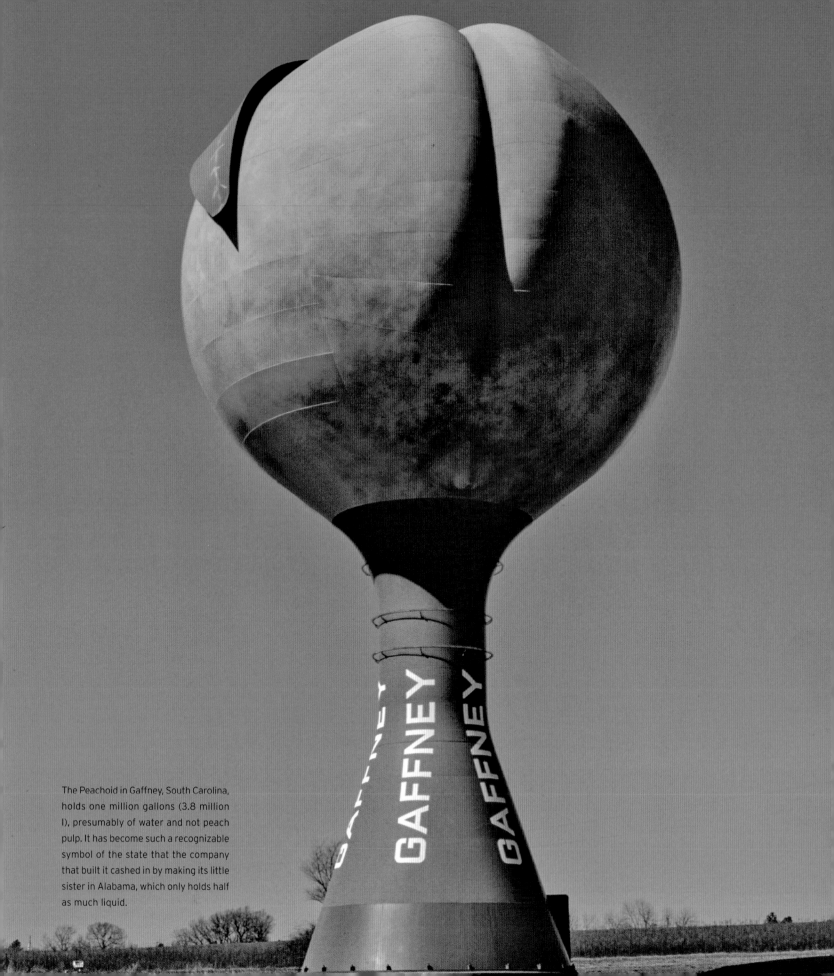

The Peachoid in Gaffney, South Carolina, holds one million gallons (3.8 million l), presumably of water and not peach pulp. It has become such a recognizable symbol of the state that the company that built it cashed in by making its little sister in Alabama, which only holds half as much liquid.

THE PEACHOID

PEACH WATER TOWER IN GAFFNEY, SOUTH CAROLINA

The strangely suggestive peach towering over Gaffney, South Carolina, has been compared to buttocks or anything that can cause controversy. Built in 1981 to prove to the world that even though Georgia is the "Peach State," the home county of the "Peachoid" produced more peaches than the entire crop of its rival state to the south. To add insult to injury, a considerably less attractive giant peach statue on the top of a pole in Byron, Georgia, was destroyed in a storm in 2011. Not only that, but Alabama tried to show up Georgia by building a slightly smaller Peachoid in its town of Clayton.

➡ As the story goes, wounded Union soldiers returned from the Civil War, rested in the fields of Iowa, and feasted on wild strawberries. The notoriously tiny berries resuscitated the sleepy soldiers who decided to found a town on the spot. To honor their ancestors, later generations built a giant strawberry that sways violently in windstorms above Strawberry Point.

➡ Two states north of the Peachoid in Gaffney, South Carolina, Winchester, Virginia, does not make too much fuss that it has The World's Largest Apple, perhaps because that is unbecoming and detracts from the grandeur of the pre-Civil War mansion behind it.

PEDRO LAND

SOUTH OF THE BORDER IN DILLON, SOUTH CAROLINA

When a county in nearby North Carolina went dry in the late 1940s, parched North Carolinians needed a watering hole. Alan Schafer saw an opportunity to quench their thirst by opening up "South of the Border Beer Depot" just across state lines. Since his site was along the busy Interstate-95 corridor, he opened a ten-seat grill and soon sold more hot dogs than beer—thus his ubiquitous billboards blaring: "You Never Sausage a Place! (You're Always a Weiner at Pedro's)."

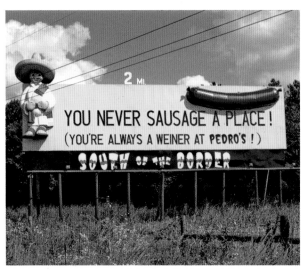

↑ South of the Border littered the highways with hundreds of clever billboards so passersby had to stop and see what the fuss was about.

What began as a pun of being south of the North Carolina border took on a life of its own with a campy Mexican theme. The most noticeable symbol of South of the Border (or SoB to insiders) is the gargantuan sombrero, essentially only worn by Mexican mariachi bands and cliché comic book characters. The SoB Steak House is a giant round sombrero, arguably the World's Largest Sombrero. Or perhaps that prize goes to the 200-foot (61 m) Sombrero Tower, a lookout to admire the peanut fields of Dillon County and the acres of parking lots.

In 1964, Schafer opened a motel of 20 rooms with bellhops leading guests to their air-conditioned rooms by bicycle. All the porters were named "pedro," with a lowercase "p" as if this describes any boy whether actually

Mexican or not. The "Pedro" theme exploded with fiberglass statues depicting the Mexican stereotypes firmly implanted in gringo minds. While Schafer's profiteering on these images was problematic, ironically, South of the Border was harrassed by the Ku Klux Klan for being open minded enough to allow any visitor, regardless of race, to enjoy the facilities.

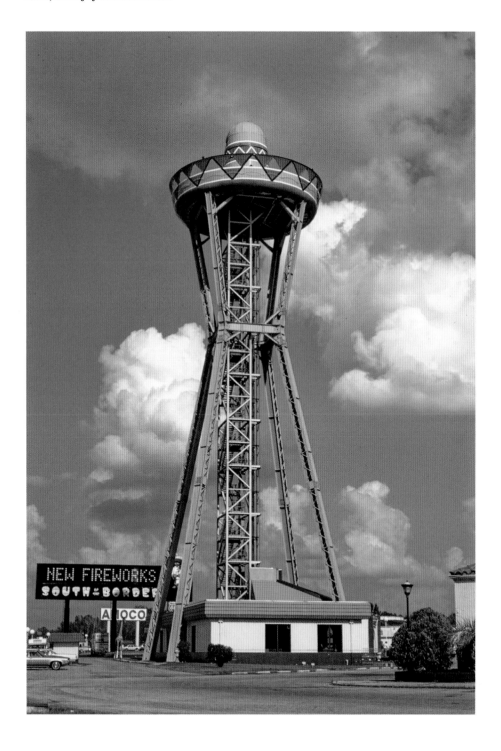

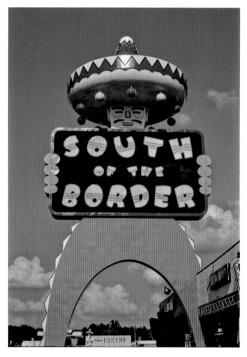

⬆ Drive under the legs of Pedro (everything is "Pedro" at SoB). The 97-foot (30 m) flat statue reinforces all those Mexican stereotypes with a Salvador Daliesque moustache and super-sized sombrero with pom-poms hanging down.

⬅ All aboard the dizzying glass elevator to rocket to the top of the 200-foot (61 m) Sombrero Tower and look north of the border to the other Carolina.

Schafer constantly updated and expanded SoB to encompass 350 acres. This small town has seen attractions come and go: "The Golf of Mexico" miniature golf is in ruins and the "Dirty Old Man Shop" has gone, leaving amorous adults to look elsewhere for their bedroom necessities. Now crocodiles, alligators, and caiman terrify eager tourists at the Reptile Lagoon, the largest indoor display of these ferocious creatures in the country, apparently. In fact, why even vacation at the beach when everything you ever wanted—and desperately don't want—is right here?

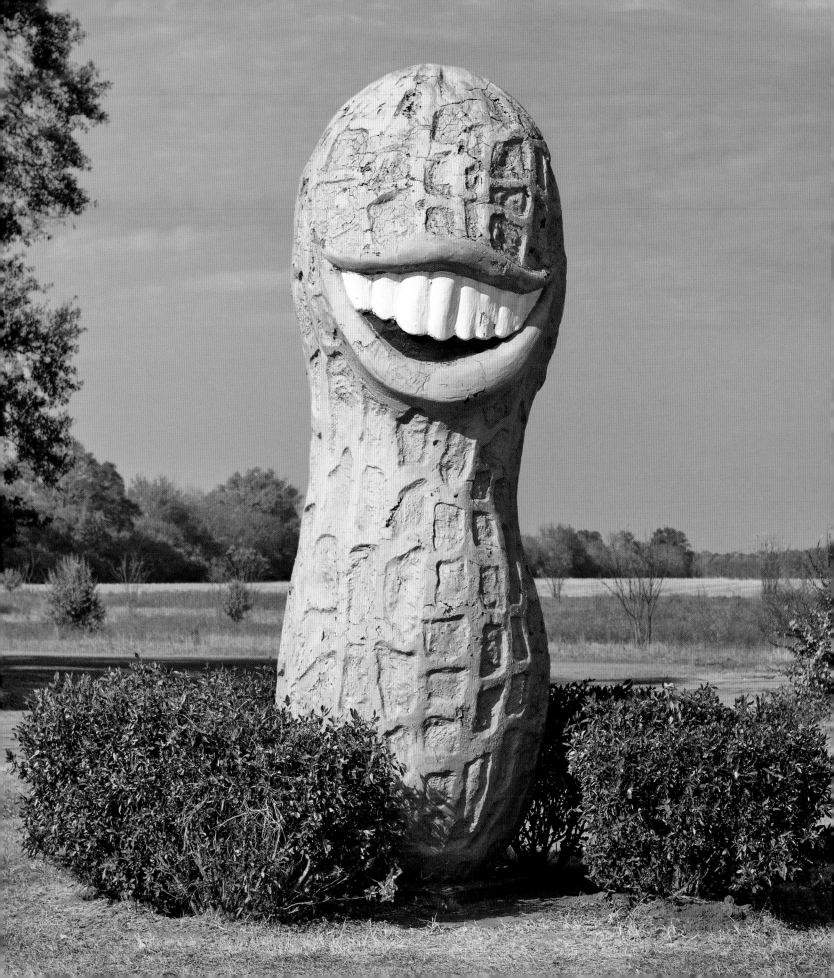

PRESIDENTIAL PEANUT

JIMMY CARTER SMILING PEANUT IN PLAINS, GEORGIA

The title for the World's Largest Peanut has been proudly held by Ashburn, Georgia, but even a giant goober pea statue atop a crown of gold couldn't withstand the storm surge of Hurricane Michael in 2018. The mighty peanut was brought to its knees and townsfolk are rallying to restore the big nut.

In the meantime, a lesser peanut an hour away unexpectedly was propelled to the throne, and clearly was pleased as punch considering the giant smile across this anthropomorphized groundnut. This statue, however, was a promotional gag erected by the Indiana Democratic Party to push Jimmy Carter's 1976 presidential campaign and his disarming toothy grin.

After the peanut farmer from Georgia ascended to the presidency, the big nut was moved to Carter's hometown of Plains, not far from where his notorious brother Billy had his gas station and promoted his watery Billy Beer. The beloved statue was never meant to last decades, but it has been carefully maintained, even after a peanut-hating driver smashed into the icon in 2000. Still, a hole in its rear is noticeably exposed and local legend says that the Secret Service inspected the peanut's hole to verify that no explosive devices were planted by the Ayatollah or other nefarious 1970s villains. (An exploding peanut would have been no more ridiculous than an exploding cigar or conch shell planted to kill Castro.) Was the Secret Service's caution so silly considering that during a fishing trip in Georgia, Carter had already batted off an aquatic attack rabbit, or a banzai bunny as the *Washington Post* called it? Through it all, Carter—and his peanut—kept smiling.

← Jimmy Carter's toothy grin became the signature symbol of the Nobel Peace Prize-winning president, as seen on the peanut in Plains, Georgia.

GEORGIA

RED ROOSTER, RED ROOSTER

THE BIG CHICKEN IN MARIETTA, GEORGIA

When Colonel Sanders first saw the 56-foot (17 m)-high chicken adorning the façade of his franchise in Marietta, Georgia, he told them to rip it down. He wanted his own famous mug promoting Sander's secret seasoning of eleven herbs and spices rather than a red rooster. Who wants to eat what their logo represents after all? Does McDonald's have a steer with an "Eat Me" sign on it?

The big red chicken was built in 1963 after a vision by Stanley R. Davis, who surely earned the nickname "Tubby" for his feats of putting away buckets of chicken. For his fried chicken restaurant named Johnny Reb's Chick-Chuck-'N-Shake, Tubby wanted the biggest structure he could erect. He envisioned an enormous cockerel, which would certainly not be allowed by today's puritanical "safety" codes that prevent such photo-worthy events as collapsing chickens on bystanders. Tubby wanted a goofy rooster with rotating googly eyes, a yellow beak that snapped open and shut, and a red comb that flapped joyously in the wind. The debut day of the mechanical motions of Tubby's animatronic cock didn't perform as planned. The vibrating motor to make the beak peck

and eyes twirl incessantly made the windows rattle and shatter. The engine was shut off before more glass filled the restaurant.

Tubby opened a second restaurant in Atlanta that boasted that his Chick-Chuck-'N'-Shake featured "Confederate Fried Chicken ... served with an authentic Civil War atmosphere with true Southern Hospitality—Yankees Welcome." Strangely, this atmosphere at the Atlanta outlet didn't appeal to everyone.

Even the Big Chicken in Marietta nearly met the chopping block several times. It survived Colonel Sanders's attempt to decapitate it after Kentucky Fried Chicken took it over in 1974. Marietta residents rallied to save the red rooster again after KFC's clandestine plot to

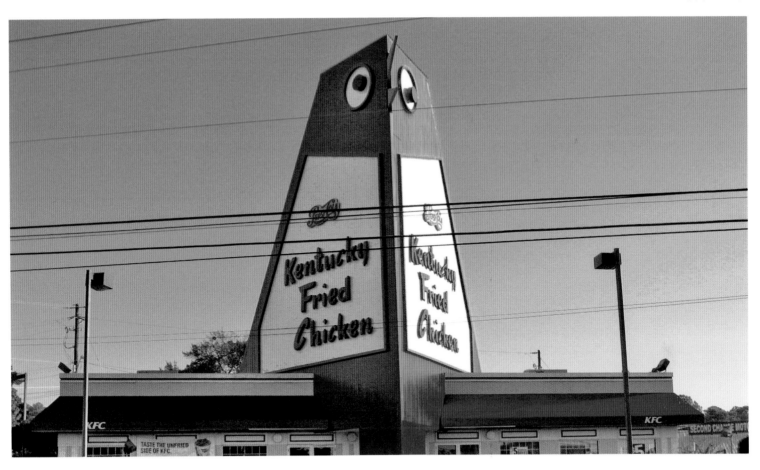

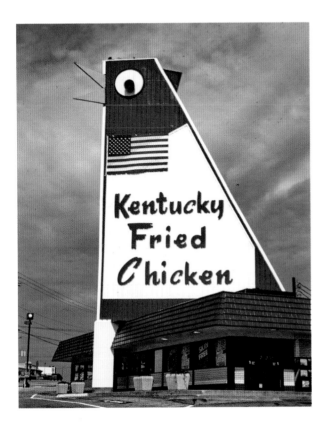

move it to a nearby town. In 1993, Colonel Sanders thought he was proven right to rid the franchise of the rooster when wind stripped off red metal panels to reveal piles of pigeon guano piled up since the bird's birth. The phoenix emerged from the ashes thanks to several renovations. The latest restoration in 2017 chalked up a $2 million tab, but now allowed the big bird to speak (did anyone really wonder what it had to say?). Most important, the makeover kept the sky from falling and even allowed the rooster's wild eyes to spin as Tubby first envisioned.

← ↑ It may come as a shock, but Colonel Sanders wasn't a military man, rather he was conferred with the honorary title of Kentucky Colonel, perhaps for his prowess in fried foods. For a time, his most successful franchise was in Marietta, Georgia, thanks to the incessant shilling of the Big Chicken.

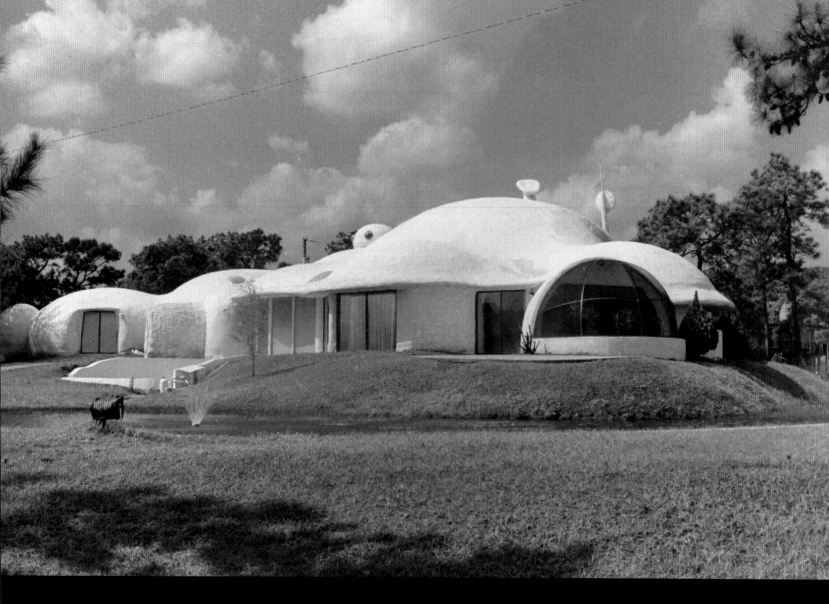

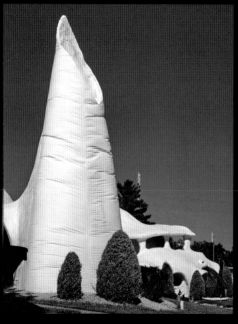

↑ Not only did Xanadu have unnerving foam walls with no right angles, but every modern convenience was supposedly provided through state-of-the-art Commodore computers. Some windows were simply television screens to provide futuristic views rather than the Gremlins and Pacers in the parking lot. This Xanadu in Kissimmee, Florida, outlasted all the others—by nearly twenty-five years.

← Imagine a three-story tower made entirely of . . . foam! Regrettably, Xanadu the Foam House of Tomorrow couldn't withstand the elements and became part of the past rather than the future.

BETTER LIVING THROUGH FOAM

XANADU, THE FOAM HOUSE OF TOMORROW, R.I.P., IN KISSIMMEE, FLORIDA

The future is foam! For your next house, simply blow up giant balloons, spray foam over them, and wait for the foam to harden. Just like Spanish architect Antoni Gaudí envisioned buildings with naturalistic, flowing lines rather than rigid right angles, Xanadu the Foam House of Tomorrow did this all from a spray bottle. Building with no wooden beams or sheetrock could save thousands of dollars and acres of forests. Besides, the foam provides instant insulation.

Displaying how we would live in the year 2100, three examples of Xanadu's outrageous architecture were built in the early 1980s in Wisconsin Dells; Gatlinburg, Tennessee; and the last survivor until recently in Kissimmee, Florida. The foam, which was supposed to last forever, became foul and even bleach couldn't keep it white. In the 1990s when Xanadu in Wisconsin Dells was deemed boring by tourists and nasty to clean, I called the local Chamber of Commerce to find out what they did with Xanadu. "Oh, it's out at the local dump now." It will outlive us all and probably never decompose.

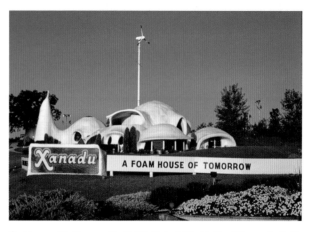

⬆ Along with Tommy Bartlett's Robot World, the Wisconsin Dells boasted Xanadu the Foam House of Tomorrow.

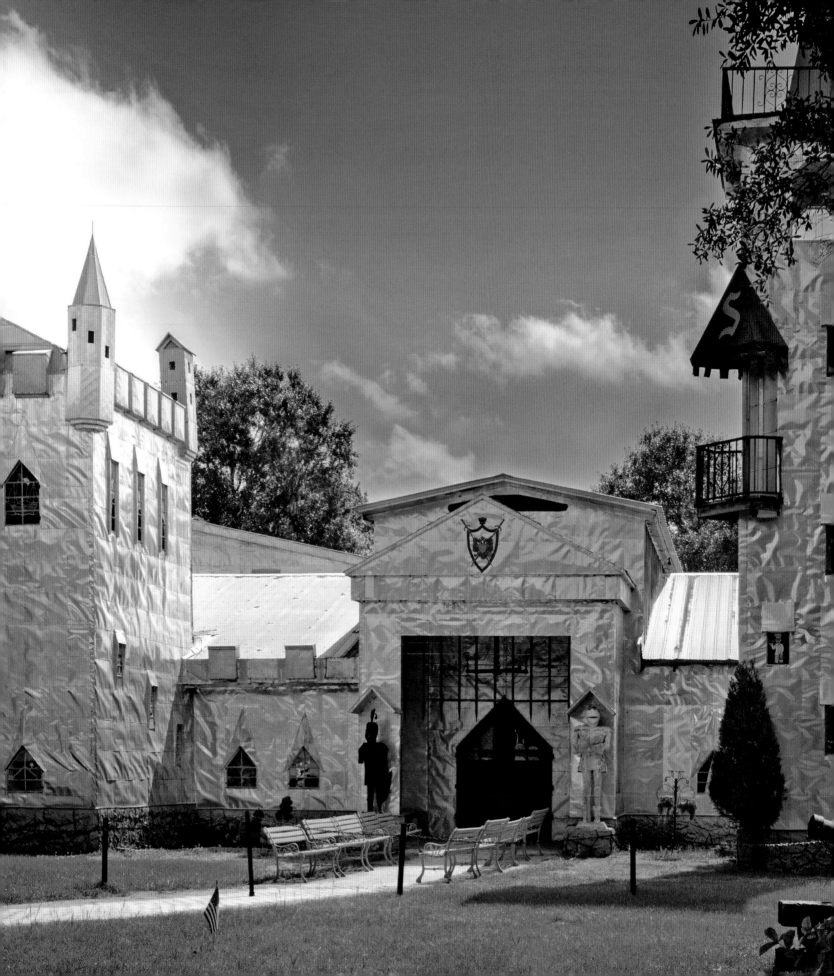

SILVER CITADEL

SOLOMON CASTLE NEAR ONA, FLORIDA

Howard Solomon complained that his ancestors built castles, but his family had been unemployed for the past 400 years since these fortresses fell out of fashion. He wanted to do something about it, so he got out the brick and mortar.

Solomon hailed from New York and worked as a found-object artist who recycled materials into new forms. He took hundreds of hangers and wound the wire into a full-sized horse that Ripley's Believe It or Not in nearby St. Augustine snatched up for its museum.

For his castle, he wanted it to gleam in the Florida sunshine, not be dull like some gloomy English castle made of stone and cement. This Floridian fortress sits on Solomon's 64 acres of land and boasts a moat filled with water and a Spanish galleon sailing around.

The local newspaper used four aluminum plates to print each page of its paper, but the metal cannot be recycled. Solomon seized them at ten cents a pop to cover his entire castle with shiny metal. When the newspaper learned what he was doing with them, the editors raised the price to 35 cents, but he had already finished most of his shining castle on the hill by then.

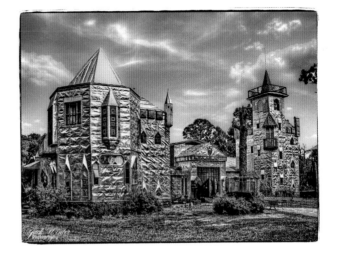

← The glimmering castle in Ona, Florida, reflects the light thanks to hundreds of aluminum plates that creator Howard Solomon salvaged from the local newspaper.

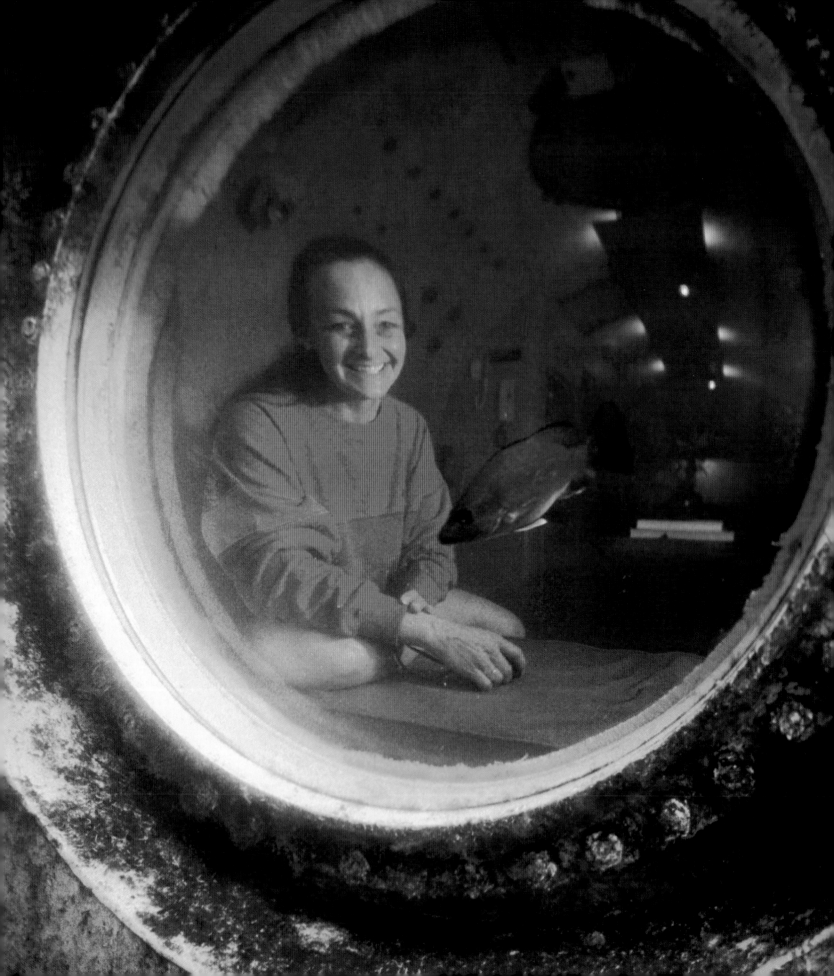

SLEEPING WITH THE FISHES

JULES' UNDERSEA LODGE BELOW KEY LARGO, FLORIDA

The most unusual hotel in the country is not accessible by plane, train, car, boat, or even by foot. Put on a wet suit, strap on air tanks, and jump into the ocean. Flap those flippers to go straight down under the waves and open the door to your hotel room 21 feet (6.5 m) below the surface. Open the underwater hatch and enter a "wet room" to change into dry duds after your clothes magically appear in a waterproof suitcase. Then prepare for the quietest night of your life—unless you're claustrophobic and worry that the glass ceiling will shatter.

Named for Jules Verne and his mysterious Captain Nemo who traveled 20,000 leagues under the sea to a mysterious island, the Jules' Undersea Lodge is a scuba diver's dream with hundreds of colorful fish schooling overhead and out every window. This underwater building in a mangrove lagoon does double duty as part of the reef and thereby attracts a kaleidoscope of sea creatures. The hotel even offers a three-hour crash course in scuba so newbies can get to the front door of their room without drowning.

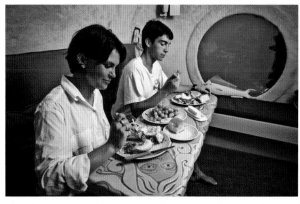

⬆ Jules Verne would approve of dinner under the watchful eye of aquatic beasts.

ALABAMA

BARENAKED DEITIES

VULCAN IN BIRMINGHAM, ALABAMA

A monument to the steel industry in Birmingham, this 56-foot (17 m) statue of Vulcan was cast for the 1904 World's Fair in St. Louis. Just as ugly Vulcan was shunned by his father Jupiter and mother Juno, so was his statue when he returned home to Birmingham.

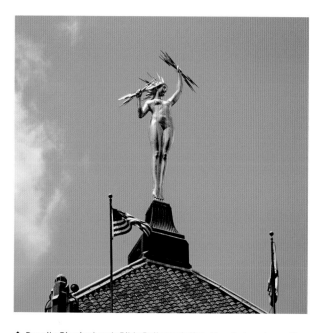

⬆ Despite Birmingham's Bible Belt reputation, the city boasts another nude statue besides Vulcan: Electra. Her golden body prohibits close inspection as she stands twenty stories overhead on the top of the Alabama Power Building.

He rusted by the railroad tracks for years until he was resurrected at the Alabama State Fairgrounds where advertisers placed everything from humiliating ice cream cones to pickles in his hands. All the king's men put him back together again incorrectly, painted his muscles with disturbing flesh-colored paint, and clothed him with an apron in an attempt to cover his supernatural birthday suit.

Eventually Birmingham came to terms with the bulging naked muscles of this sooty god and raised him to the heavens atop a 12-story tower in 1939. An elevator was added to the tower to see this colossus up close. The only catch is the view of Vulcan that visitors see as soon as they get to the top of the tower—a perfect look of the god's mighty rump. Fortunately, the museum at the site embraces these immense buttocks by selling bobblehead Vulcans with "Bobble Buns" that jiggle and twerk better than any on Mount Olympus.

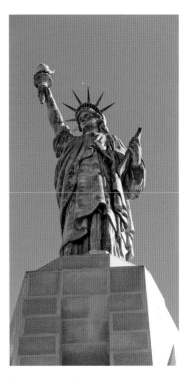

↑ While the Statue of Liberty in New York may be the largest cast metal statue in the United States, it was forged in France. Birmingham's Vulcan was sculpted by Italians in New Jersey and cast with Alabama metal. Birmingham couldn't resist adding its own Lady Liberty at a fifth the size of Liberty Island's colossus that outshines the original with a torch that has actual flames.

← Visitors to the Vulcan of Birmingham get an odd underside view of the god of volcanoes. He is the largest metal statue cast in the United States and towers over the tower on top of Red Mountain, the same place where all the ore came from to make the god of fire in the first place.

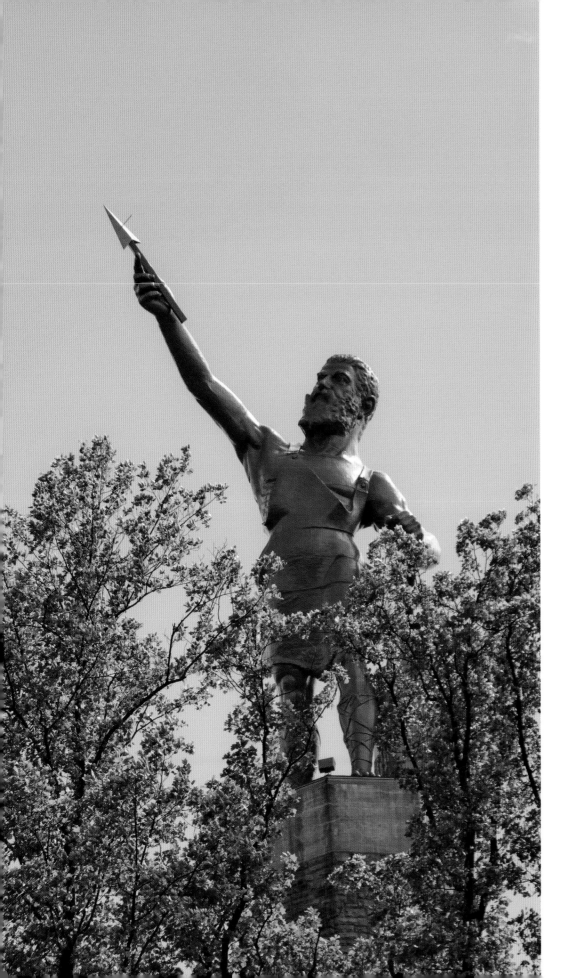

MISSISSIPPI

SELLING YOUR SOUL FOR THE BLUES

DEVIL'S CROSSROADS IN CLARKSDALE, MISSISSIPPI

Guitarist Robert Johnson had three last names before he figured out the name of his biological father. That's just the beginning of the murky questions surrounding the King of Delta Blues.

Most famously, he met the Devil at a crossroads (widely accepted as the junction of Highways 61 and 49) and sold his soul to be the best guitarist ever. Others say Satan just tuned his guitar, but more likely Johnson just practiced like the devil and learned from Son House and Willie Brown.

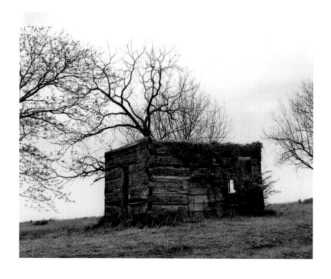

Alan Lomax drove to Clarksdale in 1941 with recording equipment that filled the back of his car in hopes of recording Robert Johnson. He found out that Johnson was dead, and his mother explained that this was the devil's work. She described to Lomax how her son wanted her to hang up his guitar on the wall before he died. "That what got me messed up, Mama. It's the devil's instrument, just like you said. And I don't want it no more," his mother reported her son as saying. He passed away while she was putting away his guitar.

The cause of death? Some say it was strychnine in whiskey. Johnson's mom said, "Some wicked girl or her boyfriend had given him poison and wasn't no doctor

← Alan Lomax recorded the first Muddy Waters's songs in Waters's little cabin on the Stovall Farm. Before the elements completely destroyed the cabin, the Delta Blues Museum in town dismantled the little house piece by piece and moved it inside the Clarksdale Rail Depot where the museum is located.

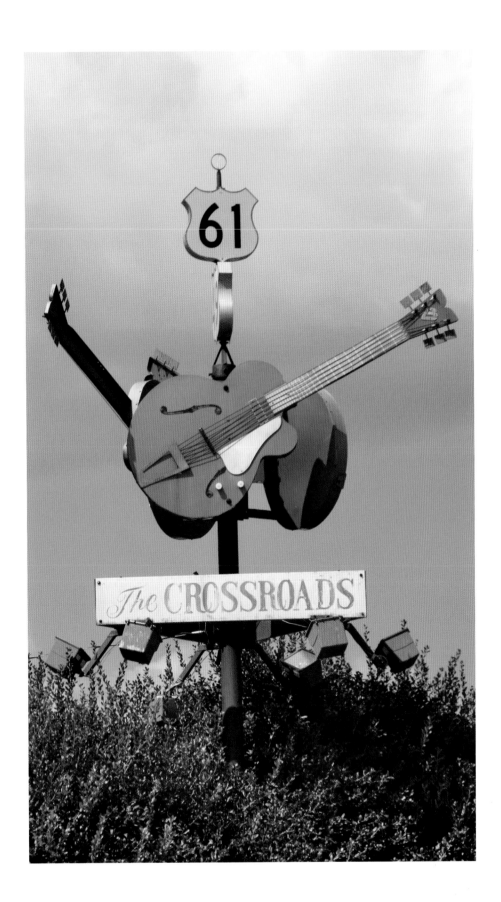

in the world could save him, so they say." Others say he had Marfan syndrome, but the landowner of their property listed the official cause of death as syphilis. Where he is buried for sure is a whole other debate.

Since Lomax was already in Clarksdale, he was told of another Blues guitarist who lived outside of town. Lomax asked the man to take a break from working out in the fields to come to the man's little cabin to record classic Blues songs that propelled his career to be the King of Chicago Blues. His name was Muddy Waters.

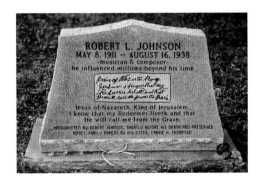

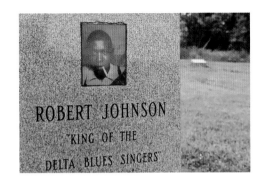

↑ Here stand the dueling tombs of Robert Johnson in Greenwood and Morgan City, Mississippi.

← The oversized guitars mark the spot where Robert Johnson supposedly sold his soul to the devil outside of Clarksdale, Mississippi.

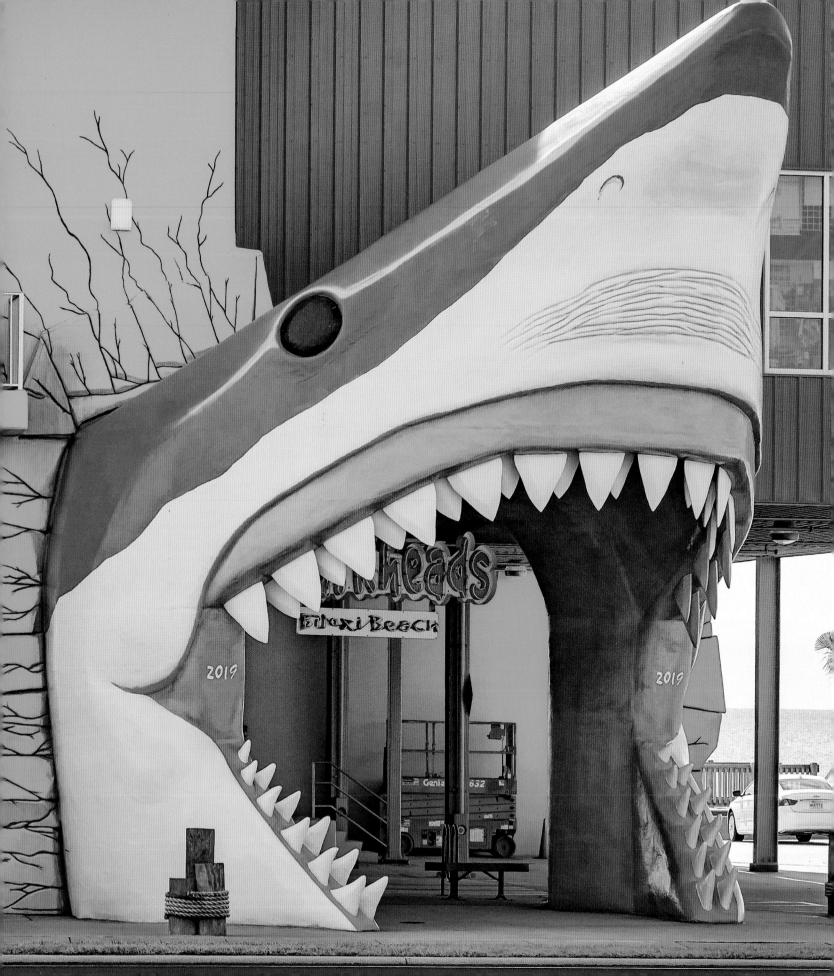

MISSISSIPPI

THE JAWS OF DEATH

SHARKHEADS IN BILOXI, MISSISSIPPI

Jonah and Pinocchio may have been swallowed by a whale, but toothier dangers are sharks and alligators. Just look at all the giant entrances to tourist shops around Florida, Alabama, and Mississippi that aren't Moby Dick but 'gators and great whites. How many nightmares have giant crocodiles created with their snapping jaws? Confront your fears and tiptoe past the sharp teeth to enter Gatorland or into the belly of the beast at the Shark Souvenir Shop in Gulf Shores, Alabama, to see through little windows what this whopper had for lunch.

The film *Sharknado* swept up viewers with a fear of man-eating sharks descending from the heavens via tornadoes. Nothing could stop these beasts that lived forever and had rows upon rows of teeth—at least until something bigger hit: a hurricane. The 32-foot (9.8 m) shark head entrance in Biloxi took on Hurricane Katrina in a grudge match worthy of Godzilla versus Megatron. The mighty winds defeated this monster, but the owners vowed to revive the shark to fight another day.

← Skip *Shark Week*, turn off *Sharktopus*, and go to the Gulf Coast to pose for a shot next to this 32-foot-tall gaping shark mouth in beautiful Biloxi, Mississippi.

ROMAN ARM

ST. VALERIA OF MILAN IN THIBODAUX, LOUISIANA

On the annual feast day of St. Valeria of Milan, the residents of Thibodaux, Louisiana, parade through town behind her severed arm. St. Valeria was one of the earliest Christian converts originally thought to have lived under Nero in first century Rome, but more likely under Marcus Aurelius in the second century.

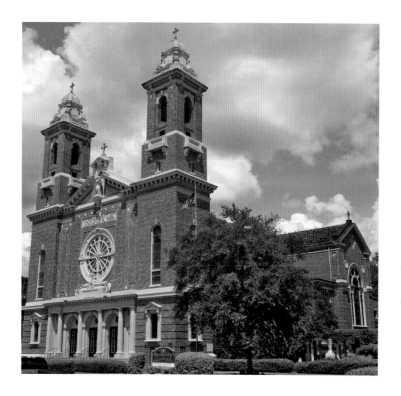

She and her husband, St. Vitalis, came from a noble family in Milan, but they both converted to Christianity. One story told of Valeria bringing to the catacombs corpses of Christians mauled in the Colosseum, which wasn't built until after Nero's death. Vitalis convinced a prominent doctor, Ursicinus, in Ravenna to not give up on his Christian faith. Ursicinus was quickly beheaded. When Vitalis retrieved his body, he was subsequently stretched on the rack and then buried alive. At least Vitalis had the mosaic-filled sixth century Basilica of San Vitale in Ravenna built for him, which is a UNESCO World Heritage Site.

Meanwhile, Valeria could not get her now-buried husband's body back, so she

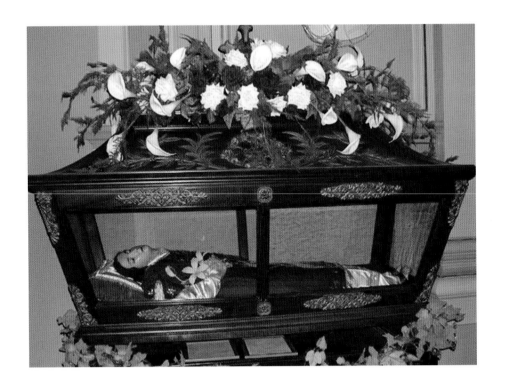

went home to Milan. As the tale goes, she then refused to worship Roman gods and was killed in all sorts of terrible ways (stories vary). Her remains ended up in the Roman catacombs and her forearm was brought to Louisiana in 1868. She is not the patron saint of dismemberment, but rather the protector from storms and floods, something Thibodaux desperately needs since the town is an hour from New Orleans in the heart of the wetlands on the bayou.

← In 1916, a fire swept through Thibodaux and burned down the cathedral containing the holy hand of St. Valeria of Milan, but firefighters rescued the relics. Today they are kept in a sarcophagus inside the "new" cathedral (shown here, opposite).

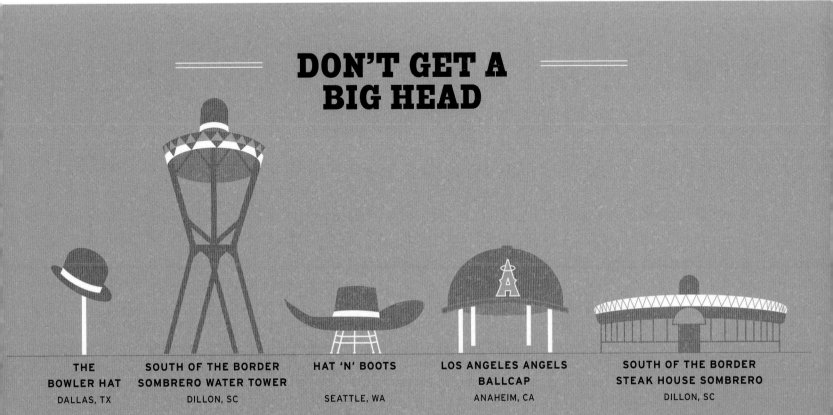

DON'T GET A BIG HEAD

THE BOWLER HAT	SOUTH OF THE BORDER SOMBRERO WATER TOWER	HAT 'N' BOOTS	LOS ANGELES ANGELS BALLCAP	SOUTH OF THE BORDER STEAK HOUSE SOMBRERO
DALLAS, TX	DILLON, SC	SEATTLE, WA	ANAHEIM, CA	DILLON, SC
22 ft. (6.7 m) wide	Approx. 42 ft. (12.8 m) wide	44 ft. (13.4 m) wide	Approx. 54 ft. (16.5 m) wide	Approx. 102 ft. (31.1 m) wide

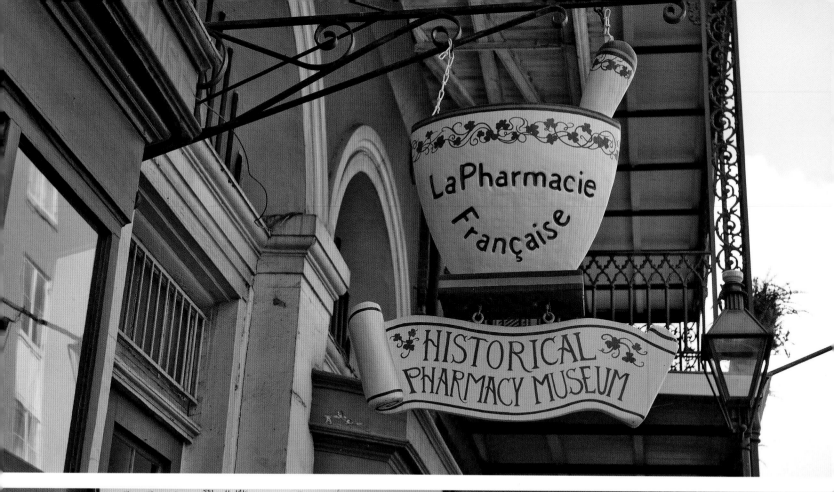

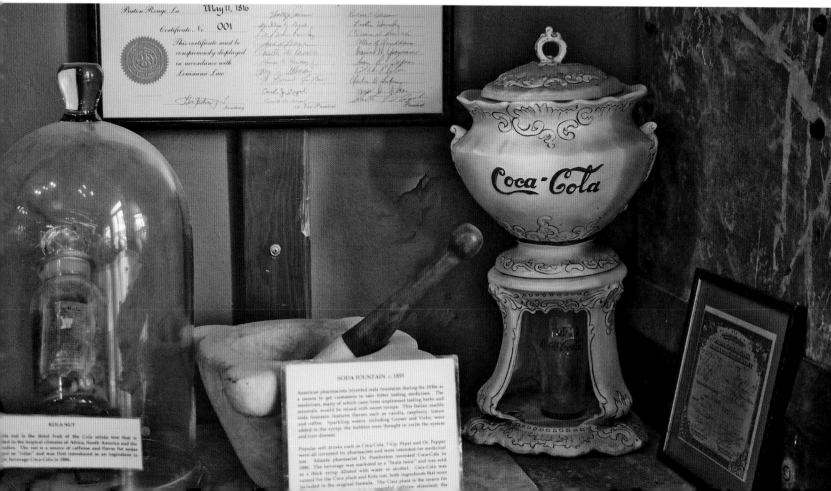

Baton Rouge, La May 11, 1816

Certificate No. 001

This certificate must be
conspicuously displayed
in accordance with
Louisiana Law

KOLA NUT

la nut is the dried fruit of the Cola nitida tree that is
ed in the tropical climates of Africa, South America and the
dies. The nut is a source of caffeine and flavor for sodas
n as "colas" and was first introduced as an ingredient in
beverage Coca-Cola in 1886.

Coca-Cola

SODA FOUNTAIN c. 1855

American pharmacists invented soda fountains during the 1830s as
a means to get customers to take bitter tasting medicines. The
medicines, many of which came from unpleasant tasting herbs and
minerals, would be mixed with sweet syrups. This Italian marble
soda fountain features flavors such as vanilla, raspberry, lemon
and coffee. Sparkling waters, including Geyser and Vichy, were
added to the syrup; the bubbles were thought to excite the system
and cure disease.

Popular soft drinks such as Coca-Cola, 7-Up, Pepsi and Dr. Pepper
were all invented by pharmacists and were intended for medicinal
use. Atlanta pharmacist Dr. Pemberton invented Coca-Cola in
1886. The beverage was marketed as a "brain tonic" and was sold
as a thick syrup diluted with water or alcohol. Coca-Cola was
named for the Coca plant and Kola nut, both ingredients that were
included in the original formula. The Coca plant is the source for
cocaine, a powerful caffeine stimulant, the

LOUISIANA

LA PHARMACIE FRANÇAISE

PHARMACY MUSEUM IN NEW ORLEANS, LOUISIANA

A trip to New Orleans requires a visit to a voodoo cemetery or perhaps a voodoo museum to see the pin cushion effigies, smell the strings of garlic around skulls, or learn to put a hex on your ex. Some of it is legitimate history, but much is exaggerated gobbledygook, like the stuffed *rougaroux* (a sort of French werewolf but is often half alligator in New Orleans).

Instead, stop in the apothecary opened in 1823 by the first pharmacist in the United States, Louis Dufilho Jr., who earned his degree in 1816 shortly after the Louisiana Purchase. Inside the French Pharmacy, actually more Creole, you'll learn about the special amorous elixirs mixed by the pharmacist and assigned numbers, which is the derivation of "Love Potion No. 9."

The drug store has a classic soda fountain dating back to the 1830s. Pharmacists in the United States used to blend bitters of herbs that could be more palatable in sweet syrup and carbonation, which was thought to aid digestion. This was the origin of such sodas as Dr. Pepper, Coca-Cola, and Pepsi. Many of these potions contained bits of controlled substances since opium, heroin, and laudanum were available over the counter until 1914. Many snake oil remedies contained narcotics and a high percentage of alcohol that did indeed dull the senses and symptoms for a time, at least until the Food and Drug Administration was formed in 1906 and actually required manufacturers to list the ingredients.

Perhaps most interesting are the voodoo potions and powders, which are not all that dissimilar to actual medicine. To cure syphilis, one early voodoo remedy recommended eating moldy bread—essentially early penicillin. Suddenly this sounds more humane than leeches and crude tools of amputation saws and trephination drills to bore a hole in the skull to relieve pressure.

← The very first pharmacy in the United States pleased its customers by selling anything legal (at the time), even voodoo powders or other controlled substances made more palatable at the soda fountain.

BEWARE OF FALLING BIRDS

TURKEY DROP IN YELLVILLE, ARKANSAS

Considering the thousands of turkeys that go to slaughter each year, the Ozark mountain town of Yellville, Arkansas, decided to give these birds one last taste of freedom. Ever since 1946, the town has celebrated the annual Turkey Trot to bring attention to all the wild turkeys roaming in the nearby woods. The most exciting part of the party was once the Turkey Toss, in which a few birds were thrown off the roof of the three-story Marion County Courthouse.

Poultry generally don't fly well, if at all. During the Turkey Toss, the birds would flap wildly to break their falls as the crowd cheered and munched on a smoked turkey leg.

To up the ante in the 1960s, low-flying planes began the "Turkey Drop" as hungry crowds gathered below. Ironically, the original idea of the Turkey Trot was to help beef up the diminishing wild turkey population, and some of the birds from the Drop did escape to re-populate in the woods.

In the late 1980s, the *National Enquirer* ran an exposé saying, "After smashing into a tree and coming to rest on a branch, one of the birds was pursued by a gang of kids who captured and fought over it—using it in a grisly tug-of-war that ended when one boy tore the turkey's wing off."

The Federal Aviation Administration even submitted a statement about the Turkey Drop: "FAA regulations don't specifically deal with dropping live animals out of airplanes, so we have no authority to prohibit the practice." People for the Ethical Treatment of Animals (PETA) protested this bizarre festival, but promoters insisted that the birds were doomed anyway, asking, is the outrageous cruelty to turkeys in cages and packing plants any more humane?

The bird-dropping festivities were stopped for a couple of years in the mid-2010s. They started up again in 2017 only to shut down again.

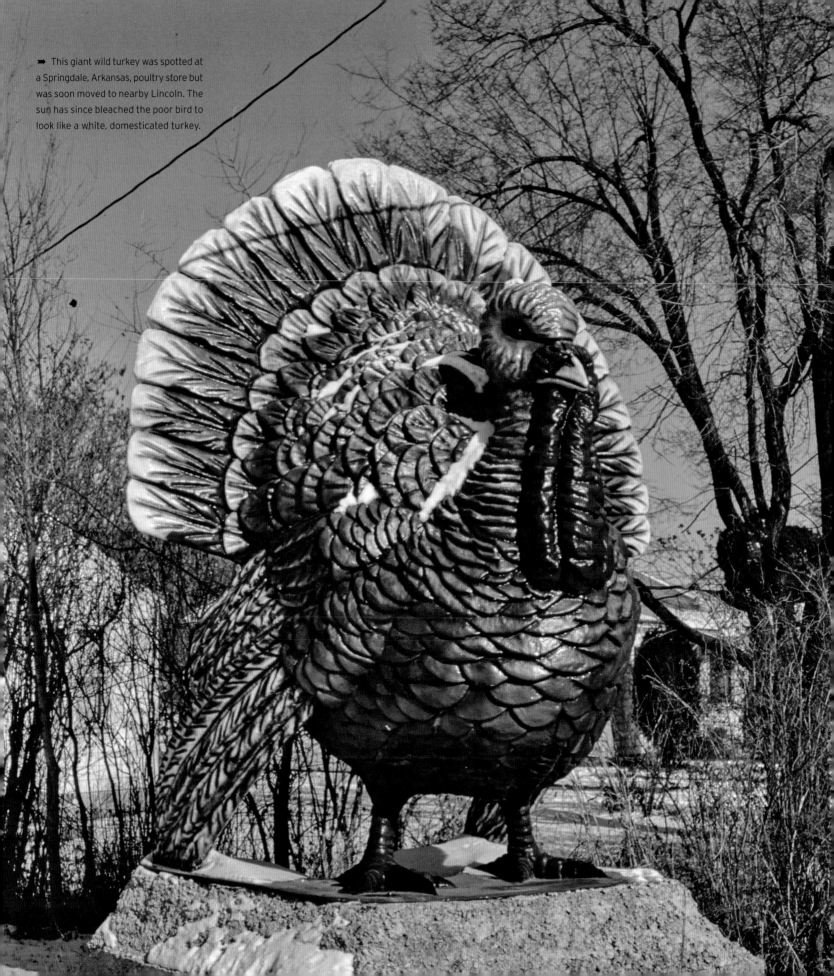

➡ This giant wild turkey was spotted at a Springdale, Arkansas, poultry store but was soon moved to nearby Lincoln. The sun has since bleached the poor bird to look like a white, domesticated turkey.

TENNESSEE

ALL HAIL ATHENA!

THE PARTHENON IN NASHVILLE, TENNESSEE

Ever since the occupying Turks used the Parthenon in Athens as an arsenal in the 1600s, this symbol of Greece has never been the same. The Parthenon exploded and many of the stones were quarried for use elsewhere. Then the English "borrowed" (indefinitely) the Elgin Marbles to stow away in the British Museum.

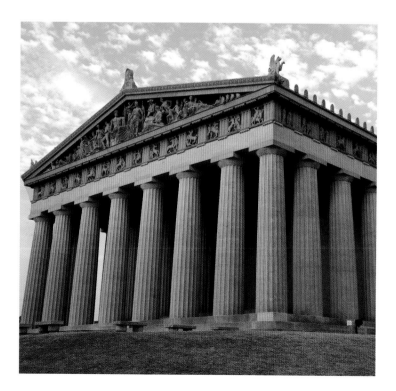

Nashville, Tennessee, sought to reproduce a slightly larger version of the Parthenon without all the decay and decline of the original. They followed the standard line of these ancient structures being starkly whitewashed instead of brightly painted. Over the years, the marble has been bleached by the sun and the bright colors on the human figures have faded.

Inside this replica of the Parthenon is not only the city's art museum but also the symbol of Greece's capital: Athena. A glimmering statue of the Goddess of War and Wisdom towers over the room at 42 feet (13 m)—the tallest indoor sculpture in the United States. The original was built around 438 B.C.E. and lasted for a thousand years until it was

probably moved to Constantinople and disappeared. The statue cost more to build than the entire Parthenon in Greece, so its gold and ivory covering was deemed too valuable to give back to Athens and sold off. While Nashville's replica may not have oodles of illegal ivory, at least Athena's dress is gold (plated).

Finding a Greek goddess in the sacred heart of the Bible Belt may seem incompatible, but Nashville once considered itself the Athens of the South and a center of enlightened education. As part of Tennessee's Centennial Exposition in 1897, Nashville built a temporary replica of this Greek temple at the top of the Acropolis. In 1931, the town rallied and made a permanent Parthenon.

Although this is easily the most impressive copy of the Parthenon, other Aegean marvels dot the American landscape as part of Greek Revival architecture. In fact, the United States has more ancient/modern Grecian architecture than Greece—well, it may sometimes be made of concrete, plywood, and foam, but at least it looks good.

◀ ➡ If you've been to Athens, Greece, you must go to Nashville to see what the Parthenon was supposed to look like. Sure, it doesn't have the whole Acropolis on top of the hill with the Greek amphitheater off to the side, but Nashville does have the Country Music Hall of Fame. Perhaps Nashville will take another note from the real Athens and build a quaint neighborhood like Plaka filled with retsina wine taverns surrounding the Pantheon with bouzouki music, dancing on the tables, and breaking plates.

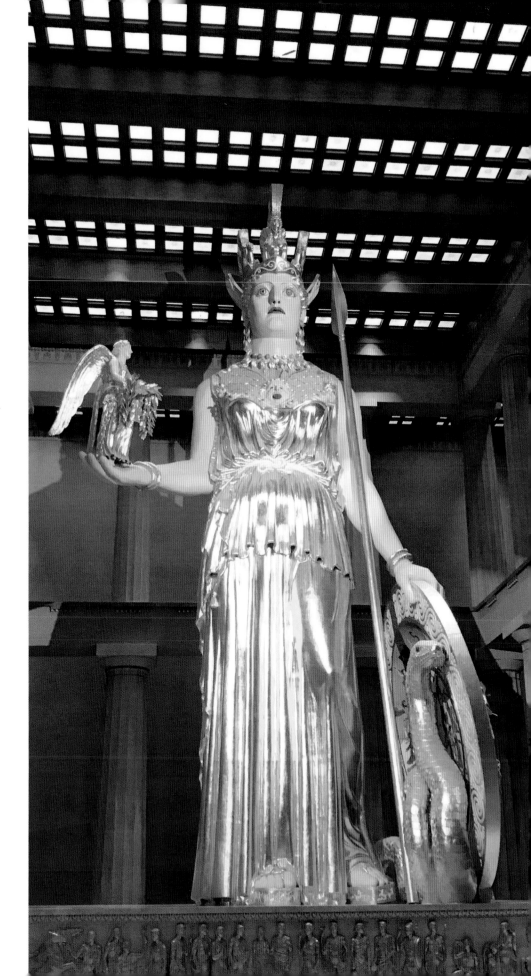

LARGER THAN LIFE

GOLDEN DRILLER

TULSA, OK

76 FT. (23.2 M)

PEDRO AT SOUTH OF THE BORDER

DILLON, SC

97 ft. (29.6 m)

JOLLY GREEN GIANT

BLUE EARTH, MN

55.5 ft. (16.9 m)

VULCAN

BIRMINGHAM, AL

56 ft. (17.0 m)

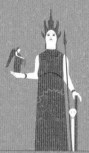

ATHENA AT THE PARTHENON

NASHVILLE, TN

41.8 ft. (12.8 m)

TIN PA ON ENCHANTED HIGHWAY

REGENT, ND

45 FT. (13.7 M)

BIG OLE

ALEXANDRIA, MN

28 ft. (8.5 m)

BIG JOHN THE GROCER

METROPOLIS, IL

30 ft. (9.1 m)

TENNESSEE

FLYING FROM PARIS TO POWELL

AIRPLANE FILLING STATION IN POWELL, TENNESSEE

Henry and Elmer Nickle saw the news clips of Charles Lindbergh traversing the Atlantic Ocean, so they built an homage to Lucky Lindy with a gas station in the shape of *The Spirit of St. Louis.* The clunky gray plane proved the perfect shape for a service station with one wing providing shelter while filling up on gas and the other for minor repairs.

Built at the height of Prohibition, the station may have doubled as a way station for moonshine since locals remember their grandparents stopping to load up on two kinds of fuel. Following the repeal of the 18th Amendment, the airplane became a bona fide booze peddler, a.k.a. a liquor store, and slowly fell into disrepair. Fortunately, the Airplane Filling Station Preservation Association—its real name!—stepped in to cut off the kudzu enveloping the poor plane and lovingly restore this classic piece of Americana.

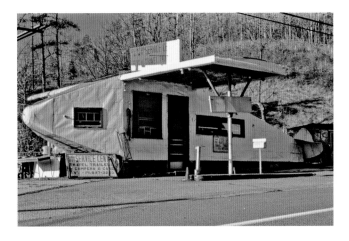

⬆ The Airplane Filling Station in Powell, Tennessee, has now been fully restored to its 1931 glory, complete with classic Texaco gas pumps. Rather than a full tank, though, inside you can get a shave and haircut at John's Barber Shop and admire the before-and-after photos of the airplane's facelift.

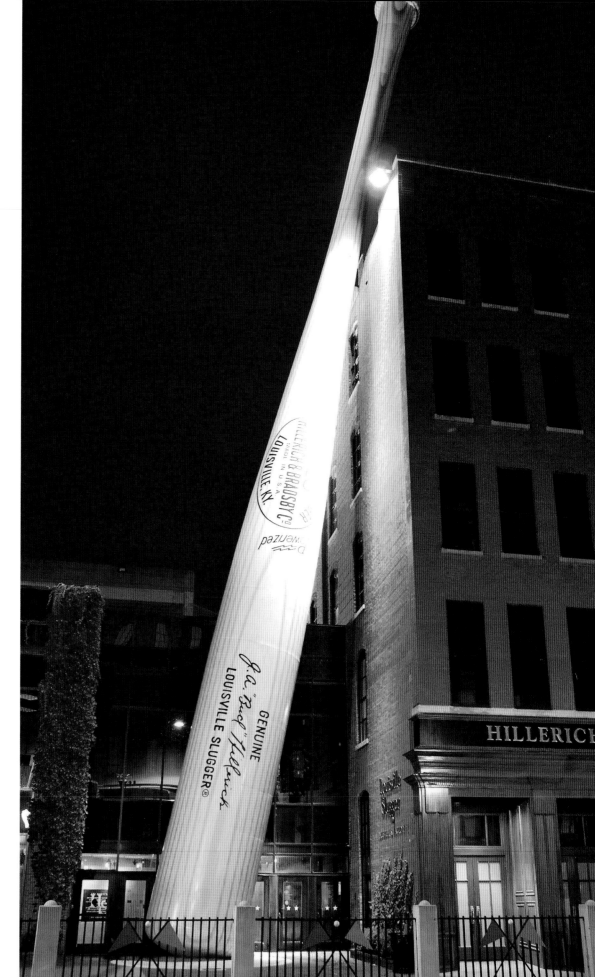

➡ Sure, the factory in Louisville may have made wooden clubs for golfers and rifle butts for snipers, but it's known for its wooden slugger with a production capacity of up to 5,000 bats per day. Just look for the World's Largest Baseball Bat and imagine the distance you could hit a ball with that beauty.

KENTUCKY

BAT BOY

WORLD'S LARGEST BASEBALL BAT IN LOUISVILLE, KENTUCKY

Sure, most baseball-crazed fans will head to Cooperstown, New York, where Abner Doubleday supposedly invented the sport in 1839. (He was actually at West Point at the time and clearly borrowed heavily from the British game of rounders.) Instead, why not head to the home of the most famous accessory: the Louisville Slugger?

These historic bats went into production in 1884 and today 1.8 million are made each year. If you've ever kept the label up and hit a fastball with the sweet spot of a Louisville Slugger, you'll understand the allure of these maple or white ash clubs.

Just look for the World's Largest Baseball Bat leaning against the five-story Louisville Slugger Museum. The company stays in business since Major League Baseball prohibits aluminum bats. Ironically this giant 120-foot (36.5 m) Slugger is made of hollow steel—and even doubles as ductwork for the building.

The bat is a giant replica of Babe Ruth's famous club that he used to indicate where his next home run would land. In the museum, marvel at a replica George Brett "Pine Tar Special," named for the notorious incident when his home run was nullified and he was called out for putting too much sticky pine tar on the handle for a better grip. Brett's original pine tar bat is in the Baseball Hall of Fame in Cooperstown.

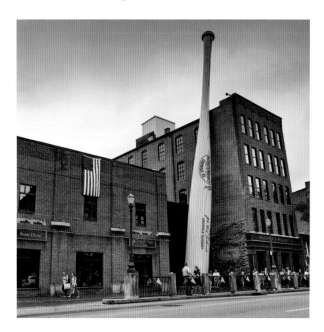

DRIVE-IN DRUGS

MORTAR AND PESTLE IN LEXINGTON, KENTUCKY

Joe Bondurant ventured to Las Vegas and came home inspired by this monument to Americana. In 1974, he erected his 30-foot (9 m)-tall mortar and pestle in Lexington, Kentucky, as an advertising gimmick of mimetic architecture that represents what it sells. Just like barber poles that came from a twisted bloody rag from pulling teeth, not many modern hairdressers yank sore incisors. Today, pharmacists don't grind their drugs, but the symbol remains. Alas, Bondurant sold his shop, and the pharmacy moved in 2011. The new owners hawked a preferred painkiller: liquor. They cleverly painted their building to be a two-story cocktail with an olive poking out the top in place of the pestle.

← A giant mortar and pestle in Lexington, Kentucky, with an apartment for the pharmacist upstairs. The drive-in window on the back still comes in handy for deliveries now that the new owners repainted the building as a different kind of sedative, a massive mixed drink that offers a mobile happy hour to motorists.

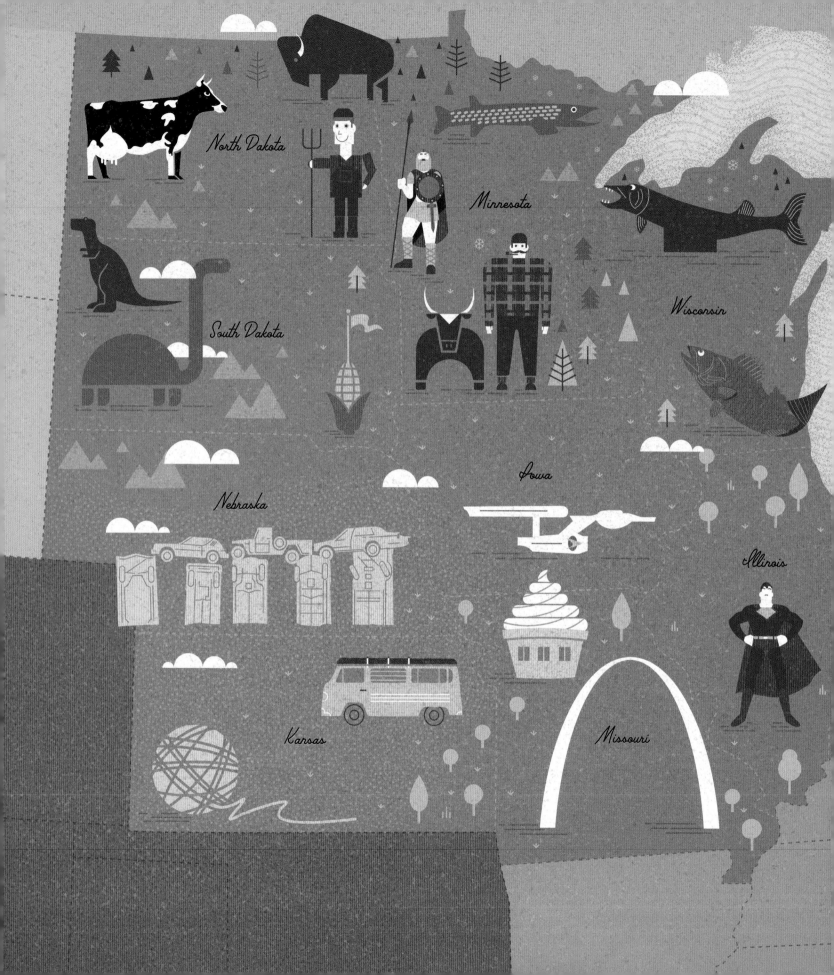

MIDWEST

The kids in the backseat have started to doze while crossing the many miles of plains. But wait! What the hell is that? A giant animatronic lumberjack who knows everyone's names? A seven-story picnic basket? A half-block-long muskie? This must be the land of the giants, where even twine balls are humongous.

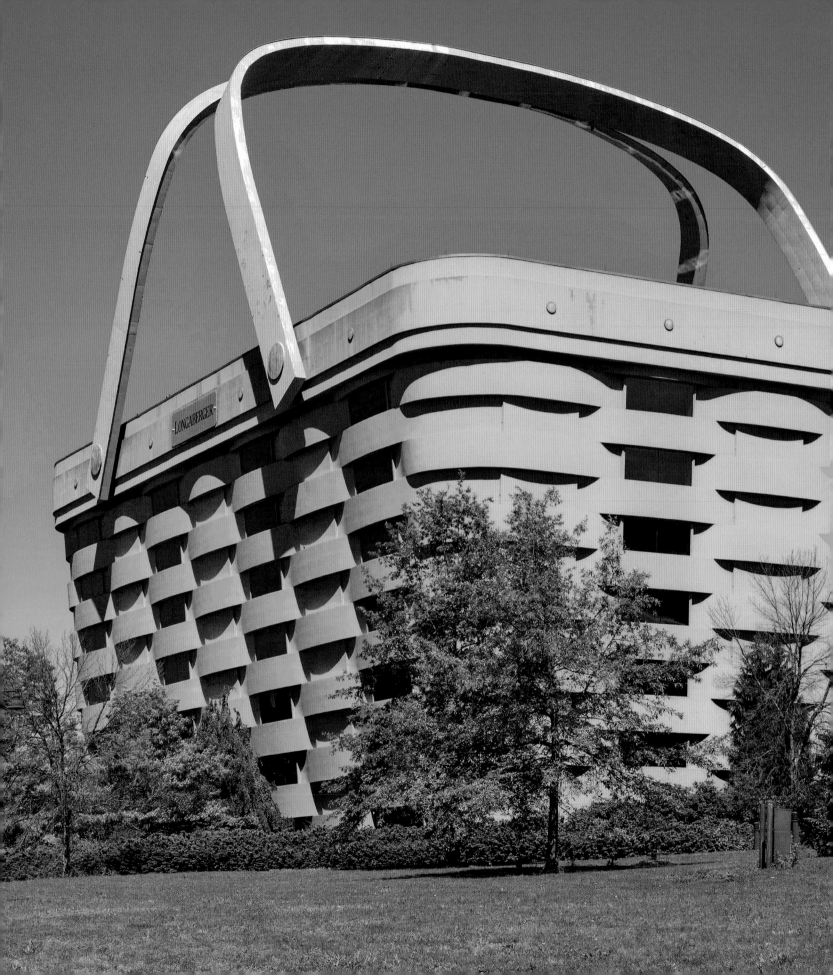

WORLD'S LARGEST PICNIC BASKET

LONGABERGER BUILDING IN NEWARK, OHIO

Owner Dave Longaberger just loved the shape of his fashionable, high-quality baskets based on the design that his grandfather perfected during the Depression. At the corporate center in Dresden, Ohio, he built the company headquarters in 1990 as a two-story basket building but wanted more. "I figured if Walt Disney could build an empire around a mouse," he wrote in his memoir, "the Longaberger home office building could resemble a basket."

The basket biz took off in the 1990s and the company was flush with funds. Longaberger envisioned a bigger basket, and employees thought he was kidding. Seven years and $30 million later, the company moved into the massive, hysterical Longaberger Basket Building in Newark, Ohio, in the suburbs of Columbus. Standing seven-stories tall, the unreal building slowly skews outwards and has a convincing basket weave with windows wound into the structure. The two 150-ton handles are purely decorative but are heated to avoid ice and snow build up that could crash down on the glass ceiling below.

After a height of 8,000 employees with $1 billion annual revenue, sales started to slump. The company declared bankruptcy, and the 9,000-ton basket was purchased in 2017 with hopes of transforming it into a hotel—with great food.

← This building seems just like another sculpture until visitors understand the sheer scale of the Longaberger basket that is 160 times the size of their once-popular product. Longaberger also made a 23-foot (7 m)-tall picnic-basket house in Dresden, Ohio, and a nearby 29-foot (9 m) World's Largest Apple Basket made of woven strips of maple.

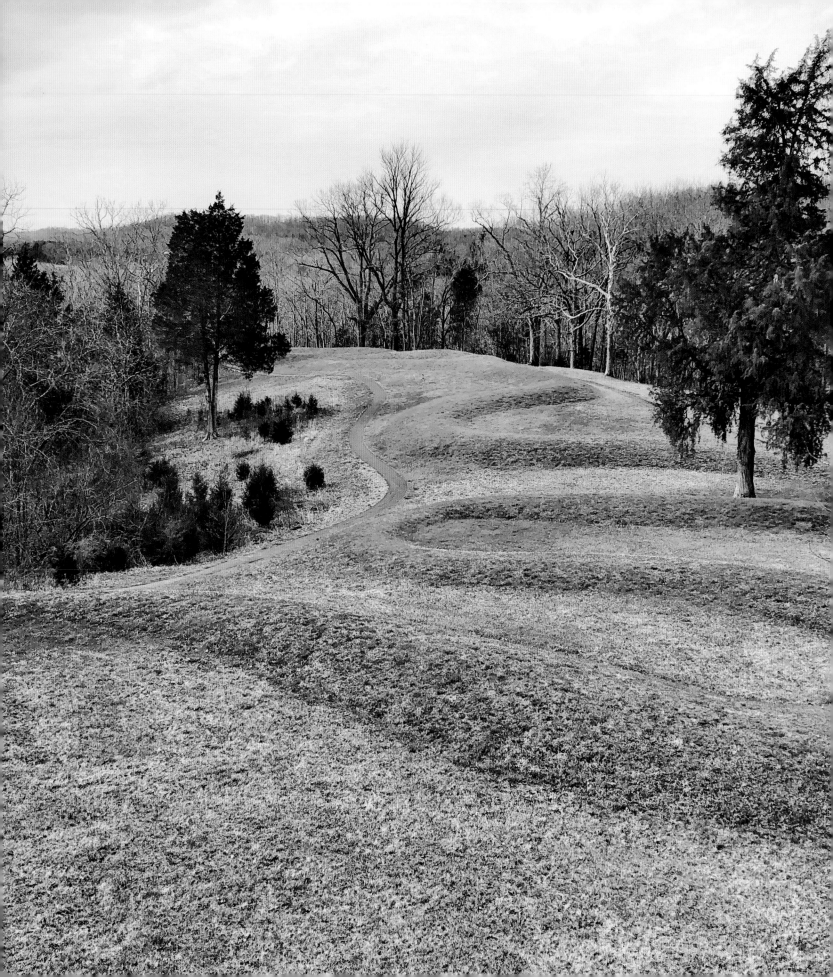

THE SNAKE THAT SWALLOWED THE MOON

GREAT SERPENT MOUND IN PEEBLES, OHIO

How many ancient animal effigies in the United States have been plowed over without even knowing of their existence? The longest, largest effigy mound in the world is tucked away in southern Ohio: a mound three feet high and winding a quarter mile to represent a giant serpent with its jaws open ready to swallow an enormous sphere. Is it an egg? The sun? The moon?

Effigy mounds in the shape of animals, usually birds, bears, bison, turtles, and lizards, have been discovered mostly from eastern Iowa to the shores of Lake Michigan: a 600-foot (183 m) bird-shaped mound was revealed near Madison, Wisconsin; the 214-foot (65 m) Man Mound, a standing humanoid (with bizarre horns or perhaps rabbit ears) was discovered in Baraboo, Wisconsin; and Milwaukee has a perplexing, oversized lizard effigy. Clearly the climate has changed, since even Serpent Mound has a nearby neighbor in the form of a giant alligator effigy, when today Ohio is not particularly known for roving alligators or crocodiles.

Little is known about these ancient Native Americans or exactly who their descendants are. Evidence shows that people have possibly been living in this area for about 12,000 years. The effigy mounds, however, were probably built between 750 and 1,400 years ago. Recent studies suggest that Serpent Mound dates back more than 2,000 years, but, other than amazing visitors, its purpose is unknown.

← Serpent Mound in southern Ohio twists for a quarter mile and now is on the list to be considered a UNESCO World Heritage Site, joining the Taj Mahal, the Colosseum, and the Great Wall of China.

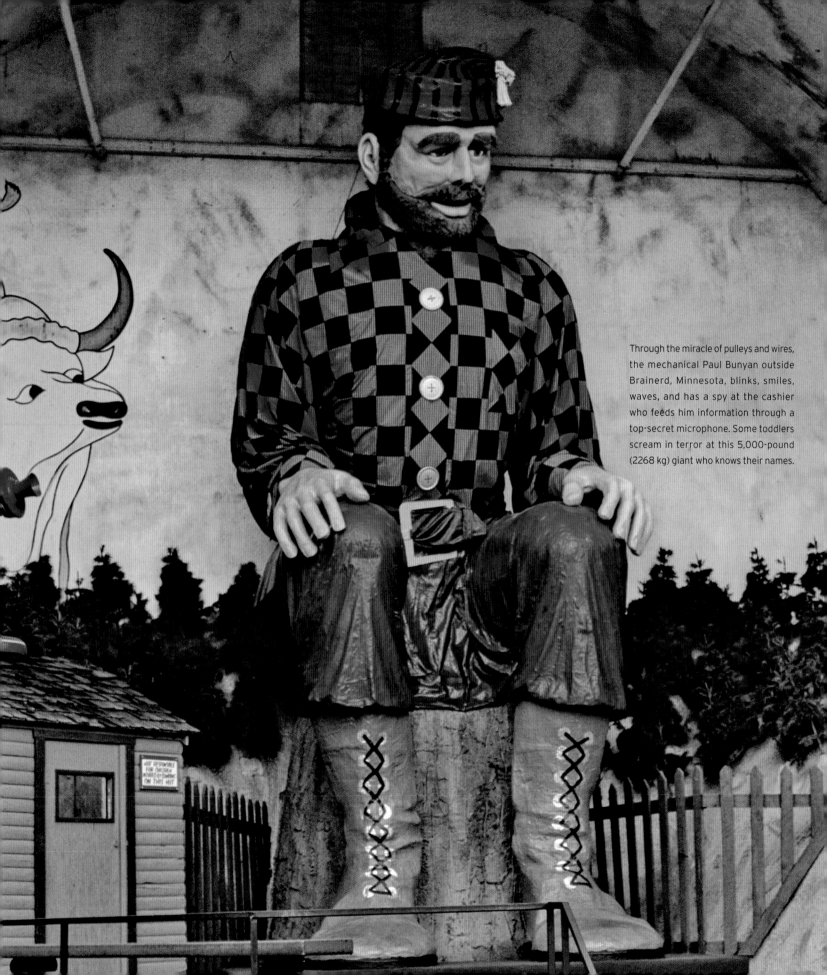

Through the miracle of pulleys and wires, the mechanical Paul Bunyan outside Brainerd, Minnesota, blinks, smiles, waves, and has a spy at the cashier who feeds him information through a top-secret microphone. Some toddlers scream in terror at this 5,000-pound (2268 kg) giant who knows their names.

MICHIGAN

HE'S A LUMBERJACK AND HE'S OK

PAUL BUNYAN IN OSCODA, MICHIGAN, AND ACROSS THE NORTH

The origin of Paul Bunyan is almost as disputed as which state has the most statues to the giant lumberjack and his blue ox. Minnesota claims that Paul first appeared in print in a promotional brochure for the Red River Lumber Co. in 1914; however, Michigan notes that the *Oscoda Press* printed an article in 1906 of Paul Bunyan stories and that the *Detroit News* picked up the pieces four years later to be published in its daily.

Bangor, Maine, claims that the giant was born there, which Walt Disney backed up in his classic 1958 short film about Paul Bunyan. Many other towns across the north claim to be the lumberjack's birthplace, and Akeley, Minnesota, has his birth certificate and cradle to prove it.

In fact, Paul Bunyan has left debris across the country. Libby, Montana, has his frying pan (as does Escanaba, Michigan). Bemidji, Minnesota, has his dice, phone, yo-yo, telephone, and even his fingernail clippings. Clayton, New York, has his golf bag, as if Paul had time for sports! Itasca Trading Post in Minnesota used to have Paul Bunyan's enormous wheelbarrow that Babe the Blue Ox in legend tipped over to form the Mississippi River.

⬆ Ossineke, Michigan, dared take Paul Bunyan's fork and spoon away from him. Anything big ends up being relics of the giant. For example, the Tahquamenon Logging Museum in Newberry, Michigan, has a giant pot, apparently used at Paul Bunyan's Cook Camp, although some dispute this was only his tea cup.

⬆ Babe the Blue Ox is nowhere in sight and Paul is hauling a tree rather than his double-bladed axe. Oscoda, Michigan's lumberjack just rips the trees out by the roots, and they celebrate this environmental destruction every year with Paul Bunyan Days.

The myth of Paul and Babe struck a chord with the enormity of this country, and the legends about them have been embellished around campfires ever since. Homemade Paul Bunyan statues dot the landscape. Hollandale, Wisconsin, had a handmade Paul Bunyan at Nick Engelbert's Grandview, but the statue was stolen and only Paul's oversized boots remain. Alpena, Michigan, has a colorful Paul Bunyan made of old Kaiser car parts in the 1960s that became the local lumberjack mascot for the community college. Brooklyn, Michigan, has a Muffler Man Paul Bunyan, but seems to have lost his double-bladed axe. Poor Paul! More statues pop up each year as Paul has come to be the sacred symbol of the north.

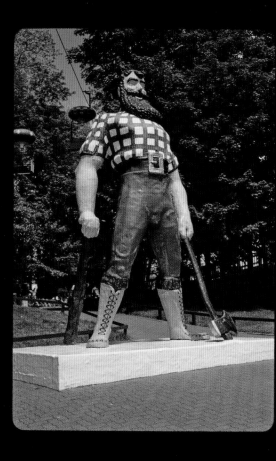

➡ Paul pumps out his chest to show he's better than the Brawny Man as he guards the entrance for the Enchanted Forest at Old Forge, New York.

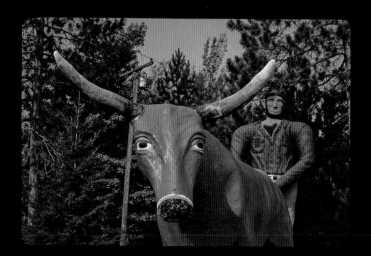

⬆ Ossineke, Michigan, has a large Paul with mutant, broad shoulders from 1940, likely the third oldest Paul Bunyan statue after Bemidji and Brainerd, Minnesota. This Paul used to talk, like the animatronic one in Brainerd still does. Unconfirmed reports tell of the poor statues being used as targets for pistol-happy Michiganders. Despite the name, this Babe was once a bull, but wayward bullets broke his rocky mountain wild oysters.

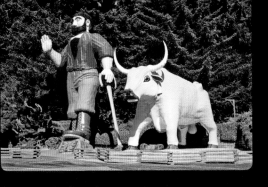

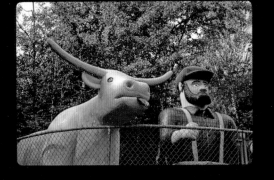

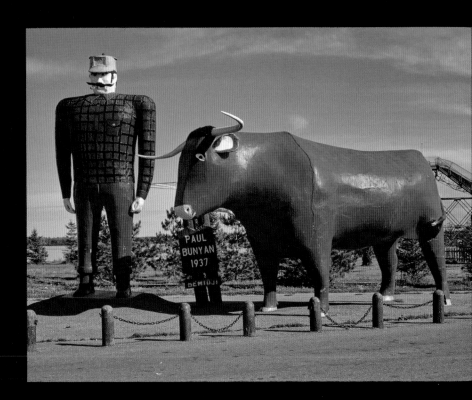

↑ Taking a tip from Brainerd, Minnesota's talking Paul Bunyan, this mighty lumberjack in Klamath, California, stands 49 feet (15 m) tall and can tell a joke or two about chopping down trees—this was back when clearcutting forests was considered a public good.

◄ At Michigan's Upper Peninsula at Castle Rock just north of St. Ignace, Paul Bunyan and Babe the Blue Ox may be mighty, but they need the protection of a cyclone fence to keep out teenagers.

↑ In 1937, Bemidji, Minnesota, mayor Earl Bucklen wanted to cement his reputation, so he posed for a broad-shouldered statue of Paul Bunyan. Babe the Blue Ox used to be portable on top of a Model T with eyes that lit up and its exhaust rigged to come out of his nose in a fabulous snort.

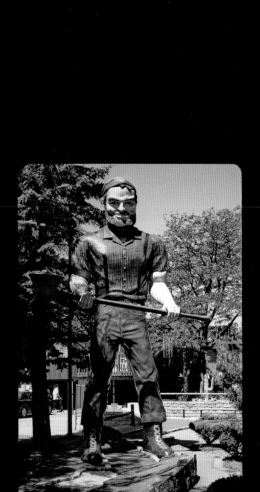

◄ The tallest giant on the putt-putt course is Paul Bunyan. Let's just hope he's not humiliated that he is reduced to be entertainment for golfers and wields his mighty axe on something other than trees.

TALL PAULS

EAU CLAIRE, WI
13 ft. (4.0 meters)

OSCODA, MI
13.3 ft. (4.1 m)

BEMIDJI, MN
18 ft. (5.5 m)

OSSINEKE, MI
25.5 ft. (7.8 m)

BRAINERD, MN
26 ft. (seated) (7.9 m)

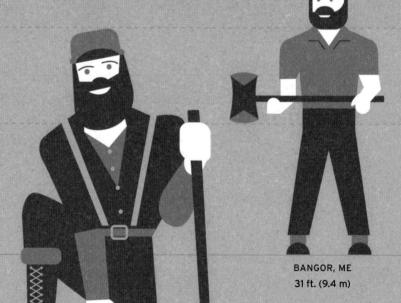

BANGOR, ME
31 ft. (9.4 m)

AKELEY, MN
33 ft. (kneeling) (10.1 m)

KLAMATH, CA
49 ft. (14.9 m)

MICHIGAN

TITANIC TIRE

WORLD'S LARGEST TIRE IN ALLEN PARK, MICHIGAN

Just imagine an 80-foot (24 m)-high tire broken free from its moorings rolling through town crushing everything in sight. That B-movie scenario never happened, but this huge monument to mechanization did once serve as a giant Ferris wheel inside of it when it debuted at the 1964 World's Fair in Queens, New York.

U.S. Royal Tires originally emblazoned its name on the amusement park tire, but Uniroyal bought them out and Michelin soon did the same. Even the ever-more enormous SUVs of the Big Three car companies are miniscule compared to this tire ready for Godzilla's monster truck.

When the giant tire was in New York, more than two million people rode the ride around the circumference of the tire in barrel-shaped pods all to glorify rubber. When the tire was moved outside of Motown, a black tread was added where the Ferris wheel once rode and a giant 11-foot (3.3 m) nail was inserted into its steel belts to show off the self-repairing rubber.

If you're on your way to visit the Henry Ford Museum and gawk at the Lincoln Continental and the Oscar Mayer Wienermobile in nearby Dearborn, you'll notice the giant tire all alone along the lonely highway, but at least it now has decorative neon to light up the Michigan night.

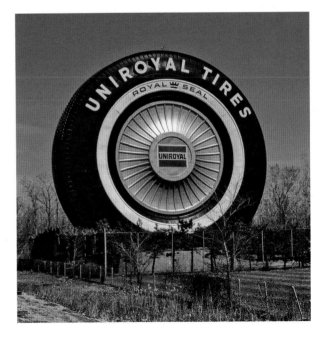

⬆ Along I-94 in Allen Park, Michigan, stands a seven-story tire to remind motorists to buy American or this Uniroyal wheel will crush you.

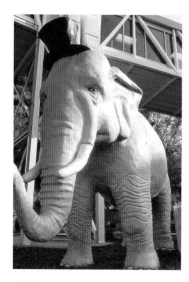

⬆ Pinky the elephant used to have his very own supper club along the Mississippi in Marquette, Iowa, but now tries to convince gamblers to stop in the casino to try their luck—that is when he's not waterskiing for the president.

⬆ Big Al and Lizzy, the pink and grey elephants, stand guard outside of Papa Joe's Fireworks in Hardeeville, South Carolina. They used to sport demonic reflective eyes and even oversized spectacles, but have since returned to relying on their own eyesight.

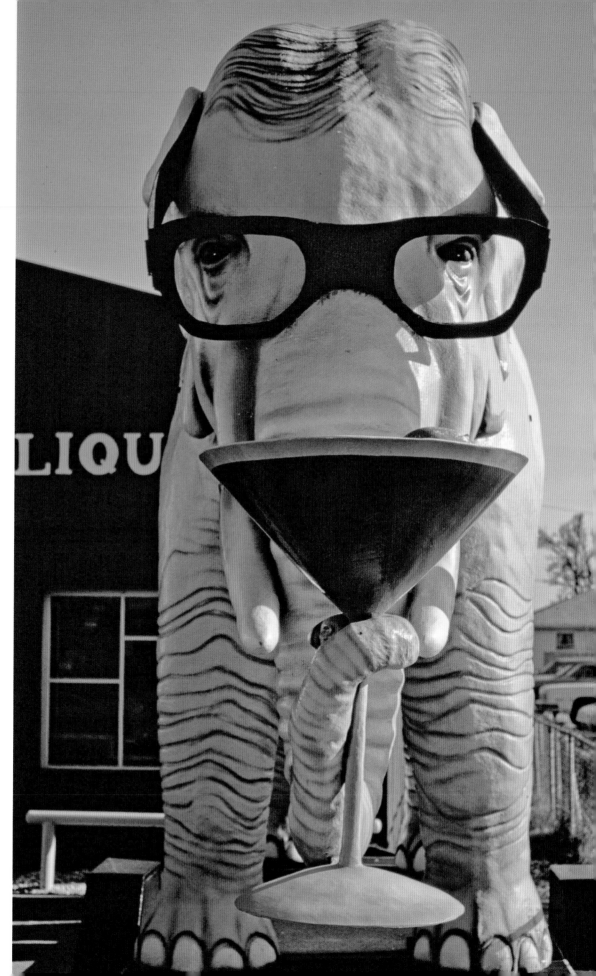

INDIANA

ELEPHANTS ON PARADE

PINK PACHYDERM IN FORTVILLE, INDIANA

The sight of pink elephants on parade is synonymous with alcohol-induced illusions, just like when Dumbo and the gang imbibed some champagne and Walt Disney drew the resulting psychedelic psychosis. Pink pachyderms dot the roadside landscape and oddly sport oversized Buddy Holly glasses to try to focus amid the delirium tremens.

Local personality Bob Reis poked fun at the famous teetotaler President Jimmy Carter when Carter visited Marquette, Iowa, along the Mississippi River in the summer of 1978. Reis zoomed his speedboat by the president's entourage with an unusual water skier: "Pinky," the rose-colored elephant statue, sporting an elegant Abe Lincoln stovepipe hat and two wooden planks plastered to its legs as water skis.

Poor Pinky eventually lost her Pink Elephant Supper Club and now promotes a riverboat casino. On the other hand, eight months later, Carter went fishing and valiantly fended off a rabid attacking rabbit without the help of any hooch.

← Not only are we hallucinating by seeing pink elephants, but that same pachyderm is sipping a giant martini. The 19-foot (5.8 m)-long beast stands outside a liquor store in Fortville, Indiana, but can't resist a parade, especially when dressed as Uncle Sam or Santa Claus.

↑ Tennessee has a rash of pink elephant sightings across the state, but some have gone missing or maybe were only a myth. Here is smaller pachyderm in McGhee, but other elephants were sighted in Madison, Clarksville, Cookeville (with glasses, water skis, and a bikini), and Cross Plains (with a martini glass because it's always happy hour somewhere).

ILLINOIS

METROPOLIS OF THE CORNFIELDS

SUPERMAN IN METROPOLIS, ILLINOIS

With a population of a bit more than 6,000, Metropolis, Illinois, may not be the Metropolis we envisioned Superman saving from Lex Luthor in each episode. But who can argue with the Illinois State Legislature that officially declared this city Superman's home? Besides, they've got the statue to prove it.

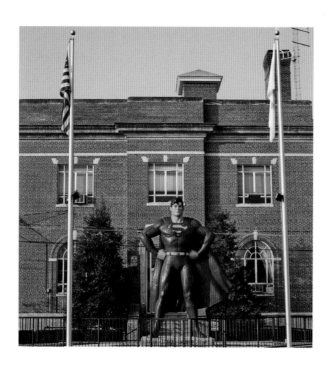

The small city had dreams of a 200-foot (61 m)-high Superman statue but settled for a more life-sized, seven-foot (2.1 m)-tall superhero. Kryptonite wasn't his only foe as Superman's fiberglass chest couldn't withstand the barrage of bullets from local villains testing to see if he truly was the man of steel. After a hefty fundraising campaign, a 15-foot (4.5 m) "man of bronze" guards the county courthouse in its quest for truth, justice, and the American way, even if to some that means shooting a shotgun at poor Superman. Beware nefarious scoundrels! It doesn't take X-ray vision to see they're up to no good.

← A bronze (not steel) Superman stands tall in Metropolis, Illinois, near a new statue of Lois Lane working for the local Metropolis Planet newspaper. Stop by in June for the Superman Festival and visit the Superman Museum.

ILLINOIS

BIG BAD JOHN

GARGANTUAN GROCER IN CARMI, ILLINOIS

Inspired by the 1961 hit single "Big Bad John" by Jimmy Dean, the supermarket chain Big John out of Carmi, Illinois, wanted a colossal statue to mirror the savings inside. That's where the similarities stop. The 30-foot (9 m) Big John sculptures ooze saccharin customer service and bona fide goodness, whereas the song's hero killed a man in New Orleans over a Cajun Queen and died in a collapsed mine.

The General Sign Co. in nearby Missouri built about thirty Big John sculptures for the supermarkets to lure in hungry customers. When some stores closed, the many Big Johns found new homes: One statue sells fireworks in Mississippi; some were left homeless as their supermarkets fell to the wrecking ball. Only nine known Big Johns still stand, with three in southern Illinois (Carmi, Eldorado, and Metropolis).

← Apparently Metropolis, Illinois, has more than one superman, but at least one of them is content just to carry groceries to your station wagon rather than having to save the whole damn world all the time.

ILLINOIS

CAR KEBAB!

THE SPINDLE (R.I.P.) OF BERWYN, ILLINOIS

The best roadside attraction in Illinois unfortunately met the wrecking ball in 2008 when Walgreen's (and instability) forced this 50-foot (15 m)-tall stack of skewered vehicles back down to the earth. Even a Save the Spindle society couldn't raise the $300,000 necessary to dismantle and re-erect the found-art sculpture in Berwyn, Illinois.

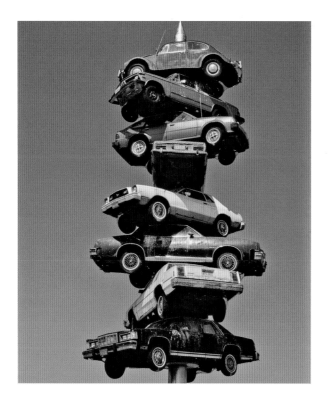

Dustin Shuler built the Spindle in 1989 with eight impaled vehicles in an otherwise non-descript suburban Chicago shopping plaza. Just like Carhenge in Alliance, Nebraska, the locals were slow to warm to the sculpture's merits. Perhaps appearances in the movie *Wayne's World* and *Zippy the Pinhead* comic strips helped melt the ice, but alas flocks of birds beat them to this new vehicular birdhouse in the sky.

◄ The most original roadside attraction in Illinois met the wrecking ball. The Spindle skewered car culture with eight impaled automobiles towering over a parking lot in suburban Chicago as if warning other vehicles to keep motoring or they'll be shish-kebabbed.

VIKINGS IN ILLINOIS?

REPLICA SHIP IN GENEVA, ILLINOIS

When Scandinavians heard about the scheduled 1893 World Columbian Exposition in Chicago, they objected to the name: Columbian? You mean based on Columbus? They knew that Leif Erikson had ventured to the New World 500 years before.

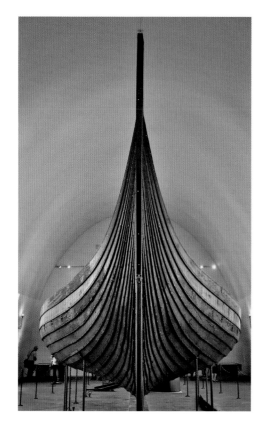

To prove their point, a shipyard at Sandefjord, Norway, built a replica Viking ship in 1892 to sail to Chicago and show that this was a pre-Columbian artifact. In other words, the Vikings arrived first—and that's setting aside the fact that between 90 and 112 million people already lived in the Americas in 1492. Based on the Gokstad Viking ship unearthed near Sandefjord in 1880 and now housed at the Viking Ship Museum in Oslo, this replica of Leif Erikson's ship set sail from Bergen, Norway, across the Atlantic to New York.

The wooden boat flexed with the harsh waves to keep from snapping in two. From the keel to the gunwales are only 6.5 feet (2 m), so water could easily slosh into the boat, but just as easily drain out. The 78-foot (23.7 m)-long ship went up the Erie Canal to the Great Lakes and a pier in Chicago to prove to thousands of amazed—if unconvinced—festival goers that Scandinavians beat Columbus to America.

After the fair, the replica Viking ship sailed down to New Orleans, and eventually ended up in Geneva, Illinois, at Good Templar Park.

← The Gokstad ship (pictured here) at the Viking Ship Museum in Oslo was the inspiration for the replica that sailed across the Atlantic to Chicago in 1893. No need to fly to Norway to see the sleek lines of a real replica—just stop in suburban Chicago.

MISSOURI

I SCREAM

WORLD'S LARGEST ICE CREAM IN ST. JOSEPH, MISSOURI

Well, it may be a bit of a stretch that the ex-Twistee Treat in St. Joseph is the "world's largest," considering that dozens of these cones exist, mostly across Florida and Texas. Indeed the Twistee Treat corporation began making these 25-foot (7.6 m) ice cream delights in 1983 and has projected to once again fill our fair country with giant cones.

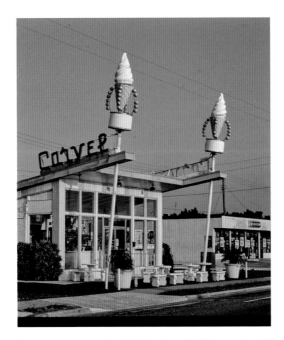

⬆ Rather than having tiki torches with flames, Carvel's in West Palm Beach, Florida, has giant soft serve cones announcing its ice cream.

The real dairy battle is the actual world's largest edible ice cream. Italians declared gelato as part of their heritage dating back to the decadence of Caesar Nero, who demanded icy treats, and Marco Polo, who supposedly sneaked back a secret gelato recipe from China. The Medici claimed to have commissioned the first real ice cream in Tuscany, so it only makes sense that the nearby beach town Rimini would make the World's Largest Gelato in 2011. The cone consisted of 2,000 wafers held together with more than 1,500 pounds (680 kg) of white chocolate to hold the 150 pounds (68 kg) of ice cream.

Before refrigeration, much of the early ice shaved to make cold desserts in Europe hailed from ice blocks exported from Norway. No wonder the Norwegians surpassed the Italians in 2015 with a 10-foot (3 m)-high cone that was a full foot higher than the Italian gelato. Now Twistee Treat needs to make a *real* 25-foot (7.6 m)-tall cone.

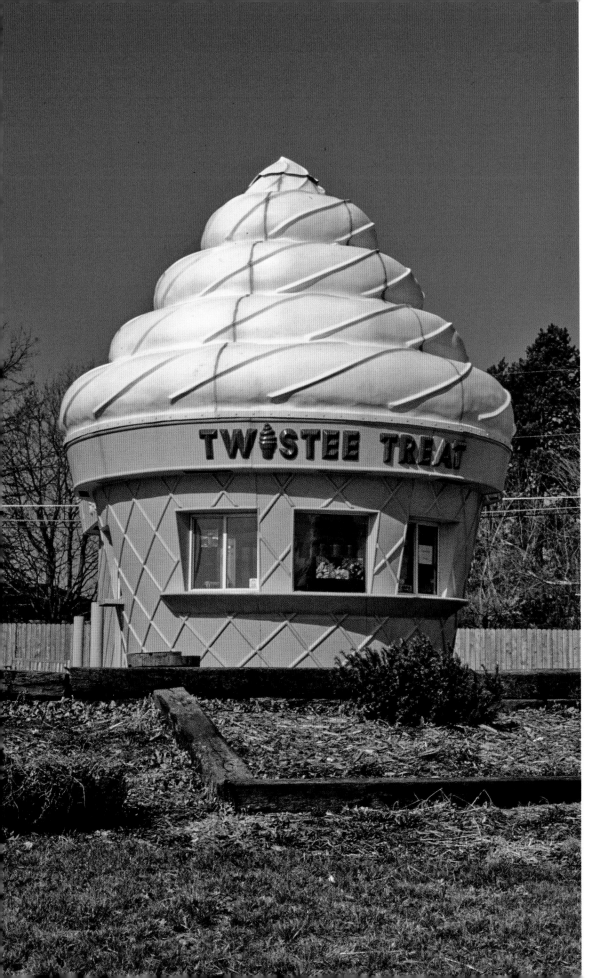

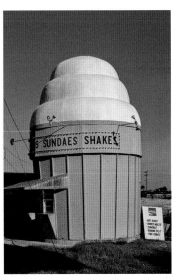

⬆ Before Twistee Treat made its enormous cones, ice cream stands such as this one in Long Beach, Florida, only seemed like a mirage for hungry vacationers crawling across the sands.

⬅ This Twistee Treat in St. Joseph, Missouri, is now locally owned as Kris and Kate's Ice Cream with a scrumptious array of sundaes, shakes, and smoothies. As they say, "If you can think it, we can make it!"

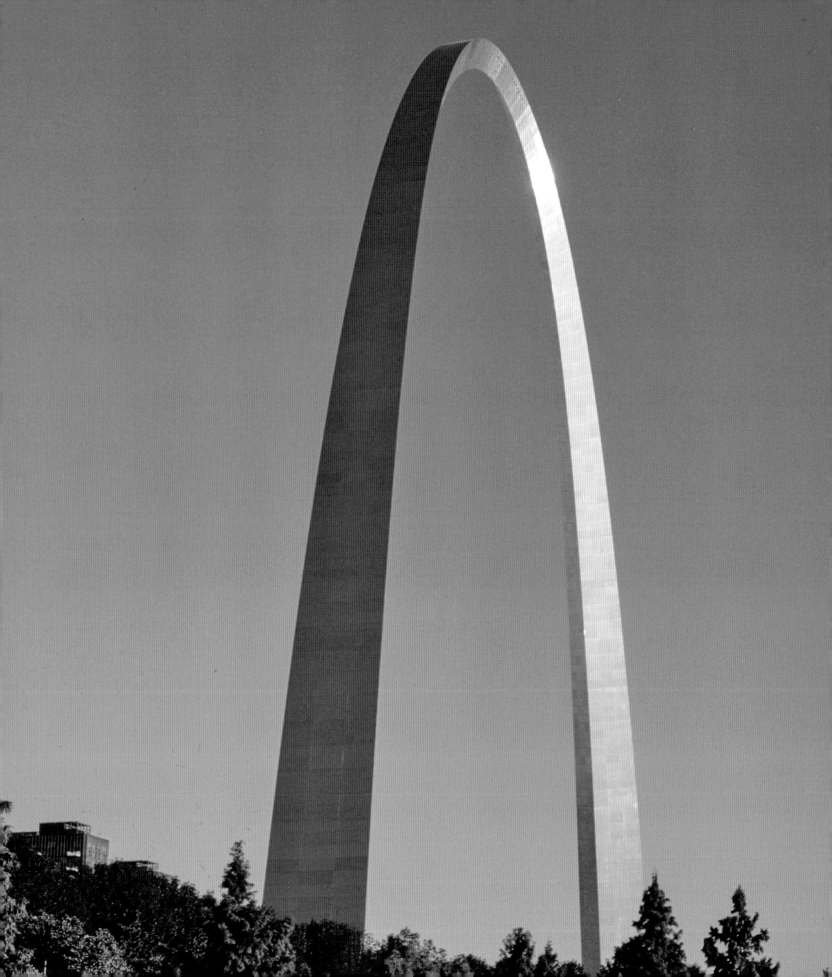

MISSOURI

SHINY STEEL RAINBOW

GATEWAY ARCH IN ST. LOUIS, MISSOURI

Imagine proposing a 630-foot (192 m)-high arch made of steel next to the Mississippi River. This would be the tallest monument in the world and could fit fifty-story skyscrapers comfortably underneath it. Not only that—a creaky elevator could go inside all the way to the top. The proposal was bold and seemingly impossible.

Incredibly, Finnish designer Eero Saarinen won the 1948 competition to complete this massive project as the masterpiece of his life's work in modernist architecture of smooth lines and functional splendor. The arch became officially known as the Jefferson National Expansion Memorial but was nicknamed the Gateway Arch since pioneers knew St. Louis as the Gateway to the West. Finally finished in 1965, the modernist masterpiece sill astounds visitors with its sleek, slick lines that even today are ahead of its time.

← A piece of string will make a semicircle if an end is held in each hand—the same form as the Gateway Arch in St. Louis. Also known as a parabola, or officially a "catenary curve," unless you're a finicky mathematician who will bore you with the differences. Thanks to the Romans, we know that an arch is the strongest structure and only becomes more durable the more weight is piled on top.

➡ The Arch Motel in St. Clair, Missouri, took advantage of tourists flocking to the area to see the Saarinen arch. The monument remains, but this motel has been bulldozed.

IOWA

PET ROCKS

THE GROTTO OF THE REDEMPTION IN WEST BEND, IOWA

In a tortured fever, seminarian Paul Dobberstein lay in his bed in Milwaukee with devastating pneumonia. He vowed to the Virgin Mary that he would build the most marvelous shrine to her if she just spared his life. She made good on the promise, and so did he.

Dobberstein finished his priestly duties in Wisconsin, and in 1898 honed his stone-collecting skills to glorify God. For forty-two years, Dobberstein collected semi-precious gems, crystals, and minerals to cement into place for the Virgin Mary. His rationale came directly from the word of God, as he explained in a pamphlet from the site that interpreted those words a bit too literally. He took liberty with the passage from Isaiah to capitalize these words to prove his point: Those who are lost "shalt have a PAVEMENT of patterned STONES, and the FOUNDATIONS shall be of SAPPHIRE; thou shalt have turrets of JASPER, and gates of carved GEMS, and all the BOUNDARY STONES, shall be JEWELS." Remember those words when creeping through the caves of the grotto.

Dobberstein remembered the pilgrimage sites of his native Germany, from where he emigrated in 1872, and stockpiled stones for his dream grotto. Northern Iowa

is mostly fertile black dirt, so Dobberstein traveled far and wide hauling back hundreds of pounds of rocks, crystals, and minerals from such places as Hot Springs, Arkansas, and the Black Hills in South Dakota.

The northern Mississippi valley is filled with numerous other grottoes and rock gardens: the Dickeyville Grotto, Itasca Rock Garden, Prairie Moon Sculpture Garden, Fountain City Rock Garden. But the Grotto of the Redemption is the king and will convince any doubter that Dobberstein took Psalm 18 literally, "the Lord is my rock."

◄ ▼ Father Paul Dobberstein with his helper Father Louis Greving spent a combined total of ninety-two years building the "World's Largest Grotto" in West Bend, Iowa. The centerpieces of the nine grottoes are relatively bland white figures of angels, Joseph of Arimathea, Nicodemus, and a replica of Michelangelo's Pietà, but the best part is wandering the maze of semi-precious gems to understand how these men of the cloth accomplished their goal of earthly immortality through rocks.

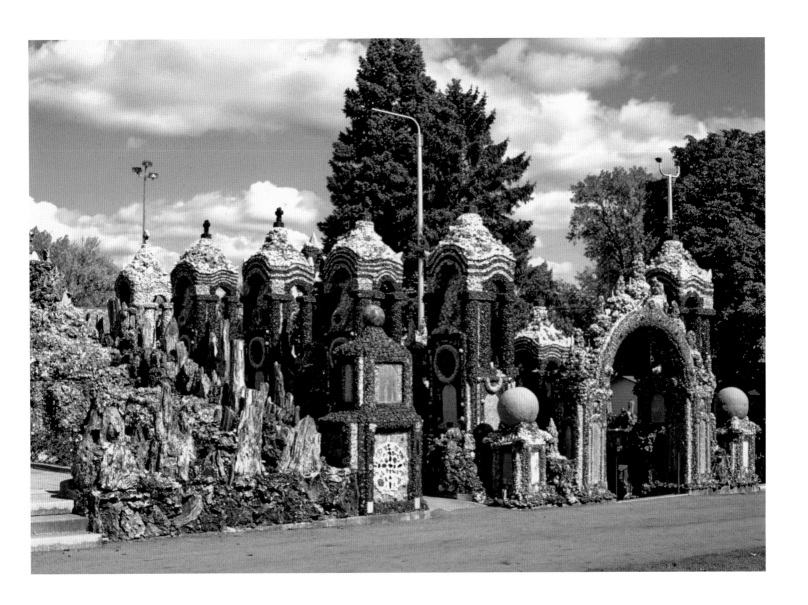

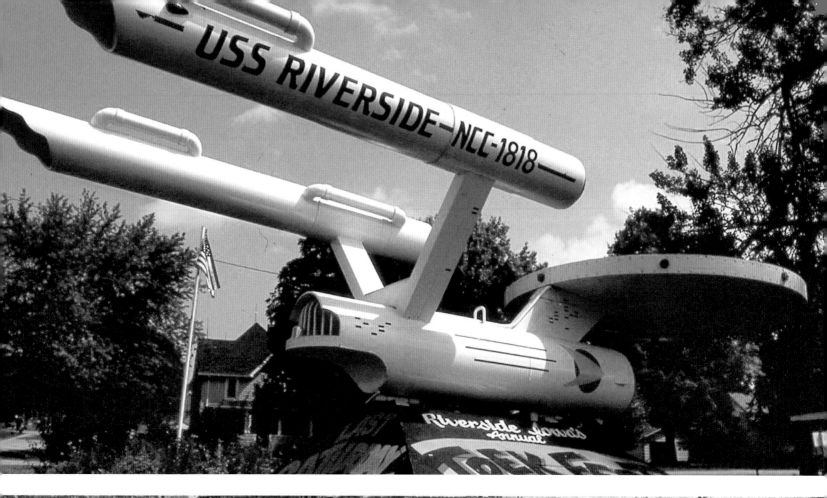

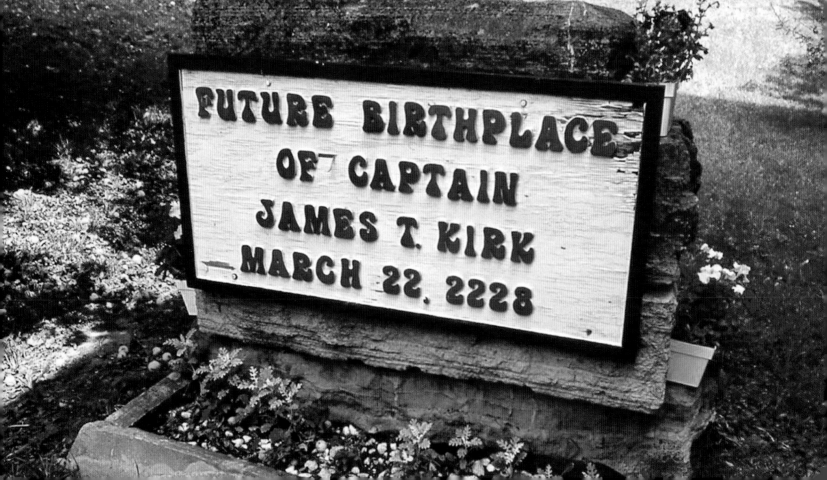

WHERE NO MAN WAS BORN BEFORE

FUTURE BIRTHPLACE OF CAPT. JAMES T. KIRK IN RIVERSIDE, IOWA

Apparently, Capt. James Tiberius Kirk of the Starship *Enterprise* will be born on March 22, 2228, but where?

Star Trek mentioned that he was born in a small town in Iowa, so Riverside City Council member Steve Miller wrote to *Star Trek* creator Gene Roddenberry in 1985 and asked why Riverside, Iowa, shouldn't be the Future Birthplace of Captain Kirk. Incredibly, Roddenberry agreed, so Trek Fest replaced the ho-hum Riverfest, and the town now fills up with Vulcans, Klingons, Coneheads, and future Starfleet cadets.

A plaque behind the yellow New Image Salon marks where the future local hero will be born, but who in the town will be his great-great-great grandparents? A sculptor who is fixing up storefronts in town told me: "The other local legend is that he'll be conceived on the pool table in Murphy's Bar—of course, that probably puts him in the running with everybody else in town! I doubt they'll put up any sort of plaque for that, though."

As the Future Birthplace of Captain Kirk, Riverside, Iowa, wanted to build a giant Starship *Enterprise*, but Paramount insisted on a hefty licensing fee of $40,000. "That's extortion!" complained an artist in town. "I'm sure, though, that whatsisname has some high paid agent that will try to get anything out of it he can." Instead, the town built a 20-foot (6 m)-long USS *Enterprise* mounted on a trailer and named it the USS *Riverside*.

← This tomb-like monument marks the spot of the birth of Capt. James T. Kirk 200 years in the future. Perhaps a hospital will be built on this spot and maybe that's his great-great-great-great grandfather serving suds at Murphy's Bar.

WISCONSIN

ROLL OVER,
FRANK LLOYD WRIGHT!

HOUSE ON THE ROCK IN SPRING GREEN, WISCONSIN

As the story goes, Alex Jordan Sr. was a real estate agent who allegedly approached legendary Wisconsin architect Frank Lloyd Wright for advice on building plans for a project near Madison. The notoriously vain Wright generally hated any project that wasn't his own and pouted, "I wouldn't hire you to design a cheese crate or chicken coop."

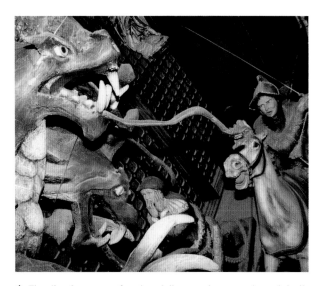

⬆ The dizzying array of nudes, dolls, monsters, angels, and devils will leave even the most sure-footed visitor swaying after the four- to five-hour visit through the labyrinth of House on the Rock.

Miffed, Alex Jordan Sr. laid plans and his son completed their own masterpiece: a sort of Prairie-School perch gone awry atop a giant protruding boulder a stone's throw away from Frank Lloyd Wright's Taliesin studio. The official line from the House on the Rock is that Alex Jordan did not build this to spite Wright; nevertheless, public records show that Wright complained bitterly about this architectural oddity and tried to buy up land around the site to prevent access.

The House on the Rock indeed drew visitors who might have visited Wright's studio, but also lured thousands of new tourists to the area to see this famous house that Jordan supposedly built by carrying baskets of rocks on his back up the 60-foot (18.2 m) chimney rock to complete the fourteen-room house. Some critics viewed

it as a parody of Wright's idea of a "Japanese House" with very low ceilings that have since been padded for tall tourists.

By 1946, Jordan Jr. finished the House on the Rock, but word trickled out about this bizarre attraction and how he tried to shoo away gawkers. Perhaps this was part of the shtick to lure them back since Jordan eventually charged them fifty cents a pop to see his masterpiece. That's when construction began in earnest.

A normal visit today takes a good four to five hours to see such sites as the precarious 350-foot (106 m) Flying Bridge through the treetops. Don't miss the optical illusion of the trompe l'œil Infinity Room, a cantilevered walkway jutting out 218 feet (66.5 m) precariously over the Wyoming Valley that gets consistently narrower further out. This idea of an Endless Bridge was subsequently copied by bigwig French architect Jean Nouvel for the Guthrie Theater in Minneapolis.

↑ The inside of the Infinity Room is an optical illusion. The seemingly endless hall actually gets narrower until it ends in a point. The room juts out over the valley as a seemingly precarious endless bridge.

← Living under a cliff presents certain uncertainties, such as giant boulders springing loose and crashing into the living room. When that happened to a newly remodeled house in Fountain City, Wisconsin, they realized the pun of the "Rock in the House" and tourists to nearby "House on the Rock" had to check it out.

The dazzling collections and reproduction of famous artifacts fill a maze of rooms for a surreal tour of claustrophobic psychedelia through the Lilliputian village of Streets of Yesterday and numerous World's Largests (cannon, organ, carrousel, chandelier, fireplace, perpetual motion clock, etc.). I asked the guide if the Crown Jewels and royal gems protected by empty armor of nonexistent knights were genuine. She pointed to a tiny card obscured by the blinking red lights that notes they are "not authentic." Real or replica are indistinguishable and perhaps unimportant in this labyrinth of sensory stimulation.

WISCONSIN

LEVIATHAN OF THE LAKES

GIANT MUSKIE AT FRESHWATER FISHING HALL OF FAME IN HAYWARD, WISCONSIN

When Jerry Vettrus and his associates built the world's largest fish, a whale of a muskellunge, "It took us nine months! The fish never would have fit on one truck, so we had to ship it up to Hayward in parts and assemble it there." This was a postcard-perfect moment, just like those days of yore with trick photography of a fish so big that it took a truck to move it.

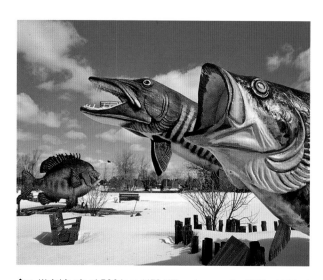

⬆ ➡ Weighing in at 500 tons (453 MT) and measuring 145 feet (44 m) long, the ultimate colossus of the deep is Hayward, Wisconsin's muskie. If that's not enough, its walls are decked with grip-and-grin photos of people holding up their trophy fish, which look puny by comparison to the world's largest fish.

The Walk-Thru-Muskie is also the world's largest fiberglass structure. They gutted the fish to make a half-block-long museum in its innards for the Freshwater Fishing Hall of Fame. Just like Jonah or Geppetto, you go into the belly of the beast and can climb two flights of steps to the mouth of the fish. This being Wisconsin, what could be more romantic than tying the knot with a special someone in a trophy-worthy muskie? The fish's mouth alone holds a wedding party of twenty, and they can admire the World's Largest Nightcrawler stuffed on the wall during the processional.

Look down below at the Sea of Fishes, a stringer full of freshwater fish: a fiberglass perch, bluegill, smallmouth bass, rainbow trout, walleye, and Coho salmon. These statues would be the centerpiece of any other Midwestern town, but next to the muskie they look like bait.

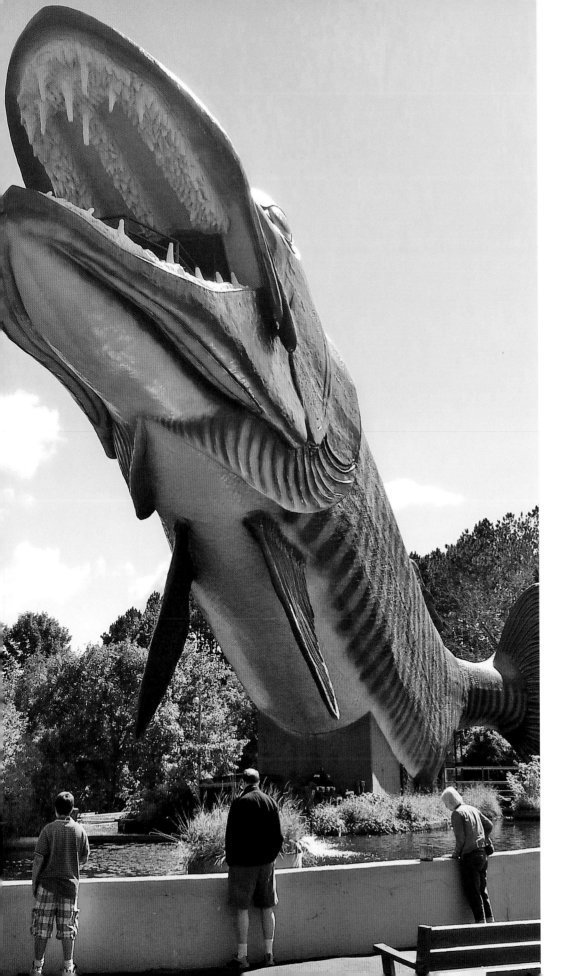

In 1979 when Creative Displays (now known as Fiberglass Animals, Statues, and Trademarks, or F.A.S.T.) built this leviathan, it was the artistic pinnacle for giant fiberglass monuments on par with Paris in the 1920s or Florence in the Renaissance. "That was a boomer year," recalled Vettrus. "We did both the Jolly Green Giant [in Blue Earth, Minnesota] and the muskie. I don't think we'll ever do anything like that again, and I'm sure nobody could afford it nowadays!"

WISCONSIN

STEAMPUNK SPACESHIP

DR. EVERMOR'S FOREVERTRON IN BARABOO, WISCONSIN

Before Tom Every, a.k.a. Dr. Evermor, departed this world for the heavens in his wrought-iron starship, he gave me a tour. He woke from his slumber in the bus from "Tommy Bartlett's Thrill Show" and told me how his job as an industrial wrecker gave him materials to make new worlds. He designed the carousel at House on the Rock. "I was there from 1964 to 1982. I went to Michigan to pick up the carousel and brought it back to make it the world's largest. I also built many of the fantasy rooms," he remembered. "I was always a friend of Alex Jordan, then a horse went through his windshield."

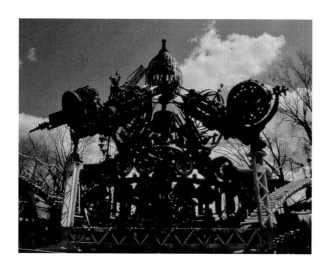

Tom Every's masterpiece, however, is the Forevertron that would someday propel him to outer space and doubles as the largest scrap metal sculpture in the world. He pointed to what looked like two telescopes and told me, "Two people can sit there in the 'Celestial Listening Ears' and listen for alien voices from the heavens and beyond. Information will then be relayed to the 'Overlord Control Center.'"

← → "If it could be, why not make it be?" Dr. Evermor asked me as we walked around his enormous electro-magnetic space station he was building to propel himself to the heavens.

"See that? That's the 'Gravitron' where the good doctor"—he often referred to his alter ego in the third person—"will de-water himself to reduce his weight before blast off. Almost all of human weight is water, so this will make the blast off easier." The pod-like Gravitron has electrical gizmos—from transformers to dynamos built by Thomas Edison—sticking out in every direction. "Then the doctor will walk down that spiral staircase, go over the bridge, and step into the copper egg inside the glass ball before being shot into space," he said as if his techno garble made any sense at all.

Dr. Evermor described the scene of the much anticipated day of the take-off: "A hum buzzes through the air, all the lightning rises, and the doctor climbs into his pod. The lights go from red to amber to green. They pull all the switches. The good doctor in his trans-temporal copper egg chamber shoots out on his magnetic lightning force beam. All the non-believers and doubting Thomases are drinking tea. It's a very happy day and everyone in the band begins playing. Everything is built for that great day." Dr. Evermore blasted off in 2020 and is now somewhere floating in his tin can.

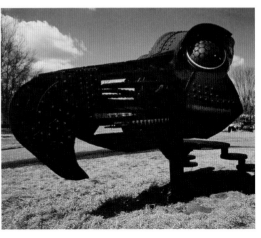

Dr. Evermor's creation derives partly from the mentality of turn-of-the-twentieth-century explorers and partly from mad scientists, like Captain Nemo meets Nikola Tesla. "If you like Jules Verne, you'll love talking to me about the possibility of what could be."

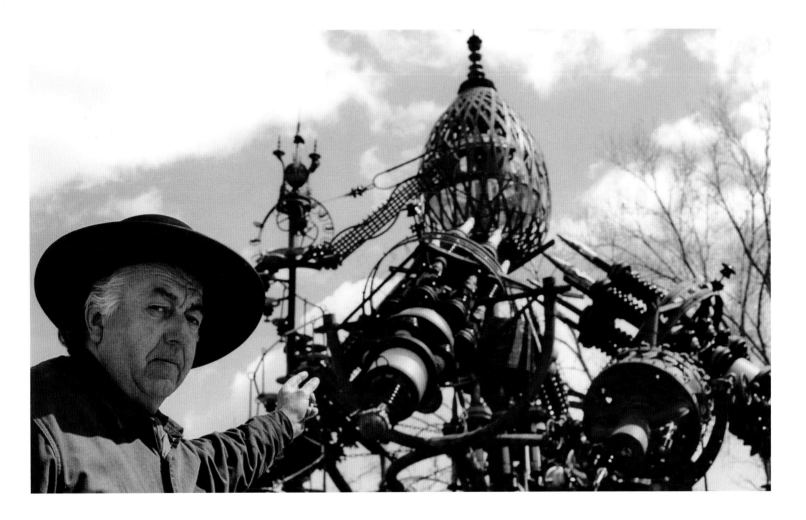

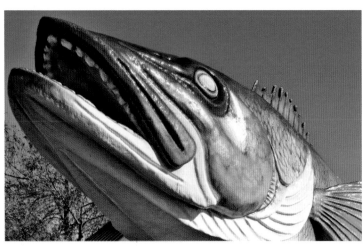

← ↑ Both Isle (left) and Garrison (above), Minnesota, on either side of Lake Mille Lacs declared themselves the "Walleye Capital of the World," even if Baudette, Minnesota, has officially trademarked this title. The question remains: How does a town prove it's the capital, apart from notarized paperwork? Maybe it's time for a fish-off!

MINNESOTA

SOMETHING'S FISHY

NORTHWOODS FISHING TOWNS

While Wisconsin clearly has the biggest fish statue in the world (in Hayward), Minnesota boasts more statues and fish festivals with its famous 10,000 lakes. Still, the battle for "world's largest" and "capital of the world" is fought vigorously, and the folks at Guinness haven't bothered to pull out the measuring tape. In the meantime, towns across the country can recklessly pronounce their bold claims with little oversight, and no one can control the imposters.

The Minnesota Congress stepped up to declare the walleye as the state fish by a tally of 128 to 1. Was that lone vote cast by some spoilsport for the bullhead? Soon after, the town of Garrison on Lake Mille Lacs nominated itself Walleye Capital of the World. Not so fast, warned Baudette, Minnesota, with its famous walleye fishing grounds of Lake of the Woods along the Canadian border. Research revealed that many towns brashly defied the truth and laid their claim as walleye capitals.

In 2007, Baudette challenged all these usurpers to the throne and tried to trademark the title Walleye Capital of the World. Incredibly, the state of Minnesota played favorites and awarded Baudette the trademark to use for ten years. The town didn't stop there but waded through stacks of documents to file its claim with the U.S. Patent and Trademark Office. The fishing bullies in Baudette now had "the right to tell other towns to back off. Indeed, it would give the bureau the right to sue in federal court to prevent unauthorized use of the trademark," according the *Star Tribune* newspaper.

I asked the Lake of the Woods Tourism Bureau about this official recognition and if they would really take these other walleye capitals to court? "Well, probably not, but we could!"

Baudette, Minnesota's Willie the Walleye, not to be confused with Wally the Walleye, weighs in at 9,500 pounds (4,309 kg) and measures 40 feet (12 m) long; it's just another fish out of Lake of the Woods. This town's application to be the trademarked "Walleye Capital of the World" has been approved. According to the *StarTribune* newspaper, Gregg Hennum of the Lake of the Woods Tourism Bureau humorlessly warned other towns about their claim to the title: "We don't want to create any enemies. But it's business."

➡ Most fish are permanently mounted, but Preston, Minnesota, opted to keep its trout on a trailer to appear at neighboring festivals and let them know where the biggest fish hide. ➡

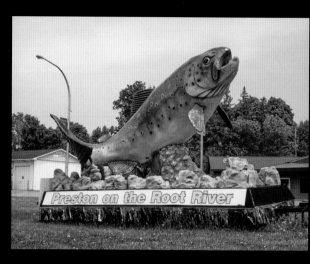

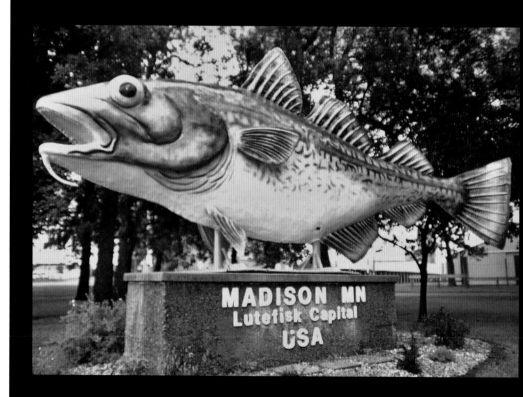

⬆ No Atlantic cod can be found in Minnesota lakes, but that didn't stop the town of Madison from erecting its 25-foot (7.6 m) fish aptly named Lou T. Fisk to warn the world that they eat more lutefisk (cured salt cod in lye) than any other town in the world. The world's record holders for professional lutefisk eaters also hail from Madison with a stomach-turning 8 pounds (3.6 kg) of the slimy fish in one sitting.

➡ One of the perennially endangered roadside attractions is the Big Fish along Highway 2 in northern Minnesota. Fast food restaurants deemed the town of Bena too small for a franchise, so residents built their own with a little drive-up window along the side for a tasty fishburger.

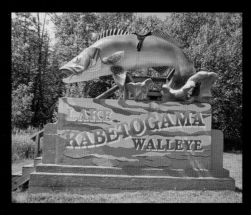

⬅ Rather than posting signs warning insistent visitors to stay off the fish, Lake Kabetogama along the Canadian border put a saddle on its 16-foot (4.8 m) concrete walleye so tourists can hop on top of the fish to pose for a snapshot to show all their friends back home how truly extraordinary the fishing is up north.

Try to get the kids to swim after they see the teeth on this walleye on the shores of Ottertail Lake in central Minnesota.

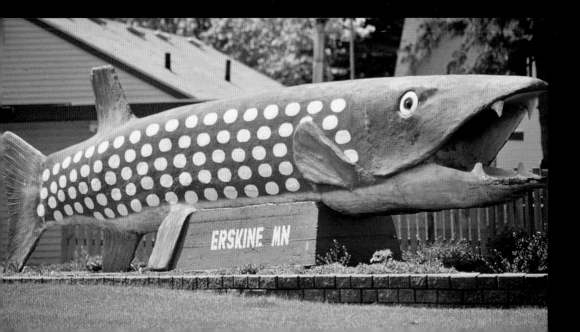

⬅ Overlooking a sandy beach on pristine Cameron Lake, this menacing pike wishes it could sink its teeth into tasty swimmers splashing in Erskine, Minnesota.

**FISHING HALL
OF FAME MUSKIE**
HAYWARD, WI
145 ft. (44.2 m)

TIPPING THE SCALES

BIG FISH
BENA, MN
65 ft. (19.8 m)

WILLIE THE WALLEYE
BAUDETTE, MN
40 ft. (12.2 m)

TIGER MUSKIE
NEVIS, MN
30 ft. (9.1 m)

WALLY WALLEYE
GARRISON, ND
26 ft. (7.9 m)

LOU T. FISK
MADISON, MN
25 ft. (7.6 m)

CAMERON LAKE PIKE
ERSKINE, MN
20 ft. (6.1 m)

RIDEABLE WALLEYE
KABETOGAMA, MN
16 ft. (4.8 m)

MINNESOTA

IT'S NOT EASY BEING GREEN

THE JOLLY GREEN GIANT OF BLUE EARTH, MINNESOTA

To commemorate connecting the country by rail in 1869, a golden spike was ceremoniously hammered into the railway—and immediately removed because who would leave 3 pounds (1.3 kg) of solid gold?

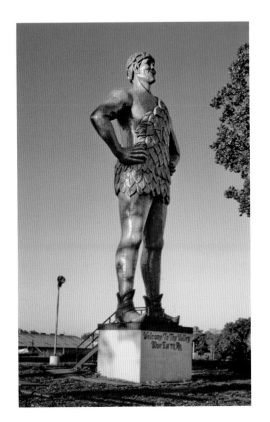

When Eisenhower's dream of paving America came true, Interstate 90 would connect the coasts and the final patch would be laid in Blue Earth, Minnesota. A golden spike didn't make much sense, so a strip of concrete at the rest stop west of town was painted gold.

The world yawned, but then a local radio DJ had a better idea than some yellowish pavement. He took to the airwaves to preach his vision and soon raised enough cash to pay Creative Displays (now F.A.S.T.) of Sparta, Wisconsin, to build the Jolly Green Giant at a thousand dollars a foot. The 55.5-foot (17 m), $55,000 colossus was completed in a mere eight weeks and trucked down I-90 to town. To mark the event, Minnesota's governor, Miss Minnesota, and Miss America were on hand to witness the installation of the giant by Creative Displays and the joining of the east and west coasts in Blue Earth.

← Despite the Jolly Green Giant's eternal four-foot smile, he's sad deep down. He hides his melancholy with a hearty "Ho, ho, ho," but he misses his sidekick Sprout. The 3-foot (1 m)-tall Sprout was abducted, beheaded, and hung from the interstate overpass by ruffians from neighboring Fairmount.

IF YOU BUILD IT WILL THEY COME?

ENCHANTED HIGHWAY NEAR REGENT, NORTH DAKOTA

Often when someone *tries* to make a roadside attraction, the attempt is vain, attention seeking, and tedious. Somehow, sculptor Gary Greff managed to self-consciously create a whole byway of sites along the Enchanted Highway that are creative, thought-provoking, and, well, funny. Mostly it's impressive that his sculptures have been able to withstand the vicious winds and winter of the North Dakota plains.

Most motorists notice the enormous Geese in Flight along I-94, which put Greff in the *Guinness Book of Records* with The World's Largest Scrap Metal Sculpture—apparently in conflict with Dr. Evermor's Forevertron. To create this gaggle of geese, Greff told me: "We used over twelve oil well tankers and five miles of weld. The National Guard was even called out for two weeks to help out!"

Greff explained his vision: "I started with the idea of how to keep this small town alive. At one time, maybe in the 1940s, close to six hundred people lived in Regent. Now it's down to two hundred. Farming has dwindled to fewer people with bigger farms. We had to figure out a way to bring people from the interstate," Greff

remembered. Clearly, giant sculptures were the answer. "It's our only chance of survival."

Easily the most original of Greff's sculptures is the 75-foot (23 m)-tall Tin Family—likely a spoof of *American Gothic*. Tin Ma, Pa, and Junior sport 10-foot (3 m) grins with drill bits hanging down as icicle earrings off the metal mother. The corn-fed teenager licks a lollipop as a propeller spins atop his hat. Father farmer clutches a giant pitchfork that could stab a truck.

The message of the medium is the machinery left behind to rust or be recycled as art. Abandoned oil drums are welded together for arms, feeding troughs jut out for feet, and huge hubcaps give a deer-in-the-headlights gaze

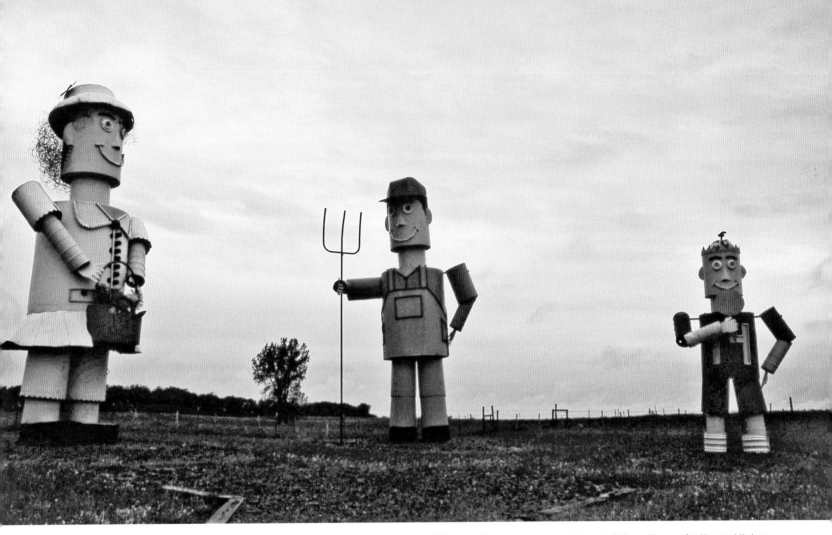

⬆ Sculptor Gary Greff proclaimed his artistic vision to me: "People are not going to come off the road for normal-sized sculpture, but they will come for the world's largest." The World's Largest Tin Family from 1991 is no exception. As his first piece along the Enchanted Highway, it's perhaps the most charming of all his sculptures with the obligatory pitchfork to reference Grant Wood's *American Gothic*, although Greff's family is all smiles.

to the eyes. Just as Michelangelo went to the quarries of Carrara to choose his marble, Greff revealed, "Mostly, I go to junkyards and find a bunch of old oil well tanks." Then he goes a step further, "I drive over them with a tractor to flatten them out."

Greff is modest about his masterpieces. "I didn't have no art classes. I just had a dream and a vision and said, 'Well, the only way you'll learn is by doing it.' Some people call it 'pop art,' but I prefer 'folk art' because I'm just taking a picture of something or a model and there's no way I can do anything different. I just make it bigger."

⬆ "A photo doesn't show how big these sculptures are," sculptor Gary Greff said about his work along the Enchanted Highway in North Dakota. His *Geese in Flight* has been crowned the World's Largest Scrap Metal Sculpture by Guinness, towering 110 feet (33.5 m) tall and 150 feet (45.7 m) wide. "You don't understand until you stand right underneath and look up and say, 'That's one big piece of metal up there!'"

BIG BOVINE TOUR OF NORTH DAKOTA

WORLD'S LARGEST BUFFALO IN JAMESTOWN AND HOLSTEIN IN NEW SALEM, NORTH DAKOTA

West along the seemingly endless stretch of Interstate 94 in North Dakota, two landmarks break the horizon and are visible for miles. Jamestown's World's Largest Buffalo weighs in at 60 tons (54 Mg) to make all the buffalo fenced in around it look like Lilliputians to Gulliver ready to stomp on them. Next to the beast is the National Buffalo Museum featuring a 10,000-year-old bison skull and a little frontier village complete with Louis L'Amour's writing shack. The cowboy author had stints as an elephant handler, seaman, and boxer and wrote his 117 westerns in this little hut.

A bit more exciting perhaps was the birth of a divine white buffalo, Mahpiya Ska (White Cloud), in the nearby town of Michigan, North Dakota, in the 1990s. According to local Lakota legends, the White Buffalo Calf Woman could change her shape and color, but generally returned to her form as a sacred white buffalo.

The giant buffalo statue was never treated with as much respect as the sacred white buffalo. Teenagers have practiced their batting skills on the poor beast with a Louisville Slugger and locals told me that a gaggle of college girls even performed hazing rituals on the poor immovable beast.

Further down the Interstate stands Salem Sue, the 38-foot (38.5 m)-long Holstein in New Salem. She has earned much more respect and was a muse for a local songsmith to compose "The Ballad of Salem Sue":

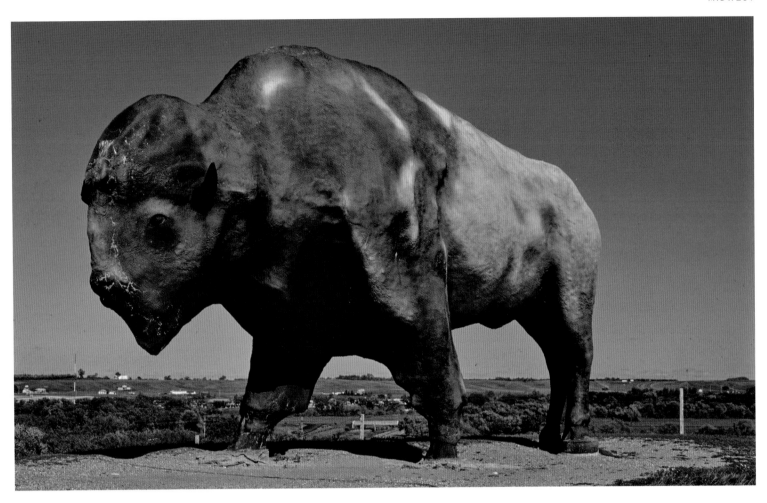

Her presence shows that New Salem grows
With milk-producers' yields;
We've got the cow, world's largest cow
That looks across our fields.

Holstein cows vastly increased dairy production across the area, perhaps out of fear of the wrath of Salem Sue if she were unmoored from her cement overshoes. Milk production broke all records and the town cashed in. To praise their productive bovines, New Salemites had hired F.A.S.T. (Fiberglass Animals, Shapes & Trademarks) of Sparta, Wisconsin, to build the largest bovine in the world. In 1974, the poor cow was still sliced in three as she was shipped more than 500 miles (804 km) to her new home in the Great Plains. The town has rallied with bovine pride around its symbol and even named the football team the Holsteins.

⬆ Standing 46 feet (14 m) long and 26 feet (8 m) tall, the World's Largest Buffalo in Jamestown, North Dakota overshadows the other live buffalo below who are "allowed to roam freely in the pasture as their heritage would dictate," except for those fences, of course.

⬇ Visible for more than five miles (8 km) in either direction, Salem Sue welcomes thousands of visitors each year who had been lulled to sleep by the endless flat prairie along I-94 around New Salem, only to be startled awake by the divine vision of the World's Largest Holstein.

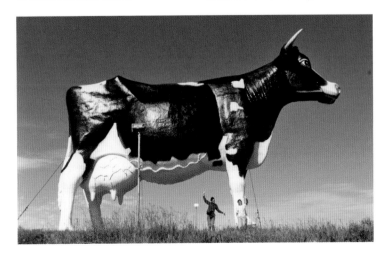

SOUTH
DAKOTA

WORLD'S BIGGEST BIRDFEEDER

CORN PALACE IN MITCHELL, SOUTH DAKOTA

The town of Mitchell did not want to be forgotten. To promote Mitchell to the world, residents called up brassy John Philip Sousa to book him for their annual Corn Festival. When he saw the dirt road that was Main Street, Sousa refused to get off the train until he was paid cash up front. He bumped up the standard cost of a concert to the hefty sum of $7,000. Amazingly, Mitchell agreed. The festival organizers coughed up the cash and the show went on. Sousa became so fond of Mitchell that he gave an additional concert every day and returned for an encore a few years later.

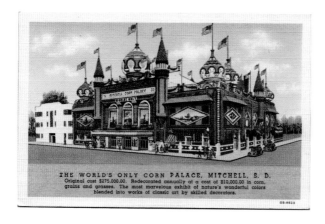

THE WORLD'S ONLY CORN PALACE, MITCHELL, S. D.
Original cost $275,000.00. Redecorated annually at a cost of $10,000.00 in corn, grains and grasses. The most marvelous exhibit of nature's wonderful colors blended into works of classic art by skilled decorators.

Although the town of Plankinton, just west of Mitchell, had already made a Grain Palace to show off its bumper crop of wheat in 1890, Mitchell far outperformed with its magnificent Corn Palace in 1892 with mosaics of corn on all sides, a large tower in the middle, and little turrets on each side.

After the Sousa visit, notable personalities began to notice as a more fabulous palace took its place every year. Mr. Champagne Music, Lawrence Welk, traveled south from his home in Strasburg, North Dakota, to lead his orchestra at The Taj Mahal of the Great Plains.

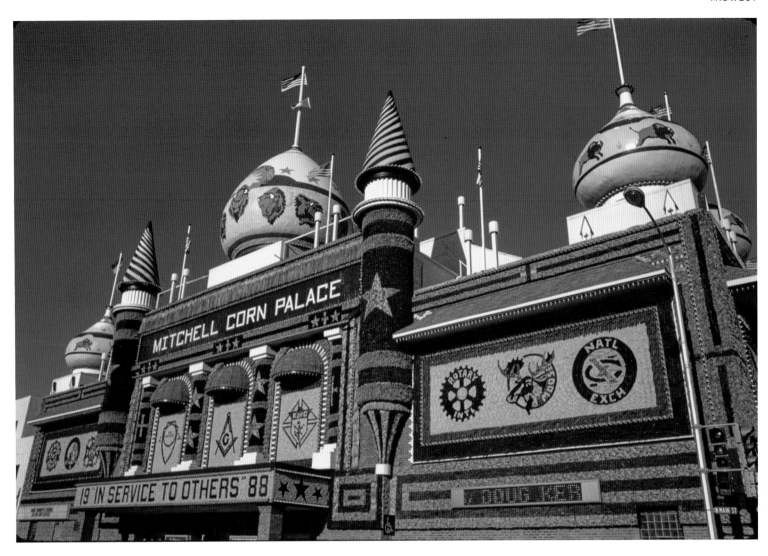

Other towns soon tried to jump on Mitchell's bandwagon. Thief River Falls made its own corn palace in 1937 and crowned a Corn Queen. This was after that northwestern Minnesotan town had made an enormous Arc de Triomphe out of its alfalfa crop thirteen years earlier.

Mitchell is the town that persisted, however, and its "ear-chitecture" and corny jokes are everywhere. The high school sports teams are dubbed "The Kernels" and even the call letters of the local radio station are KORN. All the festivities come to an end after the annual redecorating of the Corn Palace as scurries of squirrels and flocks of birds swoop in to steal the art work and fatten up for another long northern winter.

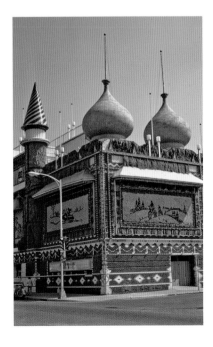

◄ ⬆ Multi-colored onion domes rise above the plains in Mitchell, South Dakota, looking like the Saint Basil's Cathedral towering over Red Square. No! This is a monument to corn, and any reference to Mother Russia is conveniently side-stepped by proclaiming the top of the towers as "Moorish" domes.

JURASSIC JUNGLE GYMS

DINOSAUR PARK IN RAPID CITY; WALL DRUG IN WALL; MAMMOTH SITE IN HOT SPRINGS, SOUTH DAKOTA; AND BADLANDS DINOSAUR MUSEUM IN DICKINSON, NORTH DAKOTA

Of all the dinosaur statues across the Dakotas, the classics sit atop a hill overlooking Rapid City. During the depths of the Great Depression, President Franklin D. Roosevelt calculated that rather than sending out checks for people to twiddle their collective thumbs, he should put them to work as part of the New Deal. The Works Progress Administration (WPA) employed thousands in the 1930s to make bridges, parks, and, well, dinosaurs.

Conservative critics assailed this quasi-socialist program, but who could deny that giant prehistoric lizards watching over the Black Hills weren't super cool? Yes, enormous dinosaurs may seem extravagant and hardly essential, but these Miocene-era fossils have become a symbol of the city and the adjacent Badlands. Tyranno-saurus Rex squares off with Triceratops (South Dakota's

➡ Be lured to Wall Drug by the 80-foot (24 m) dinosaur and discover other extraordinary animals such as the "CamelIce," a cross breed between elks and camels and jackalopes, an extraordinary chimera of jackrabbit, antelope, and sometimes pheasant with a hankering for whiskey. Oh, it's also a drug store, I think . . .

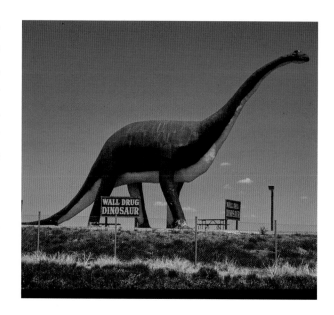

official fossil); a duck-billed Anatotitan and spiky Stegosaurus quietly graze on ferns; and an Apatosaurus (formerly Brontosaurus), towers over the whole scene.

Seeing the success of Rapid City's Dinosaur Park, Wall Drug hired the sculptor Emmet Sullivan who erected the dinosaurs (and the 65-foot [20 m]-high Christ of the Ozarks, and who worked on Mount Rushmore) to build an even bigger 80-foot (24.4 m)-tall Apatosaurus along I-90. Of course Wall Drug was already famous for … well, mostly for being famous. The drug store's brilliant scheme consisted first of offering free ice water, then mesmerizing motorists with endless billboards of "Have you dug Wall Drug?" all over the world and especially on the vacant prairie leading inevitably to kids screaming for parents to stop.

Although hailing from the Pleistocene period and not the Jurassic, extinct elephants made an appearance in the area too. A whole herd of woolly and Columbian mammoths got stuck in a sinkhole only to be unearthed 26,000 years later at the Mammoth Site in Hot Springs. Apart from the Badlands Dinosaur Museum in Dickinson, North Dakota, the Mammoth Site is the best prehistoric "in situ" open dig that shows the paleontologists busy dusting off these ancient bones to uncover the fuzzy beasts who laid down to die once they were trapped in a "spring-fed sinkhole." For travelers heading to the ruins of the nearby Flintstones' Bedrock City, no early homo sapiens or other missing links have been unearthed so far.

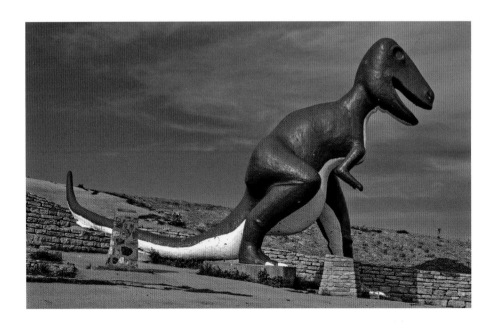

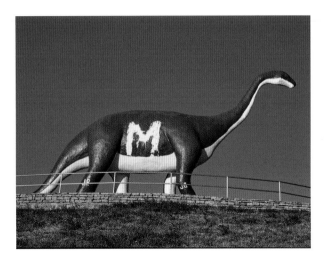

← ↑ Franklin Roosevelt commissioned artists and writers through the Works Progress Administration and New Deal with low wages to chronicle and improve the country's heritage. They also made giant dinosaurs for a Depression-era amusement park in the Black Hills and provided a mountaintop playground for toddlers for generations in Rapid City.

→ Thanks to suburban tract housing slated to be built in Hot Springs, South Dakota, in 1974, nearly a hundred woolly and Columbian mammoths were discovered underfoot, and wannabe paleontologists can see the dig in action. Still, the best photo op is the giant fiberglass replica trumpeting at the entrance.

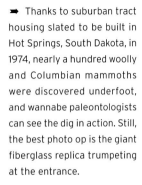

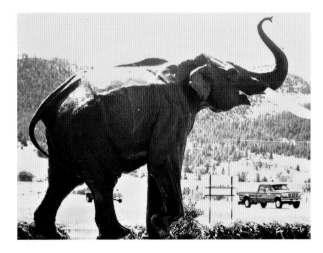

NEBRASKA

THE COUNCIL OF THE DRUIDS AT CARHENGE

CARHENGE IN ALLIANCE, NEBRASKA

No need to haul 20-foot (6 m)-tall sarsen stones from quarries across England, figured Jim Reinders, since large American automobiles fit the bill almost perfectly. Besides, the local junkyard had many discarded cars he could stack on his land in Alliance, Nebraska, to make an accurate replica of the famous monoliths on the Salisbury Plain in England. The stark Nebraska prairie proved perfect for his distinctly American vision of a proudly British landmark.

In fact, Reinders initially included a 1979 Honda and a couple other Japanese cars, but those have since been patriotically destroyed and replaced by pure, wrecked Americana.

Locals wanted to rip down Carhenge, fence it off, and have the Nebraska Department of Transportation official designate it a junk pile. Then the accolades arrived from car enthusiasts and roadtrippers who never would have ventured to western Nebraska if it hadn't been for this pagan shrine to petroleum guzzlers. The cars were spruced up with a standard gray to match its English counterpart, and modern druids hail the solstice from this sacred/sacrilegious spot. Not only that but imitators of this imitation have sprung up across the country with Foamhenge in Centreville, Virginia; Boathenge in Easley, Missouri (with only six boats); Truckhenge on the edge of Topeka, Kansas; and Limohenge in Lamont, Alberta. They all pale in comparison to this original copy.

◄ Slated to be destroyed by artistic purists, Carhenge succeeded in charming Nebraskans and has become a symbol of the western prairies and bizarre American ingenuity in Alliance, Nebraska.

The Pioneer Village continues to grow (now at twenty-eight buildings) and expand with ever-more items from a collection of cash registers to 144 Barbie dolls. Stay for many dizzying days to see it all.

2 Mi. on US 6

THE HAROLD WARP

PIONEER VILLAGE

MINDEN NEB.

30,000 ITEMS
—IN—
24 BUILDINGS
—ON—
20 ACRES

FROM SOD HOUSE DWELLER TO PLASTIC TYCOON

HAROLD WARP'S PIONEER VILLAGE IN MINDEN, NEBRASKA

Harold Warp was born in 1903 on the Nebraska prairie to Norwegian immigrants who struggled to eke out a better life on this fertile land rather than the rocky fjords. His father died when he was three and his mother when he turned eleven. He was the youngest of twelve kids, so his future looked bleak.

The family lived in a sod house on the wind-swept prairie, so no wonder he wanted windows after living those long dark winters hibernating in the earth. He and couple of his brothers moved to Chicago and invented "Flex-O-Glass" plastic window covering for greenhouses that Warp had used to cover the chicken coops from the elements. Soon "Flex-O-Bags" and "Plast-O-Mats" followed and Warp was a millionaire.

Rather than dump his money into luxury, Warp preserved the past by buying up the old buildings in his hometown and created a historical town to never forget those memories. He collected 50,000 items scattered over 28 buildings, including a Pony Express Station, a one-room schoolhouse, and exhibit halls to display collections that announce to the rest of us that he has it all.

Because of his rags-to-riches story, Warp believed in the persistent march of progress as he chronicled in his book *A History of Man's Progress*, even as his whole museum is a nostalgic trip down memory lane.

TWINE BALL BATTLE!

NEARLY THE WORLD'S LARGEST TWINE BALL IN CAWKER, KANSAS

Frank Stoeber of Cawker, Kansas, browsed through the *Guinness Book of Records* and noticed the infamous photo of Francis Johnson with his 12-foot (3.7 m) ball of twine. Frank knew he could do Francis one better, so he began to collect string. Stoeber wound and wound 1.6 million feet (487 km) of baler twine night and day. Victory was in sight as his ball reached 11 feet in diameter. If he spun just one more foot of twine around his ball, Stoeber could ring up Guinness to take his rightful place in the annals of history. Tragically on the eve of his glory, Stoeber had a heart attack and died in 1974. Rather than letting this tragedy end in defeat, Cawker, Kansas, rallied for an annual Twine-A-Thon festival to add more string to the ball in tribute to Frank. The twine ball was placed on Cawker's Main Street under a little shelter for all to admire the collective handiwork.

In Darwin, Minnesota, where Francis Johnson had rolled his original ball, folks had not been so sure about being thrown in the limelight for this stringed oddity alongside the man with the beard of bees and the guy from India with the longest fingernails. Johnson was an obsessed collector of anything he could get his hands on (five thousand pencils, two hundred feed caps, buckets, padlocks, pliers, etc.), but his secret twine ball project soon outgrew his house. He dedicated four hours a day to winding the string and eventually hoisted the ball with a railroad winch to achieve a more perfectly smooth wrapping job.

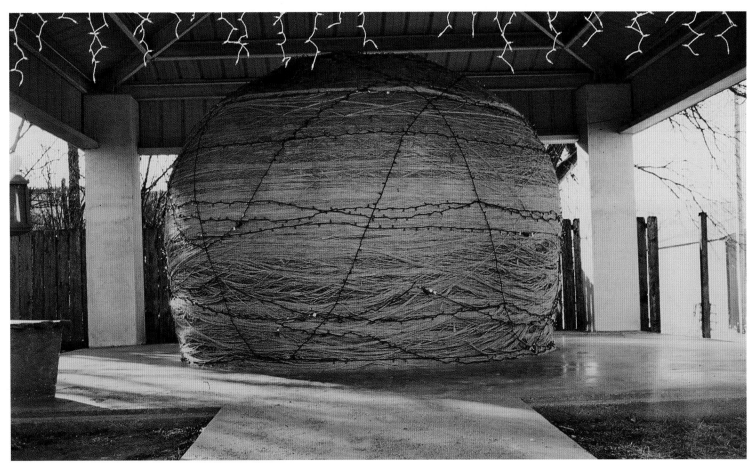

⬆ The community of Cawker, Kansas, came together to realize the vision of local eccentric Frank Stoeber in his wish to complete the World's Largest Ball of Twine after his dream was cut short by a tragic heart attack.

⬆ Competition for the dubious title of World's Largest Ball of Twine inspired residents of Darwin, Minnesota, to raise flags along the light poles for Twine Ball Days and construct a plexiglass silo to protect the sacred site. Special permission is required to breach the twine ball reliquary and lay hands on the famous ball. Just don't inhale the mildewy fumes of the hallowed artifact.

When Johnson passed on to twine ball heaven in 1989, he had spent twenty-nine years of his life spinning twine. A representative from *Ripley's Believe It or Not* paid the town of Darwin a visit to buy the ball to display next to its gallery of the grotesque and unusual in Branson, Missouri. Suddenly, the proud residents of Darwin united around the ball and refused Ripley's. Undaunted, Ripley's turned to a Texan, J. P. Payne from Mountain Springs, to surpass all balls. "They took us out of *Guinness*!" lamented the clerk at the Twine Ball Souvenir Shack in Darwin when the 13-foot, 2-inch (4 m) ball from Texas debuted in Branson. Darwin changed its claim to "World's Largest Ball of Twine Wound by One Person." Still, the competition keeps the balls in the media and another competitor is fast approaching in Lake Nebagamon, Wisconsin.

WHAT'S BURIED IN YOUR BACKYARD?

THE GARDEN OF EDEN IN LUCAS, KANSAS

After serving in the Civil War, Samuel Dinsmoor returned home a changed man. As a nurse in the Civil War, he had seen the appalling slaughter and questioned his strict religious upbringing. Back in Ohio, the radical free thinkers helped shape Dinsmoor's deistic philosophy and he moved west to be free of societal constraints. In Illinois, he was married on horseback to a widow with two children, and they settled in Lucas, Kansas, with a mission. He had five children with her in their quaint little residential house, which he envisioned as a canvas for his patriotic, populist visions for the country. At the age of sixty-four, Dinsmoor got to work.

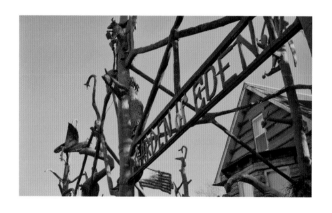

Lots of wood, loads of limestone, and 113 tons (102 MT) of cement produced a Garden of Eden with Adam and Eve. Dinsmoor told squeamish visitors that he was the model for Adam's remarkable genitalia. In his garden of sculptures, monkeys hang from 40-foot (12 m) trees, Jesus is crucified as "Labor," and an evil capitalistic octopus extends its monopolistic tentacles for world domination.

When his wife died, he couldn't live without her, so he dug up her body and lovingly placed it in a mausoleum

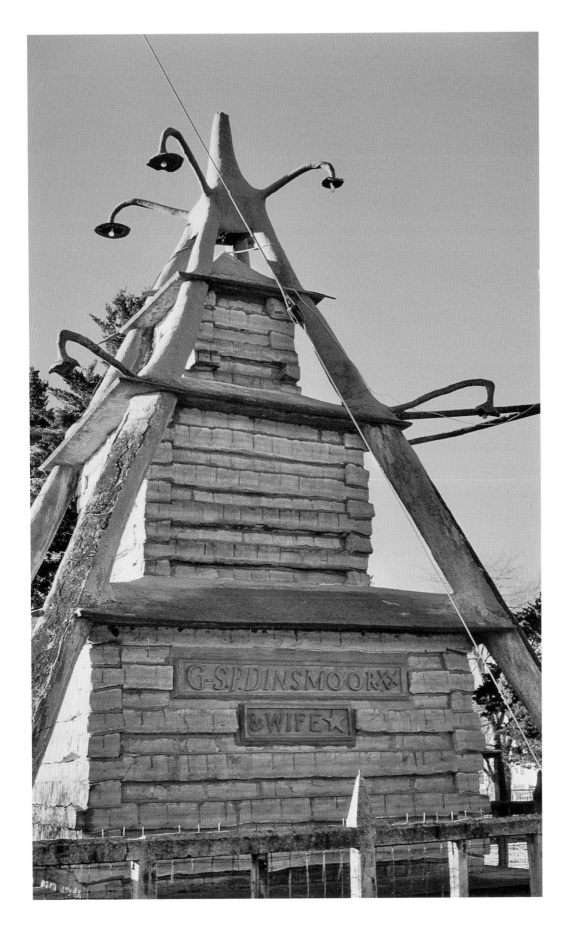

alongside the house. He prepared his own final resting place near her. While he was still alive, he would pose for two bits in his coffin for photo-happy tourists. Soon he became part of his sculpture garden, as his embalmed corpse was laid to rest in the mausoleum right above his wife's. Visitors can still peek at Dinsmoor's face and understand it's not easy being green.

← Who's buried in Dinsmoor's tomb? Not just him, but his wife right underneath him. Step up and take a peek of his greenish corpse through the window.

↓ At the Garden of Eden in Lucas, Kansas, a young woman follows a soldier, but big business has her in its tentacles. The American flag above seems patriotic, but Dinsmoor wrote, "The flag protects capital today better than it does humanity." This was in the 1920s.

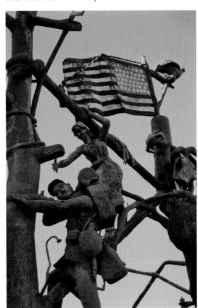

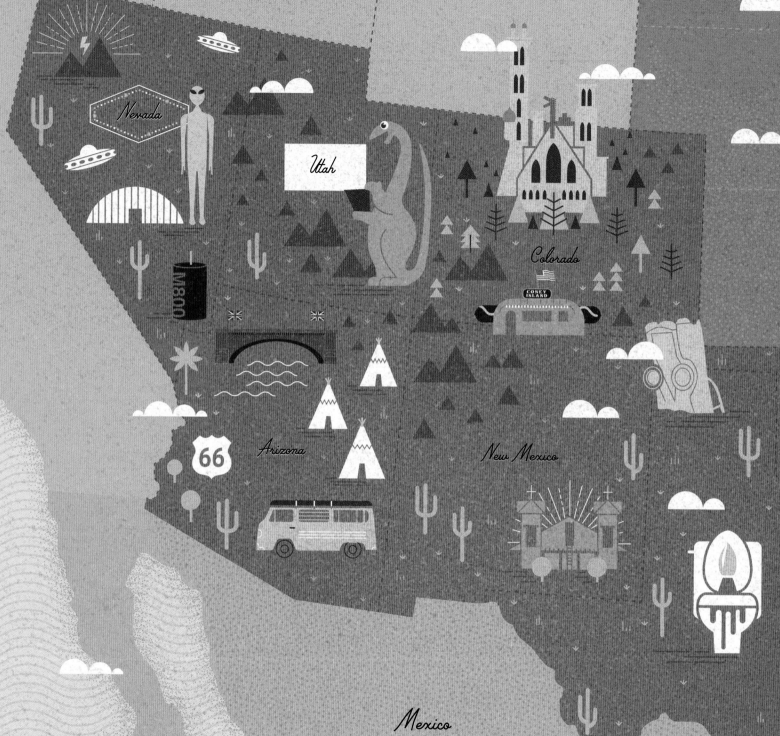

Nevada

Utah

Colorado

Arizona

New Mexico

Mexico

Pacific Ocean

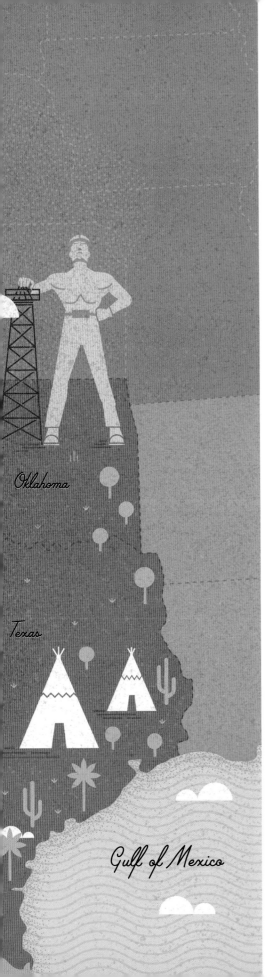

Oklahoma

Texas

Gulf of Mexico

SOHWEST

SOUTHWEST

Perhaps there's something in the water in the Southwest. What else could explain the alien invasions in Area 51, long-finned Cadillacs jutting up from the ground, and a museum of toilet seats? People dig in the dirt and declare it holy or excavate entire houses into the sides of cliffs. London Bridge was moved from London and put over a dry creek bed in the desert. A river was diverted, so water now flows underneath to make it an authentic bridge.

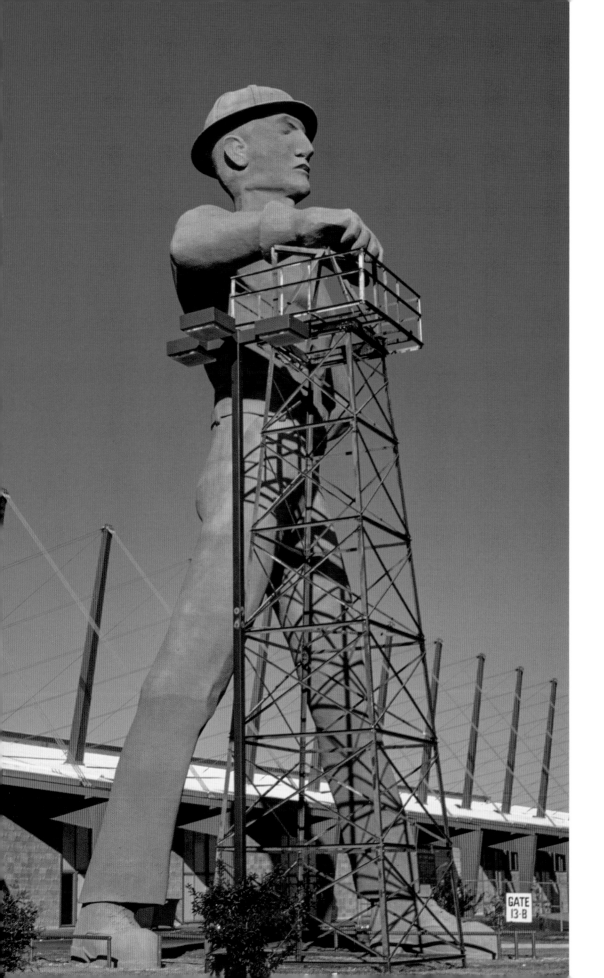

GATE
13-B

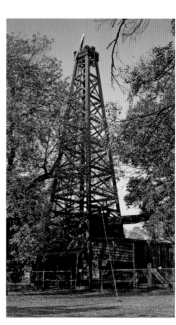

⬆ The first successful oil well in Oklahoma struck black gold in Bartlesville in 1897. The oil well, called Nellie Johnstone No. 1, produced up to seventy-five barrels a day. One winter, oil seeped out over the frozen river nearby. As the story goes, kids skating on the icy river started a fire to stay warm and the flames followed the oil spill all the way back to the source.

⬅ 43,500 pounds (20 MT) of cement were used to make the Golden Driller for the International Petroleum Exposition in 1953.

OKLAHOMA

MIDAS'S FAUSTIAN BARGAIN

GOLDEN DRILLER STATUE IN TULSA, OKLAHOMA

Right in the heart of tornado alley, a 76-foot (23 m)-tall monument to fossil fuels has withstood the worst. This statue of an oil driller still looks down on his drilling rig, which conveniently holds up his 3,000-pound (1,360 kg) arm. Of course with the vast amount of wealth from petroleum comes unbearable hardship. Like a giant King Midas who accidentally turned himself into gold from the fantastic oil money, the Golden Driller is petrified and forced to forever drill for oil until the skies turn black.

Oklahoma's oily past began when Congress passed the Indian Removal Act in 1830 and pushed 60,000 Native Americans into the newly formed "Indian Territory" in 1834. Thousands died along the way and in this harsh new terrain, which wouldn't become the state of Oklahoma until 1907.

When oil was discovered in 1897, this once forsaken land had new value. The Native Americans got their due when negotiating rights to drill with oil companies in the 1920s. The Osage Nation was sitting atop billions of barrels of oil, and bargaining was left to its leader Chief Star-That-Travels. With the help of Colonel (his first name, not his title) Walters, Star-That-Travels succeeded in landing $157 million for the tribe—in 1928 dollars. A statue marks the spot in remembrance of the millions of dollars that flowed through Skedee, Oklahoma. Today most of the buildings are abandoned, only fifty people still live there, and Skedee is considered a ghost town.

Another man who struck it big here was John Paul Getty, who secured oil leases in Tulsa in 1915 and became the richest man in the world. This wealth also made him a target and his grandson, John Paul Getty III, was kidnapped in Rome by the 'Ndrangheta mafia. The oil tycoon eventually paid the $2.2 million ransom after receiving his grandson's ear in the mail.

TEXAS

BOTTICELLI OF THE BATHROOM

TOILET SEAT MUSEUM IN DALLAS, TEXAS

I had heard about Barney Smith's obsession with painting discarded toilet seats and tracked down the address for his museum. Something seemed wrong. The quiet residential area of San Antonio was hardly a natural for tongue-in-cheek toilet humor, but there he was busy painting out in his driveway on a cool Texas evening. His garage door was wide open with toilet seat hall of fame proudly displayed.

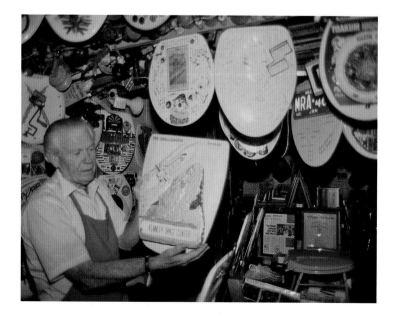

At the time, Smith was in his eighties but hardly retired from his passion of painting. His wife Velma was inside with the volume on her TV blasted. "All she wants to do in the evening is watch television, but I can't do that." He pointed around to all his painted toilet seats and told me, "Imagine my life if I just watched TV. I couldn't have done any of this!"

When I asked if he was truly the "Rembrandt of the restroom," he scoffed and said that anyone could do what he's done. He just wanted something for a canvas. "After I painted my first toilet seat, people kept giving me

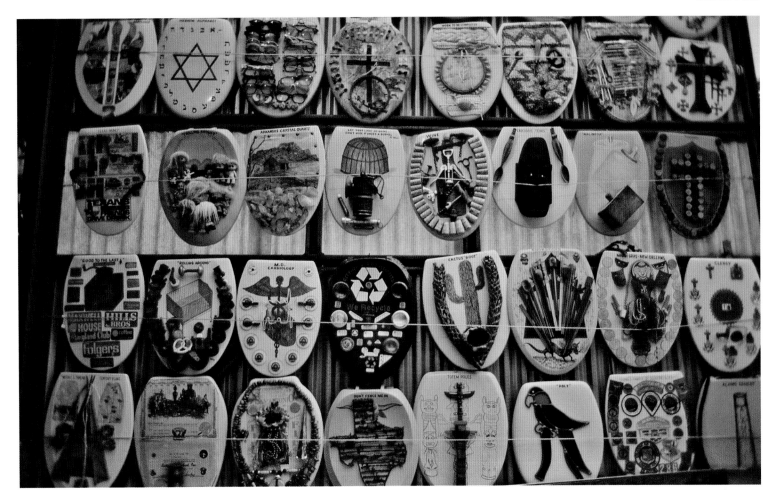

Barney Smith worked diligently painting toilet seat covers (never the rim) in his suburban San Antonio driveway/museum. From Texas barbed wire seats to collages of Pez candy dispensers glued to lids, Smith's collection was too large to fit in its entirety in its new home north of Dallas.

more toilet seats when they remodeled their bathrooms." His collection of 1,400 toilet seats includes a memorial to the exploded Challenger Space Shuttle complete with a section of charred insulation. "None of this is for sale,"

he warned, assuming I was about to make an offer. He clearly enjoyed showing visitors his potty jokes and didn't mind a distraction from his artwork to give us the grand tour. His wife called for him to come inside, but he kept painting a while longer as the sun set in the distance. Not a bad way to retire.

Smith passed away at ninety-eight years old, but not before he passed on his entire collection to a permanent site just north of Dallas at the Truck Yard, a classy outdoor beer garden with a shrine to Smith's commodes. Look overhead and notice Michelangelo's God handing Adam the very first roll of toilet paper.

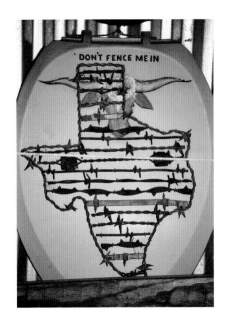

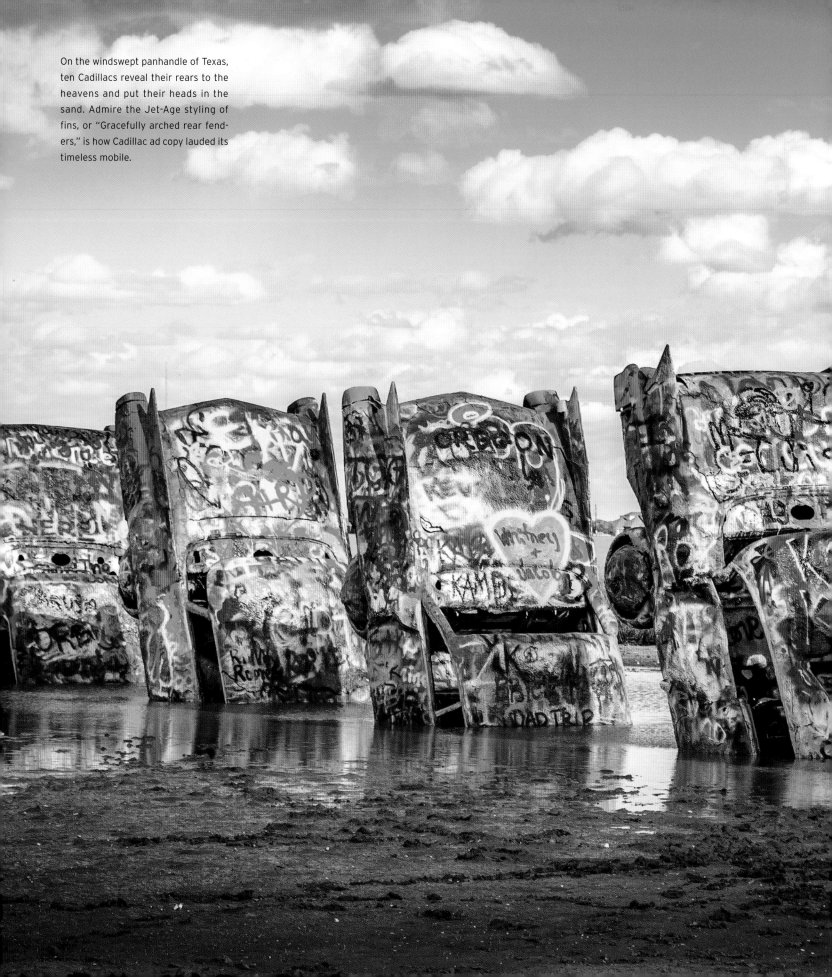

On the windswept panhandle of Texas, ten Cadillacs reveal their rears to the heavens and put their heads in the sand. Admire the Jet-Age styling of fins, or "Gracefully arched rear fenders," is how Cadillac ad copy lauded its timeless mobile.

SHAKE YOUR TAILFINS

CADILLAC RANCH IN AMARILLO, TEXAS

Harley Earl witnessed Charles Lindbergh's transatlantic flight in 1927, and we entered the age of the airplane. Earl became head of General Motors' Art and Color department and debunked Henry Ford's philosophy of making the same car, the Model T, ever cheaper so his own workers could afford one. Instead, Earl advocated for "dynamic obsolescence" to make the Joneses green with envy over their neighbor's outrageous new auto.

In 1941, Earl mulled over the P-38 fighter planes at Selfridge Air Force Base and perhaps reasoned that even if cars couldn't fly—yet!—he would sure make them look like they could. After the lean war years, Earl went whole hog and based the 1948 Cadillac design on jet planes. Fins were born!

The battle of the fins and the swept-wing look began in earnest in 1957 with auto industry claims that they were an essential element to stabilize larger cars. In reality, fins only steadied cars at speeds well over 60 miles per hour, and even then the aerodynamic effect was negligible. Unfortunately for civilians bent on escaping the ozone layer, Earl's designs offered more of the sound and fury of rockets than their actual substance.

Witness the giant fins just west of Amarillo, Texas, in the flat fields south of Interstate 40. Just like ostriches, ten Cadillacs bury their noses into the ground and leave their tail feathers in the air. "Art is a legalized form of insanity," said millionaire Stanley Marsh III, who, along with the Ant Farm art collective, gathered these cars to show the progression of automobile fins on these classic luxury mobiles. Judge for yourself or perhaps agree with Bishop Oxam who wrote in *Advertising Age* in 1958, "Who are the madmen who build cars so long they cannot be parked and are hard to turn at corners, vehicles with hideous tailfins, full of gadgets and covered with chrome, so low that an average human being has to crawl in the doors . . . ?"

NEW MEXICO

SACRED SOIL

HOLY DIRT IN CHIMAYÓ, NEW MEXICO

In the 1970s, I first heard skeptics talking dismissively about the House of the Holy Mud (actually Holy Dirt), but whether for believers or not, this sacred earth had an effect on many pilgrims that cannot be denied.

We had heard about people actually eating the reddish dirt, but most wet it down and rubbed it on sickly parts of their bodies. A room off to the side holds crutchesx,

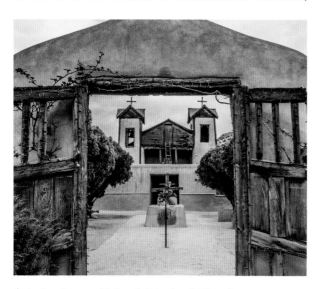

⚑ A miraculous crucifix found at the site of Chimayó, New Mexico, kept returning to this spot and a shrine was built in 1810. The local Pueblo tribe had already known of the curative powers at this site and the hot springs in the area. Now thousands of pilgrims visit to gather some of the holy dirt—a cure for what ails you.

canes, braces, and other medical instruments thrown aside after the cures. Testimonials tacked up on the wall tell the tales of miraculous recoveries that doctors struggled to explain.

Many are the legends of this holy site, but most agree that the Pueblo tribes in the area recognized this area for its curative powers—especially due to the nearby hot springs filled with minerals. Various miracles of crucifixes returning to this spot prompted the building of the little unassuming adobe chapel, like a mini Spanish mission, in 1816. Word spread of the healing power of the dirt, and pilgrims regularly make the nine-hour trek from Santa Fe at Easter and some even walk all the way from Albuquerque.

Today more than a quarter million pilgrims visit the shrine each year, so El Santuario de Chimayó has grown to accommodate them for Good Friday services. Pilgrims can take home a little dirt from *El Pocito*, the little well, but the church now has to haul in many tons of the red claylike dirt from nearby hills to cure the sick.

GETTING INSIDE A COW'S HEAD

LONGHORN GRILL IN AMADO, ARIZONA

Rather than just hanging a bull skull over the door or mantel, the Longhorn Grill in Amado, Arizona, made its whole entrance a giant longhorn. Enter through the nasal cavity to enjoy the "cast iron cooking" of bison burgers or liver and onions under wagon-wheel chandeliers.

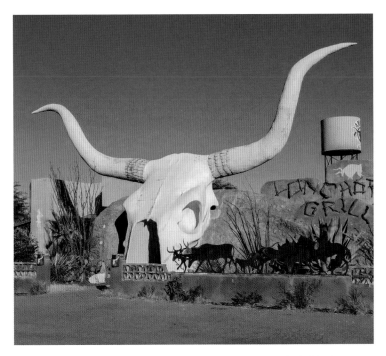

⬆ The horns atop the Longhorn Grill span a considerable 30 feet (9.1 m).

The unforgettable entrance of the longhorn skull with horns stretching 30 feet (9.1 m) has survived many owners while the famous old watering hole across the street, the Cow Palace, went belly up. The Cow Palace had a reputation as the kind of saloon where western luminaries such as John Wayne and Mae West liked to hang their hats, but surely wouldn't have waited on the leather saddles for their table. Alas, the Longhorn Grill won the restaurant battle as a freakish flood of mud flowed into the Cow Palace and shut its doors forever.

ARIZONA

WILD FOR WIGWAMS

TEEPEE MOTEL IN HOLBROOK, ARIZONA

Across Arizona and the Southwest still stand monuments to motels in the shape of teepee hotels and gift shops. Historical accuracy isn't the point, since Native Americans of the area typically have lived in adobe houses. The thick walls of clay and straw provided cool sleeping and protection from the elements in these permanent structures.

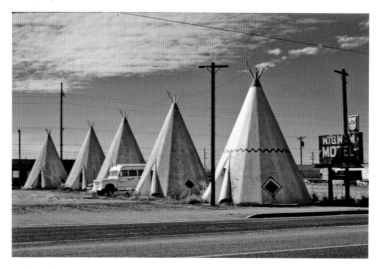

⬆ Sure, the shape is wrong for a wigwam, but what a great name? Tourists on the roadside can't be bothered with historical accuracy but want a quick fix of western delight. Pull up to the Wigwam Hotel in Holbrook, Arizona, and sleep in a teepee—or at least a cement semblance of one—complete with color TV and air conditioning, just like in the old days.

Still, Hollywood looms large as images of American Indians on horses roaming the prairies and sleeping in portable teepees is imprinted on our stereotypes so much that Wigwam Motels sprouted up along Route 66 and highways headed west. Frank Redford patented his idea for concrete teepee "Wigwam Villages" in 1936.

Today only three of the original Wigwam Villages stand: in Cave City, Kentucky; Holbrook, Arizona; and San Bernardino, California. Fortunately for us, each has been placed on the National Register of Historic Places, while other touristy teepees along the roadside keep disappearing.

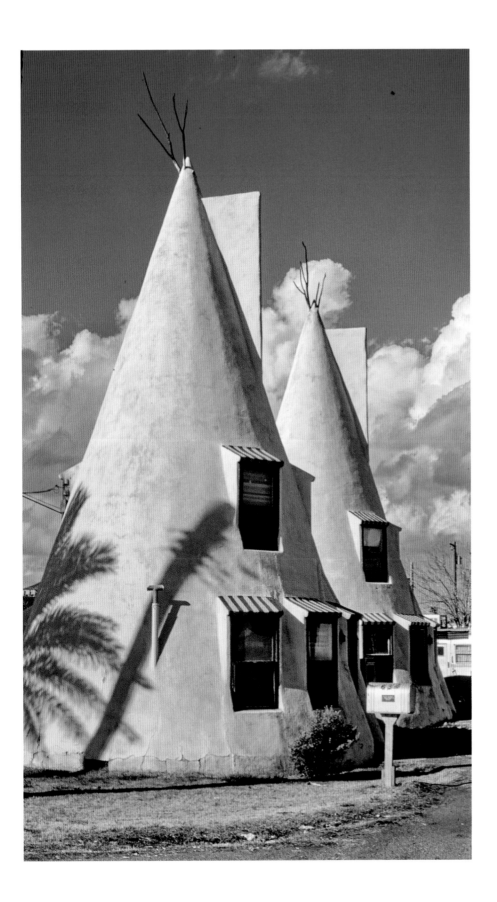

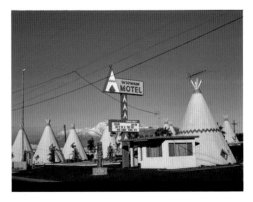

The last in the franchise of Wigwam Villages, No. 7 from 1940, still stands in sunny Rialto, California, and has withstood the waterbeds of the 1990s and "Do it in a Wigwam" signs to be an actually respectable, classic motel once again.

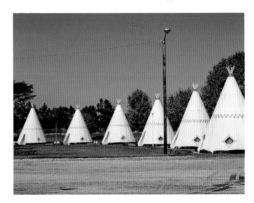

Kentucky can boast the first Wigwam Villages because Frank Redford built his motel monument to cement in Horse Cave in 1933. The updated Wigwam Village No. 2 in Cave City still survives for travelers to pull up the station wagon and reminisce about the supposed good ol' days of the Wild West.

While most tourists to Tempe will marvel at the inverted pyramid building that is still standing, others will lament the loss of the Tempe Teepees at the Wigwam Auto Court that were thoughtlessly bulldozed in 1983.

BUILD IT UP WITH BRICKS AND MORTAR

LONDON BRIDGE IN LAKE HAVASU CITY, ARIZONA

London Bridge was falling down, so why not sell it to the Americans? That's just what happened in 1968 when the English authorities deemed the "new" London Bridge from 1831 unsafe at any speed. Yes, London Bridge did fall down, or nearly so, many times ever since the Romans built the original bridge across the Thames around 50 C.E. Shops and buildings sprung up on the medieval bridge and the Chapel of St. Thomas on the Bridge in the middle marked the beginning of the pilgrimage to Canterbury.

A world away, Robert McCulloch founded the town of Lake Havasu City in the desert-like area of Arizona near the California border and needed something fantastic to bring in the tourists. He paid $2.5 million for London's crumbling bridge, had each of the stones numbered to be easily reassembled, and shelled out three times the cost of the bridge to have it moved and rebuilt. Rather than impaling heads of executed criminals on spikes at the entrance as done in the 1600s, McCulloch simply opted to replace the Union Jack with the Stars and Stripes.

Many thought McCulloch was duped into believing that London Bridge was actually the more picturesque Tower Bridge. Unlikely. Wanting to surpass McCulloch's bargain, the tourist city of Suzhou, China, skipped any authenticity check at all in 2012 and re-created London's iconic Tower Bridge. What's more, they made it double the height and with four towers rather than the measly two. The span in the middle was cantilevered so it could not lift to let ship traffic pass underneath. From a distance, the Chinese Tower Bridge is fantastic, but the Brits mocked the attempt as "shoddy" and snickered

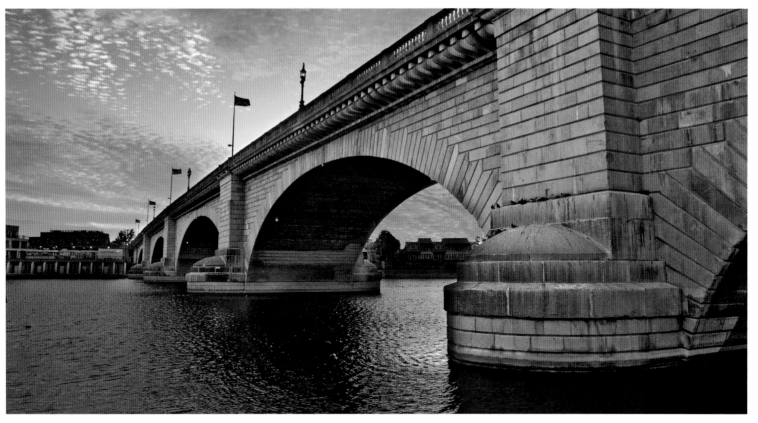

⬆ Who needs to go to stinky old England with its gloomy rain when you can go to the sunny Arizona desert? Come visit London Bridge (not the more majestic Tower Bridge, mind you) in Lake Havasu City, Arizona.

⬆ Not wanting to be duped into thinking that London Bridge is in fact the more iconic Tower Bridge, a Chinese amusement park re-created the London landmark with four rather than two towers and has since removed the turrets and painted it all a dull gray.

when just six years later China had to invest $3 million to renovate it.

McCulloch's bridge in Arizona had a different problem, however: no water. He built the bridge over dry land and then dredged a canal underneath it that connected downstream to the Colorado River. London Bridge is right upstream from Parker Dam, over which two states nearly fought a battle. The governor called up 100 National Guardsmen to travel to the dam to block construction in 1934. The media mocked this "Arizona Navy" ready to go to war with California, but the Supreme Court sided with Arizona. Maybe McCulloch already did have enough bizarre history to bring the tourists to London Bridge in the desert.

NEVADA

PROJECT BLUE BOOK

AREA 51 NEAR AMARGOSA VALLEY, NEVADA

The otherworldly desolation 83 miles northwest of Las Vegas has become one of the most famous spots in the country. The U.S. government disputed its very existence until 2013. "No Trespassing" signs line the area and the airspace is extremely restricted.

No one lived in this region until silver was discovered here in 1864 and Patrick Sheahan started a mine in 1889. Las Vegas wasn't even established until 1905. Then in 1941, the military built a landing strip here and a base—which

had various code names such as Yuletide, Watertown, Dreamland, and Paradise Ranch all in a propaganda move to convince soldiers sent here that this desolate patch of land was actually a bit of heaven.

Ten years later, the military began nuclear bomb tests here and used the base during the Cold War to spy on the Soviets. By the mid-1960s, the CIA had made a lengthy 8,500-foot (2.3 km) landing strip for faster top-secret spy planes. The first U-2 spy plane flew from here traveling at altitudes of 65,000 feet (20 km). U-2 became notorious when the Soviets captured one of the planes in 1960 and destroyed any chance of a Khrushchev-Eisenhower peace deal.

Beginning in the early 1950s, reports of unidentified objects flying very high in the sky especially at dusk emerged from pilots, perhaps some who didn't know that the CIA's planes had reached such heights. The Air Force launched Operation Blue Book in 1952 to investigate and compare the log books of the sightings to when

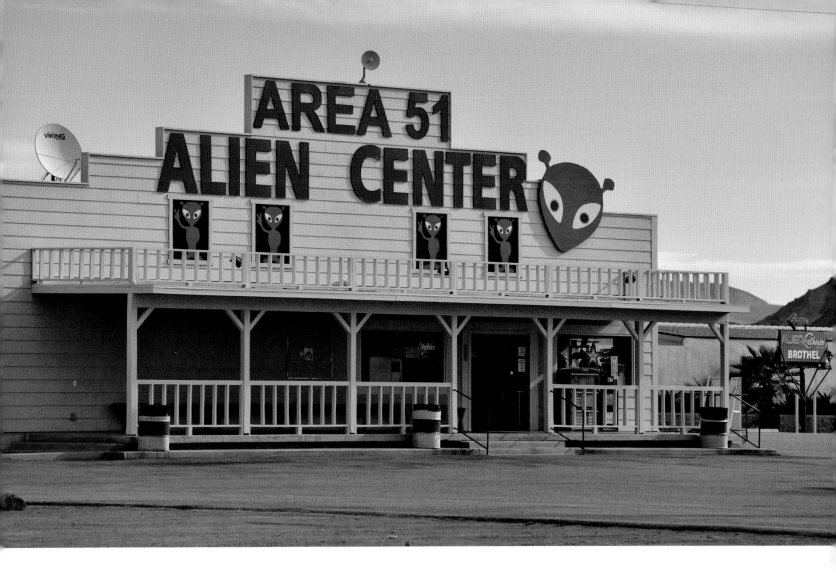

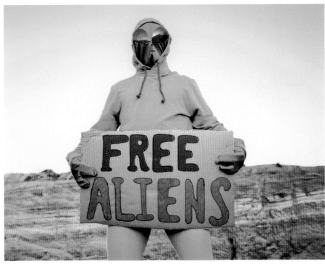

↑ Drive along the Extraterrestrial Highway and look for the World's Largest Firecracker in Amargosa Valley and you're almost there. Well, you can't get there because Area 51 is top secret. Instead, stop at the Area 51 Alien Center next to a brothel (top), the Alien Cathouse, which has Princess Leia costumes and an Alien Abduction and Probe Room.

the spy planes were flying. Any discrepancies were deemed unusual "weather phenomena."

Of course this all just led to wild speculation. It didn't help that Bob Lazar, who said he worked in Sector 4 of Area 51, claimed there is a massive underground railway system where they analyzed a captured alien ship. His job was to attempt to reverse-engineer the anti-matter reactor. Even though his story was debunked, the genie was out of the bottle.

In 2020, the Pentagon made public three videos with no explanation that pilots had filmed of UFOs flying quickly near their planes. A few years before, the Pentagon had revealed that it had spent millions of dollars for many years on a secret task force to get to the bottom of the UFO sightings. So far, no one has the answers and most ufologists are convinced the military has no intention of revealing its findings. No wonder two million people wanted to storm Area 51 in 2019 since the answer is out there.

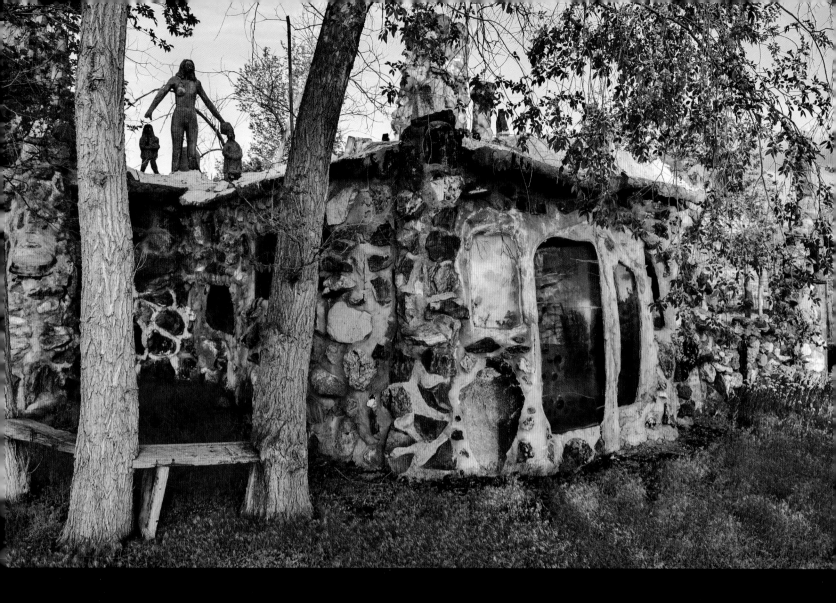

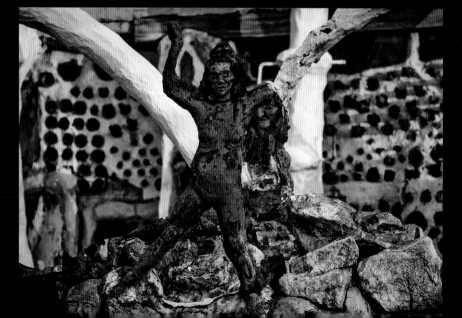

⬆➡ Frank van Zant didn't begin working on his monumental Thunder Mountain in remote Imlay, Nevada, until his late forties when his car broke down on the Wagon Master Trail, named by the ever-optimistic Nevada tourism board about this desolate landscape. Choosing the name Chief Rolling Mountain Thunder, van Zant took his inspiration from Sarah Winnemucca, Sitting Bull, and other Native American heroes whom he honored on the site. By the end of the 1970s, Thunder Mountain started to decay. Arsons burned the three-story hostel where hippies stayed in 1983 and the underground rooms caved in, but the shrine lives on.

APOCALYPSE ARCHITECTURE

THUNDER MOUNTAIN IN IMLAY, NEVADA

One of the loneliest stretches of highway in the country leads to a mirage-like maze of structures of brightly painted cement extending three stories into the giant Nevada sky with a 47-foot (14 m)-tall arch above it all. More than 200 cement structures once filled the five acres with building material ranging from old windshields to typewriters. Old wagon wheels and hoods from cars make up walls, and old cranes and pickup trucks are put to use too.

The man behind the madness was Chief Rolling Mountain Thunder, born Frank van Zant, who was a quarter Creek Indian. Van Zant went to divinity school, but then dropped out to become a sheriff's deputy for two decades. He retired from police work, remarried for the third time, and went west in 1968. His Chevy pickup broke down outside of the nearly abandoned town of Imlay more than 100 miles northeast of Reno. He camped out in the desolate prairie among the sagebrush when the owner of the land discovered him there. Van Zant bought the land and began building. That's when he became "Chief Rolling Mountain Thunder."

Chief Rolling Mountain Thunder claimed to have no need for such mental stimulants as psychedelics, but he had a had a magnetism that inspired (or sometimes repelled) others, and his dedication to the ways of his Native American ancestors brought hippies on vision quests that were also part preparation for the apocalypse. His oldest son said about his father, "He had the charismatic personality that could have made him another Jim Jones." Fortunately they didn't drink the Kool-Aid, but the artistic commune slowly moved away. In 1989, he shot himself onsite. His children have preserved the chief's vision and opened it to visitors.

TROGLODYTE DWELLINGS

HOLE N" THE ROCK OUTSIDE MOAB, UTAH

With no good trees in sight and the sun scorching the earth, Albert Christensen learned a lesson from the ancient Anasazi native tribes who lived in cool cliff dwellings dug into the rock around Four Corners. To follow their lead, Christensen had the distinct advantage of lots of dynamite to make his cozy cave as big as he could blast it. For twelve years, he detonated TNT and drilled his dream home until he had fourteen rooms to house his family.

⬆ BToday, Hole N" The Rock offers guided tours of Albert Christensen's 5,000-square-foot (465 square meter) home and a gift shop (natch).

Christensen carved a bathtub into his cavernous restroom and drilled a 65-foot (20 meter) chimney that opens into the cliff next to the "C" on the painted sign on the rocks. While his wife Gladys gathered dolls for her enormous collection, Albert took up taxidermy in his spare time when not running the Hole N" The Rock Diner that fed prospectors during the postwar uranium rush to make a better A-bomb. In 1957, Christensen died just five years after he moved in, but his widow Gladys kept the attraction alive for another seventeen years.

For a small fee, visitors can tour his grand grotto, but be on the lookout for other similar attractions in this hiker's paradise just outside of Arches National Park: The Hollow Mountain Gas Station enjoys natural air conditioning on the other side of Canyonlands and Edge of the Cedars has recreated ancient Anasazi pueblo/cave dwellings.

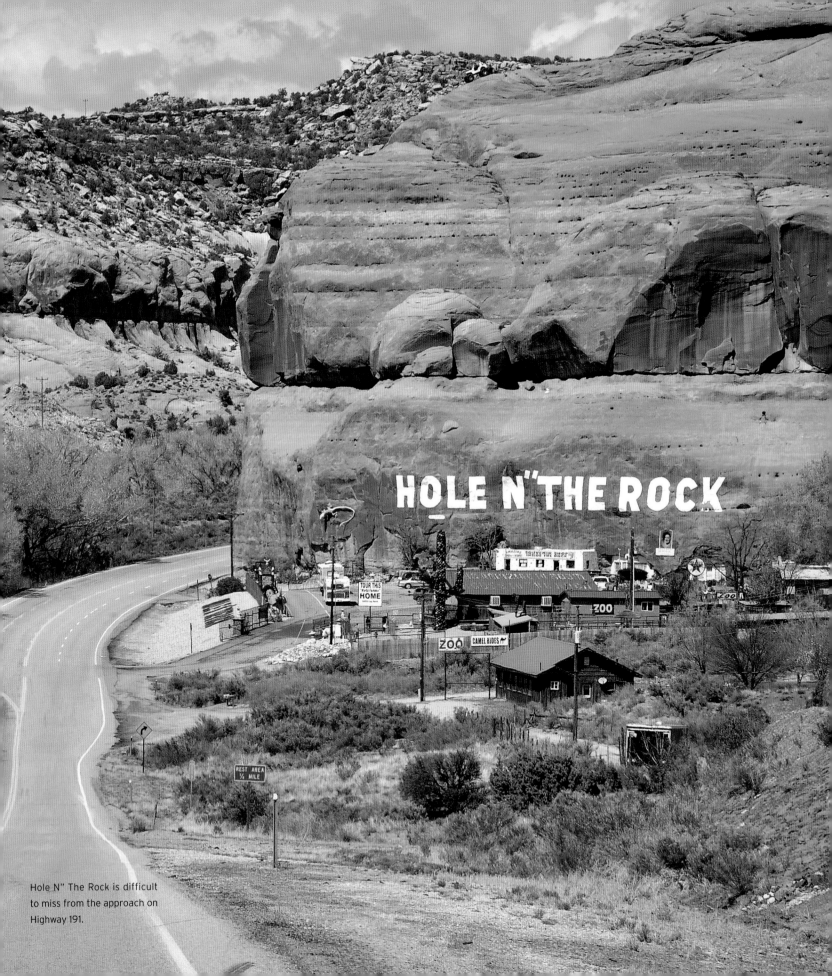

Hole N" The Rock is difficult to miss from the approach on Highway 191.

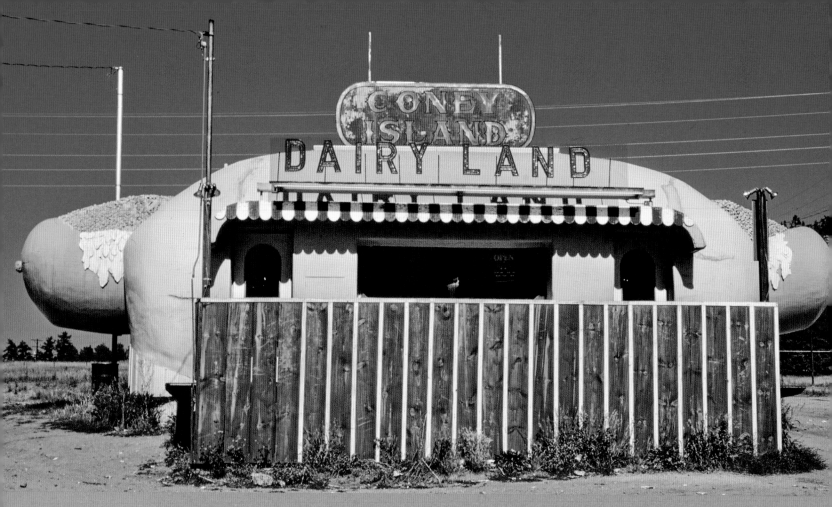

JUST A SIP

TEAPOT DOME

ZILLAH, WA

Could hold 105,600 cups of tea. Considering two cups a day, this would serve one person for nearly 145 years . . . and produce 89,760 cups of urine.

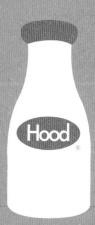

HOOD MILK BOTTLE

BOSTON, MA

Could hold 319,000 cups of milk . . . enough for three cups per day for 291 years.

SANDY JUG

PORTLAND, OR

Could hold 4,660,000 shots of whiskey, or could keep someone drunk (at 8 shots a day) for 1,596 years.

HOT DOG HEAVEN

CONEY ISLAND IN BAILEY, COLORADO

Coney Island may be a world away from Colorado, but this 42-foot (12.8 m) wiener inside a 35-foot (10.6 m) bun proves that hungry eaters needn't be at an amusement park for savory pork products. Marcus Shannon built the Coney Island diner in 1966 and envisioned an entire squadron of hot dogs to take over the culinary world of wieners. Healthy Coloradans, however, didn't immediately embrace the swine diet and the Coney Island went under in 1969. The diner moved to nearby Aspen Park (pictured) in 1970 and thrived there until 1999. With a move in 2006 and another renovation in 2016, the Coney Island Boardwalk flourishes with lines of eager eaters waiting to order the new modern menu with locally sourced products for healthy living.

◄ Who needs one of the six Oscar Mayer Wiener mobiles touring the country when you can go to a classic Coney Island hot dog stand outside of lovely Bailey, Colorado? Weighing in at 18 ttons (16 MT), this hot dog, if made of real pig parts, could feed a family three meals a day for three decades, but imagine how they'd look after that!

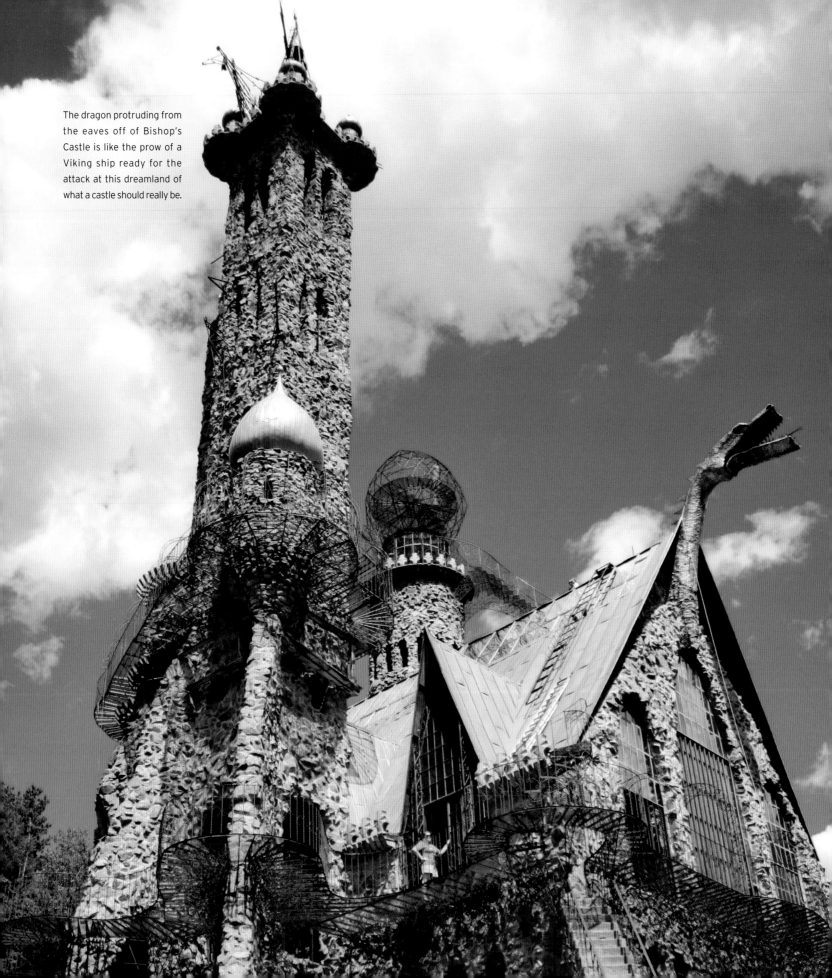

The dragon protruding from the eaves off of Bishop's Castle is like the prow of a Viking ship ready for the attack at this dreamland of what a castle should really be.

COLORADO CAMELOT

BISHOP'S CASTLE NEAR RYE, COLORADO

Dragon heads bare their teeth from eaves and are designed to spew flames. Crenelated fortress walls connect gigantic keeps with arched buttresses. Wait, this is in Colorado?

Jim Bishop had always dreamed of building a fortress, but on his own terms. He constructed steep roofs covered with the metal of old box cars salvaged from the railroad, and he hauled in tons of river rock to make his Colorado castle. Because of the 100-foot (30 m) bartizan turret with a stunning gold acorn-shaped roof, architectural critics have dubbed the tower the "Colorado Kremlin," but it's also part Notre Dame, part Stave Church with its dragons, and part Camelot.

The third floor has an enormous ballroom with soaring 40-foot (12 m) ceilings and a giant pipe organ—thanks to a local church. Step down to the second floor and notice the 20-foot (6 m) ceilings that give plenty of space to display medieval battleaxes, spiked morning stars, deadly maces, and steel shields. Bishop's deadliest weapon, however, is his tongue as he's famous for his anti-government rants and worries that clones will take over.

All he needs now to complete his medieval mountain fortress is jousting matches and Robin Hood to save Maid Marian. In fact, he told the *Wall Street Journal* that he hoped to make a second castle for his ever-patient wife. "I want to live as long as I can and keep building that castle bigger and bigger and bigger." He questioned what else he could do for happiness since this is his destiny: "What can you do in heaven?"

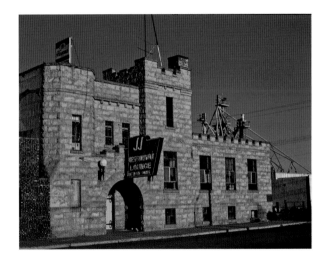

➡ Just over Great Sand Dunes from Bishop's Castle in Monte Vista, Colorado, stands another mock fortress that once offered daily dining to hungry travelers but today is just office space for cubicle warriors.

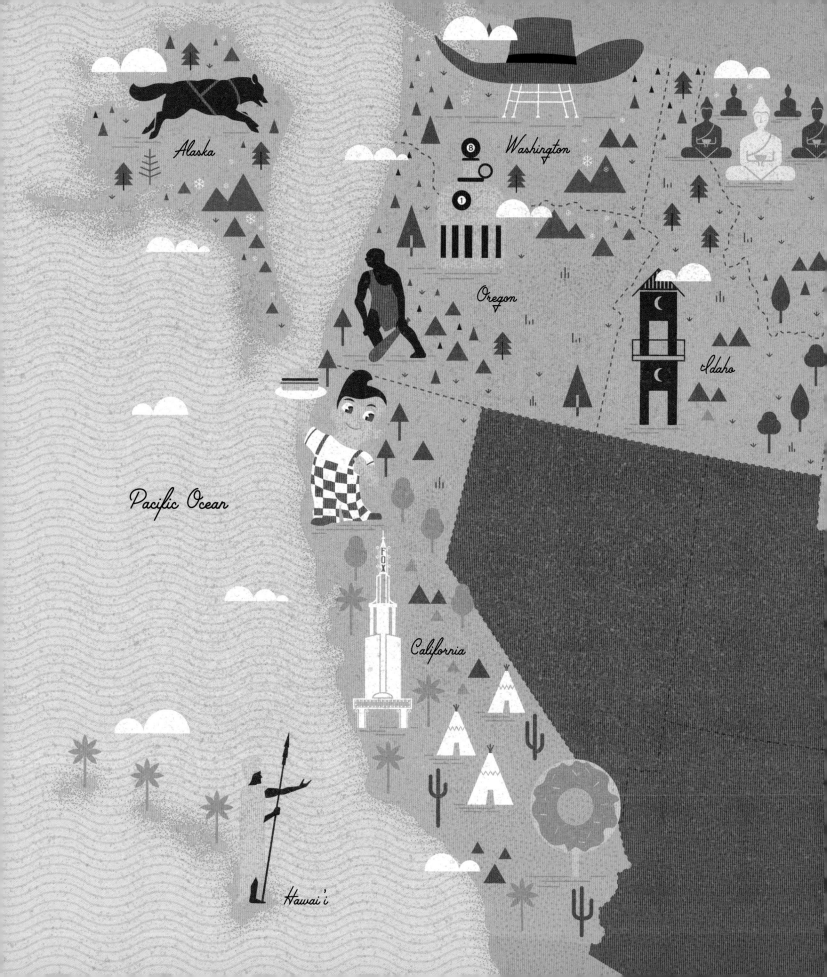

Alaska

Washington

Oregon

Idaho

Pacific Ocean

California

Hawai'i

FOX

Canada

na

Wyoming

WEST

Tall tales of the Wild West are alive and well with bona fide double-decker outhouses, jackalopes, and shoes made from the skin of dead bank robbers. The challenges of this rugged landscape are met by brave huskies and the king of surfing defying the waves of the Pacific. On the other hand, the glamor of Tinseltown mesmerizes the world with its glitzy theaters and giant donuts atop drive-ins.

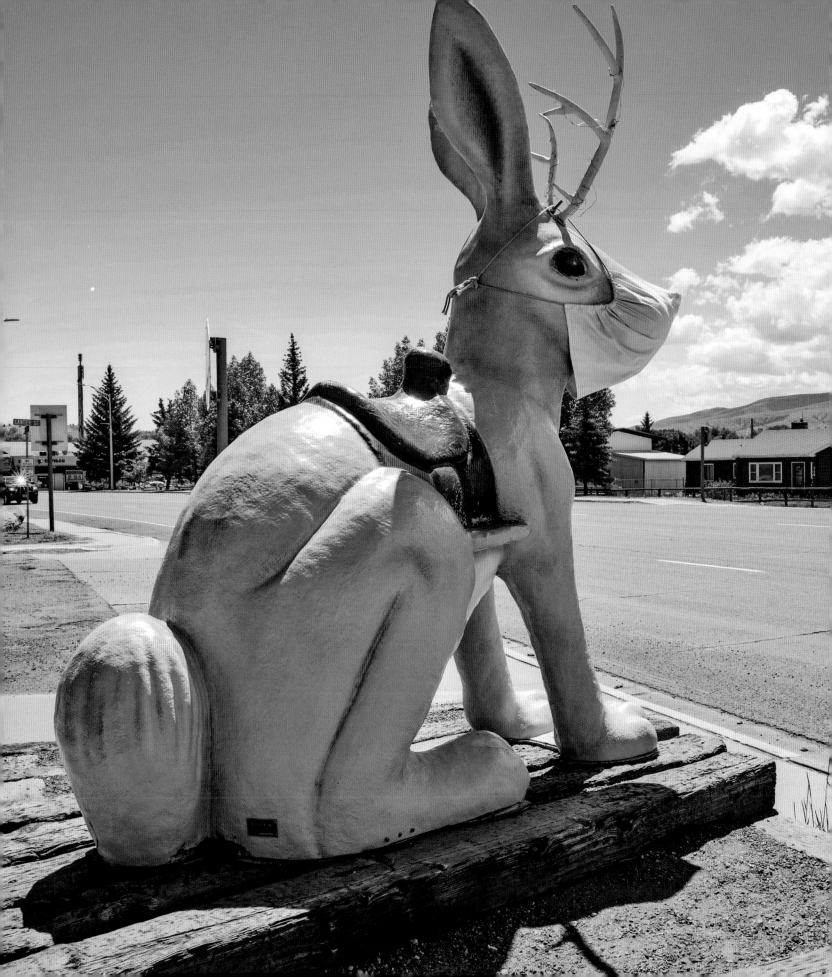

ATTACK RABBITS

JACKALOPE STATUES IN DOUGLAS, WYOMING

Jackrabbits used to roam the Great Plains, and farmers would pull out their hair as the bunnies ate all of their crops right down to the roots. Historical museums across the west are filled with photos of hunters posing next to dozens of dead critters.

A docent at the Arv Hus Museum on the prairie, Billy Thompson, explained to me how they hunted rabbits: "In 1942, we'd get forty men in four sections that were two miles on each side. We'd get ten men on each side spread out and bring them to the center. We'd flush out all the jack rabbits, bring them to the center and then we'd shoot 'em all—about 125 of them." Then they'd take the carcasses, drape them over a car, and parade through town selling them for a buck each.

Rather than settling for rabbit pelts, taxidermists in Douglas, Wyoming, had other plans. They had likely seen some of these huge rabbits infected with a disease, the shope papilloma virus, which causes bizarre growths out of their heads that resemble horns. Rather than meddling with small horns, creative taxidermists mounted giant racks of antelope and deer antlers on these smaller creatures. Wall Drug even had a jackalope with pheasant wings.

Legislators have tried repeatedly to promote this long-eared chimera as the "official mythological creature of Wyoming." Besides, any self-respecting tavern in Wyoming has at least one stuffed jackalope. These beastly creatures are attracted by whiskey, but mimic cowboy yodeling and can attack at the drop of a hat. To stave off these deadly animals, the *New York Times* reported that the state of Wyoming allows jackalope hunting, but applicants must "pass a test to prove he has an I.Q. higher than 50 but not more than 72. Hunting is permitted only on June 31, from midnight to 2 a.m."

◄ The most impressive jackalopes are those mounted in bars across the West. Even so, the mixed-monster originates in Douglas, Wyoming, and has spawned ever-larger rabbit statues. This statue sits outside a gas station in Dubois, Wyoming, complete with a mask against COVID-19. Inside the station, a rideable (if slightly mangy) jackalope seeks shelter from the storm of tourists.

DHARMA BUDDHAS

GARDEN OF ONE THOUSAND BUDDHAS IN ARLEE, MONTANA

Not far from Pistol Creek Lookout, in probably the place you would least expect, stand a thousand Buddha statues meditating. The stark white Bodhisattvas are laid out in the pattern of the Dharma Chakra, the same symbol as on the flag of India and also known as "The Wheel of Fortune."

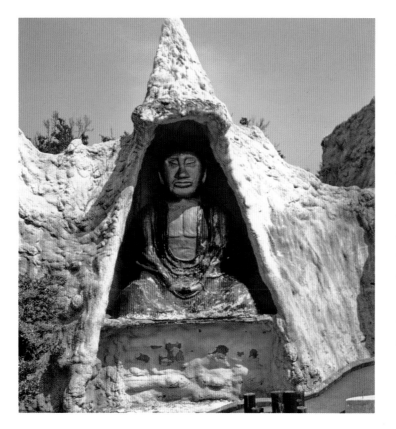

The pristine location in the Rocky Mountains may seem odd for a Buddhist sanctuary—these mountains are just foothills compared to the Himalayas. In the center of the wheel that represents the "Noble Eightfold Path to Enlightenment" sits Yum Chenmo, the Great Mother of Wisdom, in full color contrast to the bleached Buddhas.

Remote Montana attracts different groups who seek the freedom of Big Sky country to express themselves. While the Church Universal and Triumphant just north of Yellowstone Park armed itself for the coming of the apocalypse in its mountain bunkers, the Nyingma School is preparing itself for the coming of their spiritual leader.

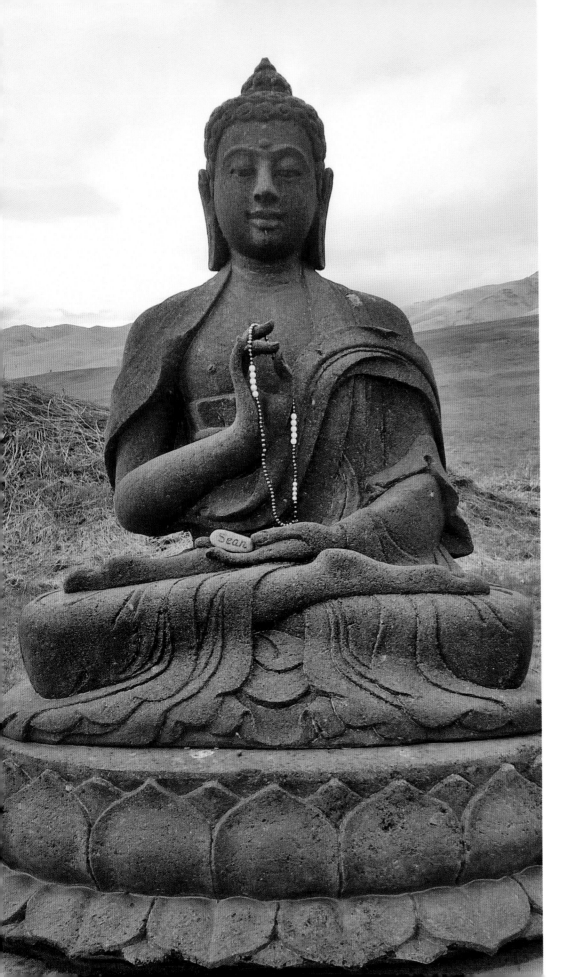

⬆ Who would have thought spiritual enlightenment would also make a fun putt-putt golf hole? Although the Taliban destroyed the world's two largest statues of Buddha with anti-aircraft fire, tanks, and truckloads of dynamite, Wacky Golf in Myrtle Beach, South Carolina, simply went out of business and its statue of Buddha (pictured) ascended to Nirvana.

⬅ The wide open spaces of Montana's high plains are perfect for meditating and achieving bliss-filled nothingness. These thousand statues of meditating Buddhas are arranged in a wheel pattern, an enormous chakra, just north of Missoula.

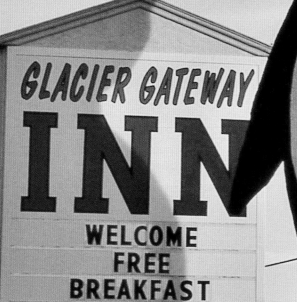

GLACIER GATEWAY
INN
WELCOME
FREE
BREAKFAST

AAA
Approved

WELCOME TO
CUT BANK MT.
COLDEST SPOT IN
THE NATION

MONTANA

COLDEST SPOT IN THE COUNTRY

WORLD'S LARGEST PENGUIN, CUT BANK, MONTANA

The battle to the bottom, at least temperature-wise, is on! Cut Bank, Montana, has a legitimate claim as "The Coldest Spot in the Nation" since nearby Roger Pass, Montana, recorded -70°F (-56°C) in 1954. What's more, Cut Bank has a 27-foot (8.2m)-tall penguin to prove it. Once upon a time, the penguin could speak, but with temperatures this cold, don't hold your breath.

Some states cried foul, however, since the wind-chill factor could have skewed the numbers in 1954. They wanted the prize for the most brutally cold spot to keep all tourists away. For example, northern Idaho is often just as cold, and the Rocky Mountains and wind-swept plains of North Dakota often reach brutally low temperatures. Cartoon characters Rocky and Bullwinkle live in Frostbite Falls, or International Falls, Minnesota, which calls itself the Nation's Icebox. The town even has a 22-foot (6.7 m)-high thermometer but soon realized that hot temps are much more impressive than cold ones, just ask Baker, California, and its 134-foot (41 m)-high thermometer.

The fight to be frozen changes each year as other towns from Utah to Colorado claim much colder temperatures than Frostbite Falls. All this is moot, of course, considering Alaska is colder than them all. Just remember Jack London's "To Build a Fire" in nearby Yukon when the mercury plummets to -75°F (-56°C). It doesn't end well.

← The largest prehistoric penguin ever found weighed 220 pounds (100 kg) and measured 6 feet 8 inches (2 m) high, but that's nothing next to Cut Bank, Montana's 27-foot (8.2 m)-tall statue on the edge of Glacier National Park.

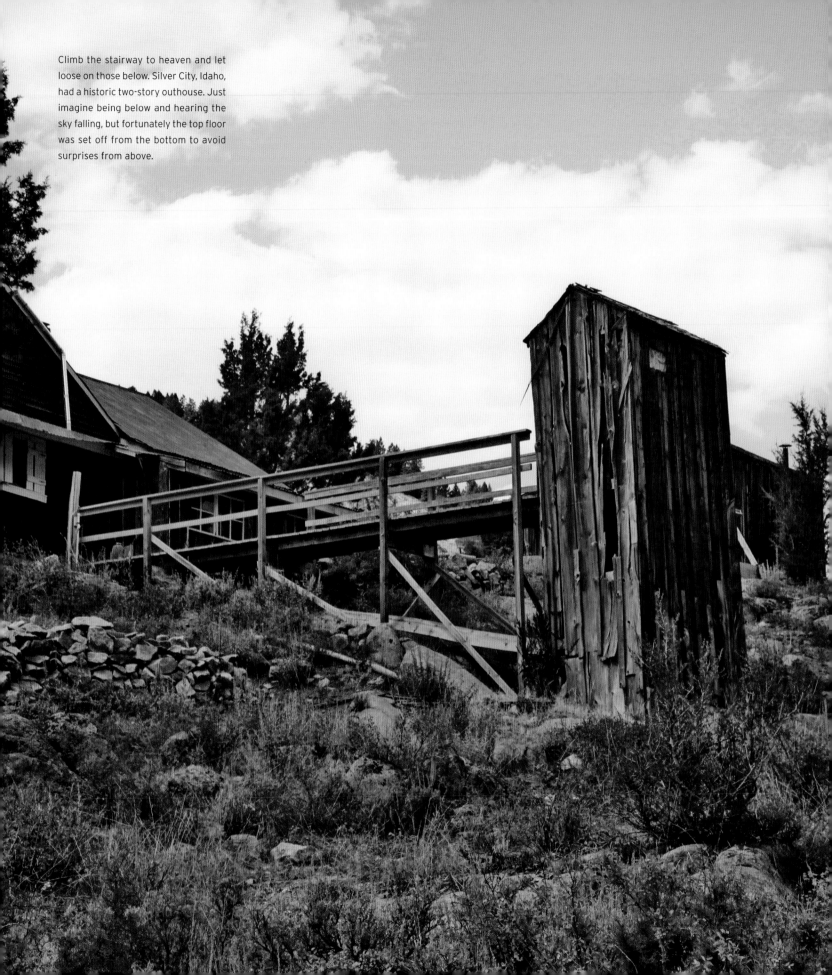

Climb the stairway to heaven and let loose on those below. Silver City, Idaho, had a historic two-story outhouse. Just imagine being below and hearing the sky falling, but fortunately the top floor was set off from the bottom to avoid surprises from above.

IDAHO

SURPRISES FROM ABOVE!

DOUBLE-DECKER OUTHOUSE IN SILVER CITY, IDAHO

Tucked into the mountains of Idaho was a famous double-decker outhouse, a fully functioning joke. In northern climates, however, snow piled up in a hurry. Doing the potty dance while shoveling a path to the outhouse soon proved the necessity for a second-story solution. Just pop in the top and do your duty.

When pioneers settled the land, social climbers boasted that they had a real outhouse rather than just squatting over a hole. Even President Franklin D. Roosevelt weighed in on the personal hygiene emergency by encouraging advancement in "sanitary" outdoor latrines. The presidential decree in 1933 freed up funds for a million outhouses as part of the Works Progress Administration (WPA) at five dollars a pop. Some thanks! The nation responded by nicknaming these biffies, The Roosevelt.

Some turned up their noses at the president's offer to clean up the muck and made scatological skyscrapers. The historic Hooper-Bowler-Hill house in Belle Plaine, Minnesota, contains a beautifully-kept, working version of the running joke dating back to 1871. Perhaps the only outhouse on the National Register of Historic Places, this rare "five holer" could prevent lines to the restrooms and host family reunions within its walls. The easily accessible two-story wonder was attached by a skyway to the second floor of the mansion, but still far enough away to keep the fumes at bay.

The scourge of indoor plumbing and sanitary toilets threatened to remove a staple from the Wild West: the outhouse. Along came South Dakota crapper curator Richard Papousek, who envisioned saving the fresh-air privy. Folks in his town of Gregory were not so keen on being known for discarded biffies. Signs in his collection boasted of a two-story beauty found in Minnesota and imported to South Dakota: "DOUBLE JOHNNY 'Come lately.' Dwell on this . . . 4 feet of snow—an 8 foot drift. How do you open the outhouse door?? Two story Johns were built for stormy weather. Second story holes were located further back than the first story holes!!" Unfortunately his questionable collection has searched for a home after a less-than-warm reception for his architectural unmentionables.

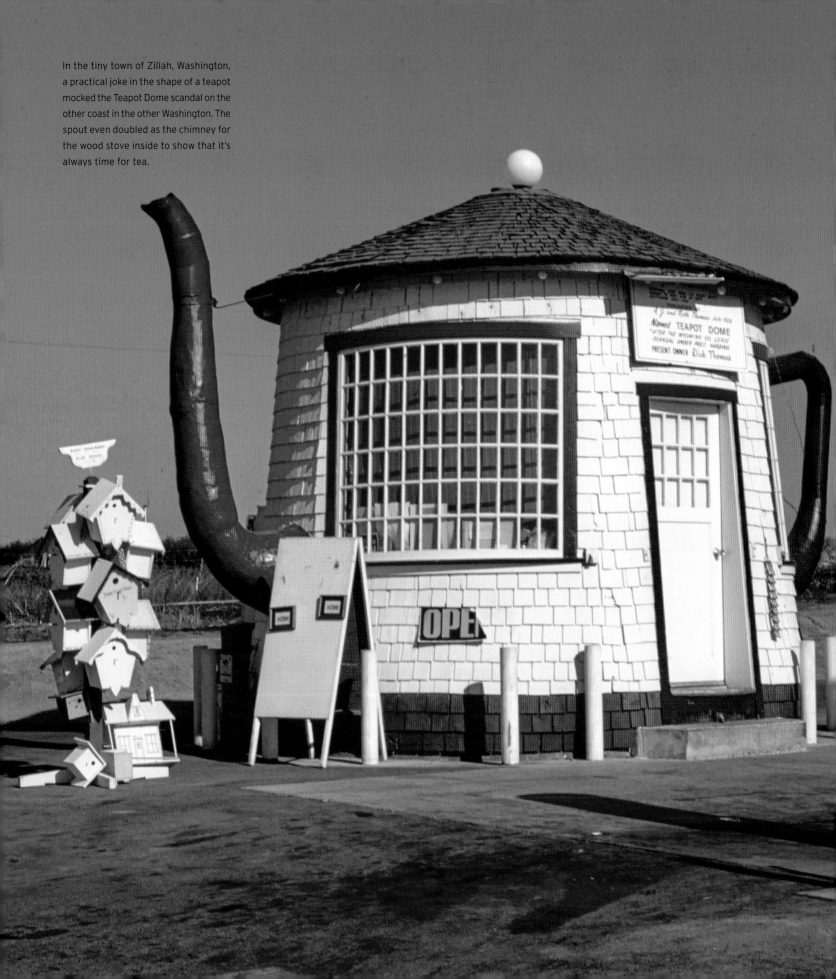

In the tiny town of Zillah, Washington, a practical joke in the shape of a teapot mocked the Teapot Dome scandal on the other coast in the other Washington. The spout even doubled as the chimney for the wood stove inside to show that it's always time for tea.

GAS GAG

TEAPOT DOME GAS STATION IN ZILLAH, WASHINGTON

Until the 1970s, proof of the most corrupt administration in U.S. history was the Teapot Dome Scandal of 1921–1923, named for a $400,000 bribe paid to the Secretary of the Interior Albert Fall, for exclusive rights to the Teapot Dome oil reserves in Wyoming.

We've had Watergate, Iran Contra, "Zippergate," Bush v. Gore, and storming the Capitol Building, but this shady deal for drilling rights led to the imprisonment of Fall for accepting what would be nearly $6 million in today's dollars and a six-month prison term for oil tycoon Harry F. Sinclair for bribing the jury. (Each time you fill up the tank at a Sinclair Station, you can reminisce on how he got rich.) So much pressure was put on President Harding that he had a heart attack and died. His wife destroyed all records of Harding's death, leading to unsubstantiated conspiracy theories that she poisoned him.

The country watched in disgust and I-told-you-so amusement that all politicians are crooked. The year before the president passed away in 1923, Jack Ainsworth built this 14-foot-tall teapot gas station to mock Harding and his corrupt cronies.

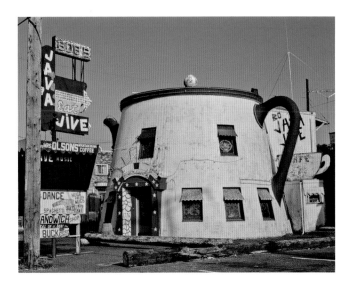

⬆ Who knows if the Teapot Dome gas station a couple hours away influenced the construction of this giant coffeepot in Tacoma five years later? In any case, this is classic roadside architecture that began as a diner, turned into a Tiki Bar, and ended up as a coffeeshop with surf bands like The Ventures as the house band. Although built in 1927, Bob's Java Jive didn't earn its name until 1955 when the owners reminisced about the catchy 1940s "Java Jive" song: "I like coffee, I like tea. I like the Java Jive, and it likes me."

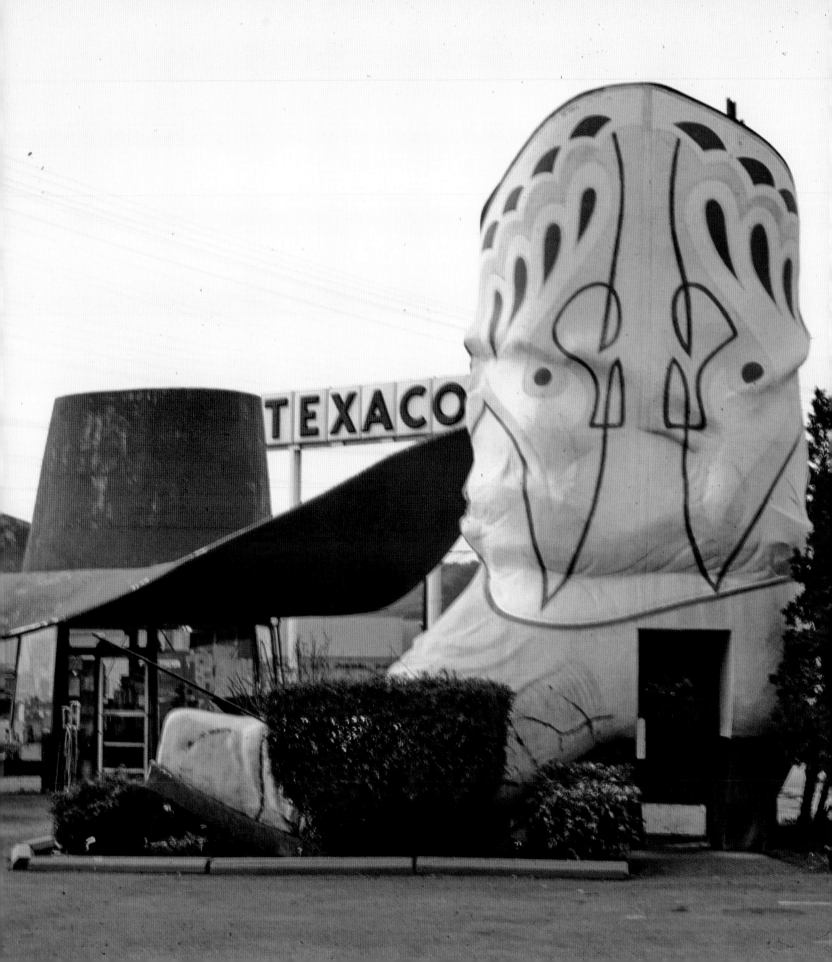

WASHINGTON

ALL HAT AND NO COWBOY

HAT 'N' BOOTS GAS STATION IN SEATTLE, WASHINGTON

Ever since 1955, the giant red hat and cowboy boots announced that Texaco (get it?) gas was for sale in one of the oldest neighborhoods in Seattle: Georgetown. The ten-gallon hat doubled as the roof of the station with the brim stretched out like extended eaves. To use the restrooms, motorists had to pee in a boot. The slightly smaller powder blue boot was for the cowgirls and the dark blue 24-foot (7.3 m)-high boot was for the menfolk.

The quirky station was a hit and visiting celebrities wanted to be seen by the hat. During the 1962 World's Fair held in Seattle, Elvis Presley came to the Hat 'n' Boots. The station was only stage one of a projected Western-themed shopping center dubbed Frontier Village. Mercifully, the whole wrangler mall never emerged.

Incredibly, these monstrous cowboy duds weren't appreciated by all and fell into disrepair in the late 1980s. Skateboarders used the hat's long visor for tricks, and graffiti artists defaced the poor sculpture. Then residents of Georgetown rallied and bought the decrepit Stetson and boots for $1 as long as they moved it. Finally in 2010, the hat and boots were free of the gas station and fully restored in nearby Oxbow Park.

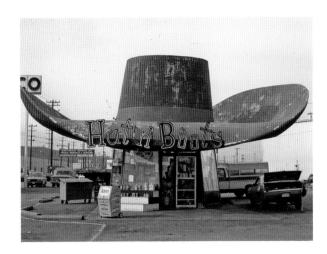

⬆ Here are the Hat 'n' Boots in 1977 before the gas station closed and skateboarders used the rim as a ramp then broke a piece of the classic Stetson. Today, the hat has been lovingly restored and provides shelter at a nearby park.

➡ "Walk loudly and carry a big stick—and dress in bearskins," could be the motto of the Oregon Cavemen who erected a thick browed caveman statue in Grants Pass.

OREGON

EMBRACING OUR INNER NEANDERTHAL

CAVEMAN IN GRANTS PASS, OREGON

To promote the nearby Marble Caves, a group of 300 local Cro-Magnon wannabes known as the Oregon Cavemen dressed in pelts, beat drums, wore decaying false teeth, and donned horsehair wigs during town parades in the early 1920s. The Cavemen would drag their knuckles on the ground and "steal" gawkers from the crowd—but wouldn't quite pull the ladies by their hair as the stereotype demands.

Ever since 1922, Grants Pass has been known for the Cavemen and even named the local high school athletic teams in their honor. Businesses in town took the cue and named themselves for the popular mascot: Caveman Fence & Fabrication, Caveman Bowl, and the anachronistic Caveman Computers.

Grants Pass erected a caveman statue as the town symbol in 1956, but it slowly sank into oblivion. In 1971, the Cavemen raised $10,000 for an 18-foot (5.5 m) slunk-shouldered Neanderthal statue out of ultramodern fiberglass. In 2004, teenaged delinquents discovered that the resins used with fiberglass burn quite well. Caveman Towing reconstructed the beloved symbol and placed him atop an 8-foot (2.5 m) pedestal, well out of the reach of pyromaniacal punks.

Then in 2013, the *Wall Street Journal* reported that some of the few remaining elder Cavemen thought that moving the statue to the local high school would ensure a caveman caretaker after they'd gone the way of the dinosaur. They were sure that neighboring high schools would never view their rival mascot as a target for vandalism. Others argued that the nearby town of Ashland had its hoity-toity Shakespeare Festival while Grants Pass banged their chest and grunted. Alas, poor Caveman just needs a skull in his hand to ponder his existence and suddenly he's Hamlet—or a cannibal.

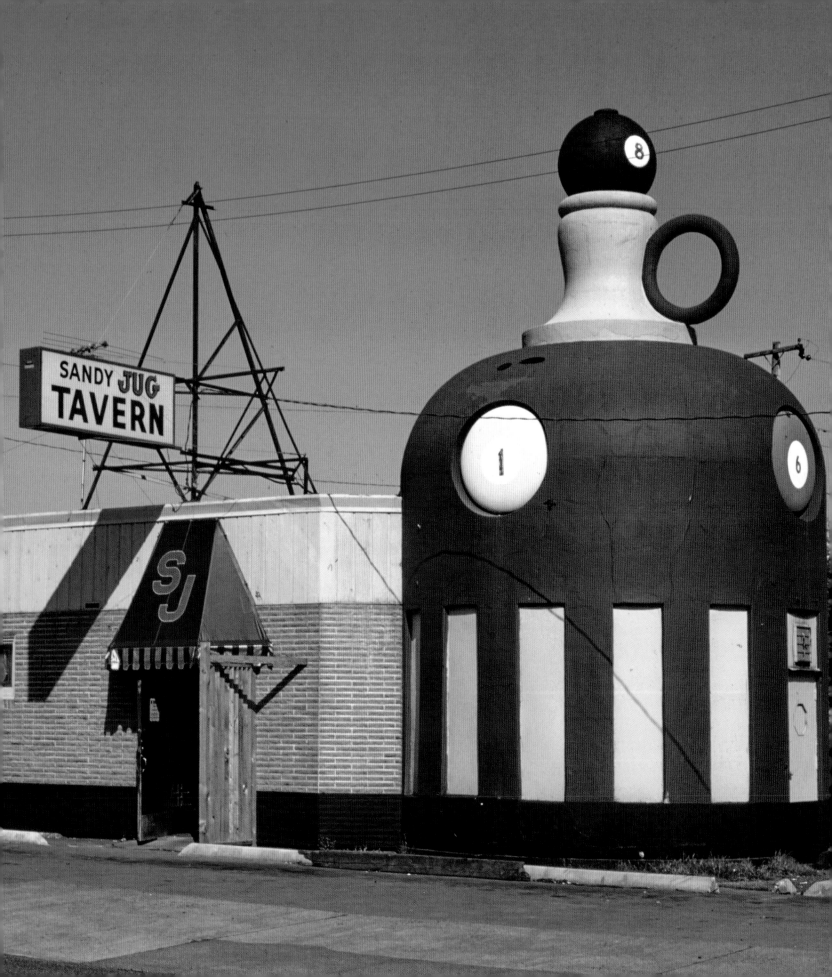

OREGON

BIG BROWN JUG

THE SANDY JUG TAVERN IN PORTLAND, OREGON

Neighbors like to reminisce that the bottle-shaped building from 1928 was the wholesome Orange Blossom Jug Luncheonette with windows that are stuccoed over now and Coca-Cola signs where the round signs are above. Maybe, but city records state the Jug restaurant was built as a whiskey bottle with an eight-ball for a cork and the round circles as pool balls.

By the 1970s, the Sandy Jug became a full-on tavern with regular nudie shows of dancers inside the bottle. In 2002, the Jug was put on the market and neighbors waxed nostalgic about the good ol' days when kids could get an ice cream soda without full frontal nudity.

Hope springs eternal as the new name of Pirate's Cove seemed to promise swashbuckling kitsch and perhaps some cheesy buccaneer-wearing bellhops. At least the new owners did paint a lovely seaside mural of a pirate galleon.

◄► The Sandy Jug has been a neighborhood symbol in Portland since the Depression and gone through several incarnations. The red and baby blue bottle photo was taken in 1976 and the new tan paint job of the stucco is from 1980. Today the Pirate's Cove is all red and nary a pool ball in sight.

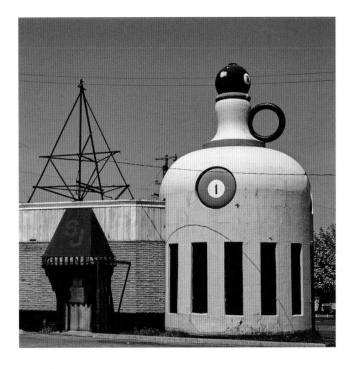

CALIFORNIA

"FAT BOY" BURGERS

BOB'S BIG BOY IN BURBANK, CALIFORNIA

Six-year-old Richard was short and squat with droopy overalls. This plump little lad swept up at Bob's Pantry—child labor be damned!—in exchange for a couple of hamburgers. Owner Bob Wian, who had sold his 1933 DeSoto to buy the sandwich shop, was inspired by Richard and his nickname "Fat Boy," a name he considered for his especially beefy burger.

⬆ A Hollywood cartoonist scribbled the original Big Boy on a napkin in the 1930s and soon burger builders, lovingly called "Boyfriends," had made five million hamburgers by 1955. This required five million bottles of ketchup, 38,000 gallons (144,000 l) of mayo, 25,000 gallons (95,000 l) of relish, and many tons of lipid-rich beef to expand America's waistline.

His ten-stool hamburger stand became a popular hangout for musicians in Glendale, California. (The Beatles didn't eat there until their 1965 tour.) A local band, Chuck Forster's Orchestra, always ordered the juicy hamburgers, but the bassist asked Bob after one practice in 1937, "How 'bout something different for a change, Bob?" To prove that his burger couldn't be beat, he teased the musician by cutting his sesame seed bun in three parts and put two patties with lettuce, cheese, and relish. Bob's multilayered burger was a hit and the Big Boy was born named for chubby little Richard.

Soon copycats popped up across the country, such as Beefy Boy, Chubby Boy, Husky Boy, Brawny Boy, Goody Boy, Super Boy, Hi-Boy, Bun Boy, and Fat Boy. Even *The Simpsons* featured a demonic Lard Lad holding a giant donut and Austin Powers's nemesis blasts into space in a rocket shaped like a Big Boy.

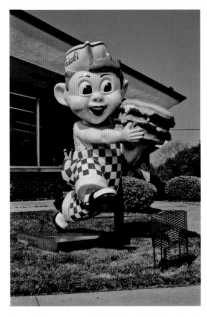

⬆ Big Boys spread out from California all across the country. Dave Frisch franchised the name in Ohio, Kentucky, Indiana, and Florida. This active redhead resides in Lancaster, Ohio, and Frisch opened a Big Boy Museum in Cincinnati.

⬆ This uncooked Big Boy awaits a proper paint job at the "graveyard" of F.A.S.T. (Fiberglass Animals, Shapes, and Trademarks) in Sparta, Wisconsin, that fabricates roadside Americana.

TINSELTOWN THEATER TOUR

CINEMAS IN LOS ANGELES, CALIFORNIA

While masses of people visit Disneyland, Universal Studios, or other Los Angeles mainstays, others veer off the tourist track and stop at classic movie theaters around the city. These are the most ornate, gaudy, beautiful, and extravagant in the world, and many of them barely escaped the wrecking ball. Most were built in the Spanish Colonial Revival style with Streamline Moderne Art Deco design that is only found in Southern California.

Anyone who looks up at the stars will be awed by the remarkable marquees, and the turquoise Eastern building (while not a theater like the others) is one of the most beautiful skyscrapers in the country. The amazing marquees for vaudeville-era theaters and classic skyscrapers can only be rivaled by those in Chicago or New York.

◄ In the heart of Hollywood stands its greatest symbol: Grauman's Chinese Theater from 1927. Stroll down the Hollywood Walk of Fame to the equally fantastic Grauman's Egyptian Theater, which opened in 1922 amid all the hubbub around the discovery of Tutankhamun's tomb in Egypt.

↑ Built on the lot where Paramount Pictures originally filmed its moving pictures, the Palladium Theater is a classic Streamline Moderne Art Deco building that has seen performances by everyone from Frank Sinatra to Jimi Hendrix.

↑ The fabulous Loyola theater in Westchester (just west of Los Angeles) made it as a Designated Historic Monument, but not before the auditorium and 900 feet (274 m) of neon were destroyed to make it an office building.

← Just look for the 170-foot (52 m) FOX tower with Art Deco flourishes such as winged Venetian lions. You've arrived at the Fox Village Theater from the 1930s that has hosted red-carpet debuts of the best films Hollywood has to offer.

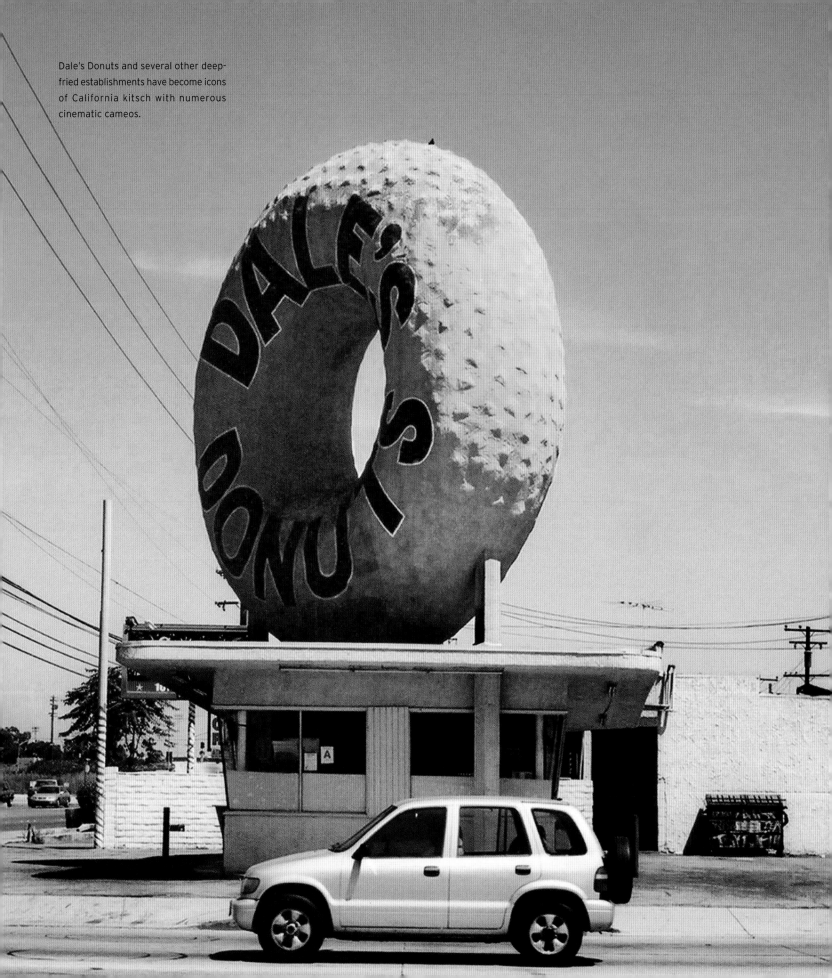

Dale's Donuts and several other deep-fried establishments have become icons of California kitsch with numerous cinematic cameos.

CALIFORNIA

HEAVENLY HALO OF DOUGH

GIANT DONUTS AROUND LOS ANGELES, CALIFORNIA

When old New York was once New Amsterdam, the Dutch introduced their *olykoek*, literally "oil cake," of sweet dough deep fried in lard. Clearly this would be a hit and soon compete with bacon and eggs to be the classic American breakfast.

Rip Van Winkle's creator Washington Irving waxed poetic about these fatty "dough-nuts" that were "fried in hog's fat." One problem remained: the dough in the middle never cooked through. Many claim to be the first to cut out the middle for the classic ring-shaped breakfast delight that has expanded waistlines for decades.

In 1938, the Salvation Army declared National Donut Day for the first Friday in June every year to honor the donut lassies who served the sweet treats to servicemen during World War I, and to raise funds to help families survive the Great Depression. The Donut Dollies took up this mission during World War II and the Vietnam War to risk their lives to bring donuts and good cheer into war zones. Little wonder why this unhealthy bit of bliss has become an American icon.

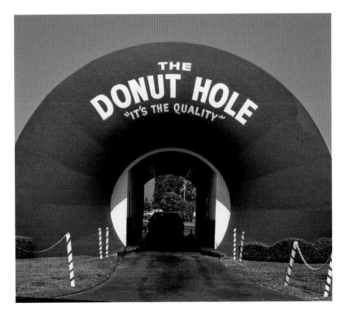

↑ This sculpture stands in the Los Angeles neighborhood of La Puente, where you can drive right into donut-filled bliss. Sure, many other pastry shops around town have a giant donut on the roof just waiting to roll through town like Godzilla on a bakery run, but only the Donut Hole is full-immersion where the donut eats you.

NO, THANKS . . . I'M FULL

BIG BOY'S HAMBURGER
BURBANK, CA

About 15 cu. ft. or 900 quarter-pound hamburgers. Could feed a big boy a hamburger every day for almost 2.5 years.

DALE'S DONUT
COMPTON, CA

22,740 cu. ft. or 379,000 donuts at 0.06 cu. ft. for average donut. Would feed someone two donuts a day for 1,038 years. More than 4 million grams of fat . . . enough to make 114 people morbidly obese.

TWISTEE TREAT
ST. JOSEPH, MO

2,415 cu. ft. . . . enough ice cream for 402,500 cones or one cone a day for more than 1,100 years.

CONEY ISLAND
BAILEY, CO

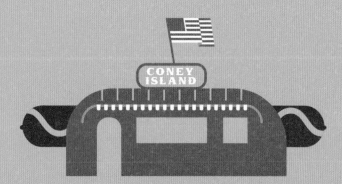

1,272 cu. ft. of meat or nearly 85 pigs. Could provide a half-pound of pork every day to one person for 118 years. The saturated fat could completely block the arteries of six otherwise healthy people and clog 180,000 miles of arteries that could encircle the globe more than seven times.

LONGABERGER
BUILDING PICNIC BASKET
NEWARK, OH

2,352,000 cu. ft. could hold more than 82.3 million pounds of food. Could feed the entire state of Ohio a picnic lunch for more than a week.

ALASKA

BEST DOG EVER

HUSKY STATUES IN ALASKA

In 1925 when diphtheria was poised to devastate the children in Nome, Alaska, pharmacists in Anchorage prepared a serum to send to this remote coastal town. But no road led to Nome, and the frigid temperatures froze the engine of the bush plane that was ready to fly. A treacherous blizzard struck with near white-out conditions, so many gave up hope of salvation.

Mushers stepped up and led relay teams of sled dogs over the 674 miles across the frozen tundra. The final relay team was led by a Siberian husky, Balto, and another dog named Kaasen and ran through subzero temperatures (down to -23°F [-31°C]) with winds whipping off the Bering Sea.

They made it just in time to deliver the antitoxin. Balto became a superstar and toured the lower forty-eight states because everyone wanted to see the superdog. He received a hero's welcome for the inauguration of a Balto statue in Central Park. He lived out his days at a zoo in Cleveland after the city gave the husky a tickertape parade to welcome him. The Cleveland Museum of Natural History has Balto stuffed for all kids to admire, but they can't caress him since he's safely behind plexiglass.

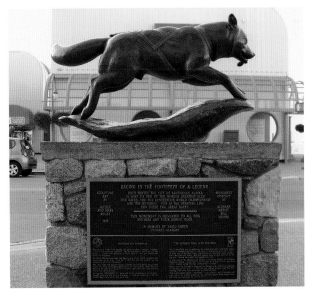

⬆ Even today, no roads lead to Nome, nor are there ferries. Alaska Airlines offers flights, but dogsleds are the most reliable. Husky statues pay homage to the famous Balto who helped deliver medicine to save children from diphtheria in Nome. The life-saving journey inspired the current Iditarod race from Anchorage to Nome.

COOKED COOK

KING KAMEHAMEHA STATUE IN HILO, HAWAI'I

Capt. James Cook is credited with discovering the Hawaiian Islands in 1778, even though Polynesians had colonized the islands 1,200 years earlier. That didn't stop Cook naming them the "Sandwich Islands" in honor of the sponsor of his voyage, the Earl of Sandwich, who is the very same Lord Sandwich who gave his name to "the sandwich." Thankfully, the name of these tropical islands returned to what locals had always called them, and parents everywhere will never need to explain that the islands have nothing to do with lunch food.

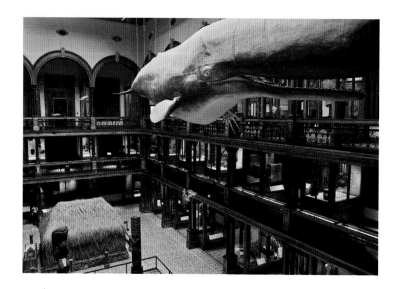

Cook was a celebrity explorer. Even when the American colonies were at war with England, Benjamin Franklin declared that Captain Cook's exploratory ships were "common friends to mankind" and should be given a pass. The behavior of Cook's men, however, wasn't so exemplary. Their introduction of sexually transmitted diseases and other

← Bishop's Museum in Honolulu records the fascinating history of Hawai'i's royal Kamehameha family with all their colorful robes, boats with outriggers, and chronicles of the death of Captain Cook.

illnesses brought by Europeans to Hawai'i would eventually wipe out half of the population.

Cook circled the islands and landed at Kealakekua Bay during the annual Makahiki fertility festival for the god Lono. The native Hawaiians honored their visitors and Cook and his crew accepted all the gifts and honorary feasts for an entire month. His men horded everything they could, including some wooden idols to use as firewood. This didn't go over so well.

Cook and crew sailed away, but at sea one of the masts of his ship snapped and they were forced to return to the island.

On February 14, 1779, a group of Hawaiians stole one of the small English sailboats. An infuriated Cook tried to lead their King Kalani'ōpu'u to the ship to kidnap him for ransom to get his boat back. The Hawaiians realized what was happening and swarmed Cook and his crew. Nearly all of them perished. Some claim that Captain Cook was eaten by the native Hawaiians, but they were not cannibals. He was indeed cooked, however. The Hawaiians believed a person's power lay in the bones, so the skeleton could be easily removed once the flesh fell off.

Today, Valentine's Day marks a special anniversary in Hawai'i as the day they conquered Cook. An obelisk at the town of Captain Cook shows the spot where the commander met his maker. A regal golden statue of King Kamehameha, who united the islands and was the descendant of King Kalani'ōpu'u, basks in the sun at Hilo on the Big Island.

← As the captain of both the HMS *Discovery* and *Resolution*, James Cook searched for the Northwest Passage (he never found it) and nearly made it to Antarctica. He did discover that he could save his crew from scurvy by simply eating sauerkraut, but that only kept the Grim Reaper at bay. Cook met an untimely demise in Kealakekua Bay when he tried to kidnap the Hawaiian King Kalani'ōpu'u.

↓ Resisting tsunamis, this gilded statue in Hilo features King Kamehameha who united the islands of Hawai'i. Cast in bronze in Italy, a similar statue stands in the U.S. Capitol building in Washington, D.C. Similar to King Arthur who yanked a sword from a stone, King Kamehameha lifted the impossibly heavy Naha Stone. See the 3.5-ton (3.2 MT) boulder in front of the Hilo Public Library and realize we are all mere mortals.

ACKNOWLEDGMENTS

Thanks to Fred Case for his outrageous stories; Michael Dregni for turning me on to the *New Roadside America* in the early '90s and beginning the quest for the bizarre; Katy McCarthy for being the best road trip companion ever; Lib Peck for showing me the literal dirt of New York; Dennis Pernu for asking if this book is in my wheelhouse— and how!; the Quasi Endowment Grant at Concordia University; the 'rents for being willing to hop in the car with me at a moment's notice for a trip across, say, North Dakota for a week; Vinnie & the Stardüsters for providing the soundtrack; and Kerri Westenberg for publishing my travel writing in the *StarTribune*.

ABOUT THE AUTHOR

Eric Dregni is professor of English, journalism, and Italian at Concordia University in St. Paul, Minnesota. He is the author of several titles from Motorbooks such as *Ads That Put America on Wheels* and *Let's Go Bowling!* He has written extensively about scooter culture in *Life Vespa* and co-authored *The Scooter Bible*. His obsessions range from futuristic jet packs (as seen in *Follies of Science: 20th Century Visions of our Fantastic Future*) to ice resurfacers (*Zamboni: Coolest Machines on Ice*). He's written several books about roadside attractions, including *Weird Minnesota* and *Midwest Marvels*.

Dregni worked in Italy for five years as a travel journalist for a weekly paper and wrote *Never Trust a Thin Cook* about the experience. He's written two memoirs about traveling in Norway: *In Cod We Trust* and *For the Love of Cod*. In the summer, he's dean of the Italian Concordia Language Village, *Lago del Bosco*, which he wrote about in his memoir *You're Sending Me Where? Dispatches from Summer Camp*. He lives in Minneapolis.

IMAGE CREDITS

A=ALL, B=BOTTOM, L=LEFT, M=MIDDLE, R=RIGHT, T=TOP

Alamy Stock Photos: 19, Alex Larson; 22R, Andre Jenny; 60, Purcell Team; 61, Planetpix; 66, Carmen K. Sisson/ Cloudybright. **Creative Commons:** 9, Hans-Jürgen Hübner/CC BY-SA 3.0 Unported; 55T, Brent Moore/CC BY-NC 2.0; 56T, Wollewoox/CC BY-SA 4.0; 59, Jack Winter/CC BY-NC-ND 2.0; 68–69A, Farragutful - Own work, CC BY-SA 4.0; 145, Burley Packwood/CCA-SA4.0-INTL; 185, Reywas92/CCA-SA 3.0. **Eric Dregni:** 37; 39B; 48TL; 94TL; 99; 106A; 108–114A; 116TL; 116B; 117TL; 117M; 117B; 121A; 123B; 127B; 131A; 134–135A; 140–141A; 166; 179BR; 182; 188. **Michael Dregni:** 64. **Getty Images:** 27, Bettmann; 33T, Keystone. **Library of Congress** (all John Margolies, Prints and Photographs Division, except where noted): 5T, Dorothea Lange; 5B; 10–11A; 12–13A; 15; 16B, Brady-Handy Collection; 24; 28; 29B; 30, Highsmith (Carol M.) Archive; 32; 38; 39T; 39M; 46A; 47; 48BL; 48R; 50–51A; 55B; 56B; 57; 73; 77; 80; 88–91A; 93; 94BL; 94R; 95; 96–97; 98; 100–105A; 116T; 117TR; 119; 123T; 125A; 126; 127T; 127M; 130–131; 138A; 146–147A; 156; 159; 164; 165R; 170–171; 172–177A; 179L; 179TR; 181A; 183. **Motorbooks Collection:** 25; 35; 124. **Peabody Museum of Archaeology and Ethnology at Harvard University:** 16T, Gift of the Heirs of David Kimball Peabody Museum of Archaeology & Ethnology, PM #97-39-70/72853 © President and Fellows of Harvard College. **Shutterstock:** 14, LnP Images; 21, DRLPhotoRI; 22L, Moavg; 29T, gary718; 31, Felix Lipov; 33B, digidreamgrafix; 34, Andrei Medvedev; 36, Roman Babakin; 42, Wendy van Overstreet; 45T, Rob Crandall; 45B, Evgenia Parajanian; 52, Nagel Photography; 58, Luis Andres Ojeda Havas; 62 Lia Adlaf; 63 Darryl Vest; 65L, Jose Carlos Castro Antelo; 65TR–65BR, Rob Crandall; 70A, Nat Intaraprom; 74, KennStilger47; 75 T-J Photography; 78, James Kirkikis; 79, AevanStock; 84, Kenneth Sponsler; 86, Justin Lee DeLong; 128, marekuliasz; 142, mcrvlife; 144, LizCoughlan; 149T, Peter Kunasz; 149B, Bildagentur Zoonar GmbH; 150, Nebs; 151T, clayton harrison; 151B, Masarik; 152A, V. Vormann; 154, Ellie-Rose Cousins; 155, OLOS; 158, TaylorLBlake; 162, melissamn; 165L, Phillip A Champagne; 178, Logan Bush; 180, Sean Pavone; 186, 7maru; 187T, George Burba; 187B, Yoga Ardi Nugroho. **US Food and Drug Administration:** 8. **Western Mining History:** 168.

INDEX

INDEX

First Published in 2021 by Motorbooks, an imprint of The Quarto Group,
100 Cummings Center, Suite 265-D, Beverly, MA 01915, USA.
T (978) 282-9590 F (978) 283-2742 QuartoKnows.com

Motorbooks titles are also available at discount for retail, wholesale, promotional, and bulk purchase. For details, contact the Special Sales Manager by email at specialsales@quarto.com or by mail at The Quarto Group, Attn: Special Sales Manager, 100 Cummings Center, Suite 265-D, Beverly, MA 01915, USA.

25 24 23 22 2 3 4 5

ISBN: 978-0-7603-7029-2

Digital edition published in 2021
eISBN: 978-0-7603-7030-8

Library of Congress Cataloging-in-Publication Data

Names: Dregni, Eric, 1968- author.
Title: The impossible road trip : an unforgettable journey to past and present roadside attractions in all 50 states / Eric Dregni.
Description: Beverly, MA : Motorbookss, an imprint of the Quarto Group, 2021. | Includes index.
Identifiers: LCCN 2021015735 (print) | LCCN 2021015736 (ebook) | ISBN 9780760370292 (hardcover) ISBN 9780760370308 (ebook)
Subjects: LCSH: Automobile travel—United States--Guidebooks. | Curiosities and wonders--United States—Guidebooks. | United States—Guidebooks. | United States—Description and travel.
Classification: LCC E158 .D73 2021 (print) | LCC E158 (ebook) | DDC 917.304--dc23
LC record available at https://lccn.loc.gov/2021015735
LC ebook record available at https://lccn.loc.gov/2021015736

Acquiring Editor: Dennis Pernu
Cover and Book Design: Rick Landers
Illustrations: Rick Landers

Printed in China

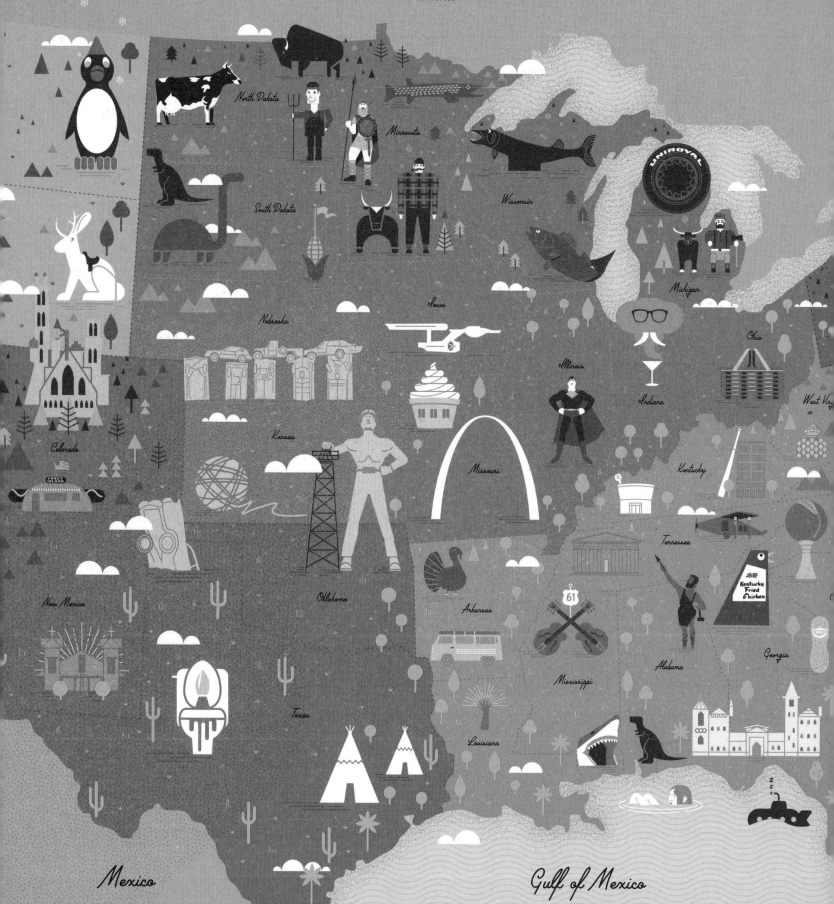

Canada

North Dakota

Minnesota

South Dakota

Wisconsin

Michigan

UNIROYAL

Iowa

Nebraska

Ohio

Illinois

Indiana

West Vir...

Colorado

Kansas

Missouri

Kentucky

CONEY ISLAND

Tennessee

New Mexico

Oklahoma

Arkansas

61

Kentucky Fried Chicken

Georgia

Alabama

Mississippi

Texas

Louisiana

Mexico

Gulf of Mexico